THE ART OF

PERSUASION

PUBLISHED IN CONJUNCTION WITH AN EXHIBITION
ORGANIZED BY THE INTERNATIONAL MUSEUM
OF PHOTOGRAPHY AT GEORGE EASTMAN HOUSE,
AND SPONSORED BY EASTMAN KODAK COMPANY
AND AMERICAN PHOTOGRAPHER

A HISTORY OF ADVERTISING PHOTOGRAPHY

HARRY N. ABRAMS, INC., PUBLISHERS, NEW YORK

ROBERT A. SOBIESZEK

THE ART OF
PERSUASION

Editor: Robert Morton
Assistant Editor: Harriet Whelchel
Designer: Elissa Ichiyasu

Library of Congress
Cataloging-in-Publication Data

Sobieszek, Robert A., 1943–
The Art of persuasion: a history of advertising
photography
by Robert A. Sobieszek.
p. cm.
Bibliography: p. 200
Includes index.
ISBN 0–8109–1469–7
1. Photography, Advertising—History.
I. Title.
TR690.4.S63 1988
779'.974167—dc19
87–26938
CIP
ISBN 0–8109–2386–6 (pbk.)

Preliminary research support for the exhibition was
granted by the National Endowment for the Arts,
a Federal agency

Reproduction photography for Irving Penn's *Two in
a Canoe, Composition with Triangle,* and L'Oréal's
Palette tearsheet by Otto Nelson

Published in 1988 by Harry N. Abrams,
Incorporated, New York

A Times Mirror Company

Printed and bound in Japan

Note: The captions accompanying the plates
include the essential information for each image.
Titles provided by the artist or owner are indicated
by *italics*. When no title was available, a
descriptive title has been given. A photograph that
is a variant of the one eventually chosen for an
advertisement is indicated in brackets when
known. Dates are given for the year the original
image was made, or as close an approximation as
possible. In many cases the same image was used
in a campaign over a number of years. While the
names of clients are almost always listed, the
names of responsible advertising agencies and art
(or creative) directors are not as easily
discoverable, especially with works some decades
old. Agency information, when available, is given
after the date.

Finished advertisements were customarily
produced by photo-offset printing processes in
magazines or on posters; here, in almost all cases
the process indicates the method used in making
the photograph. Some photographs, originally in
color, have been converted to black and white.
Cases where the artifact is a transparency have
been indicated and the conventional size of the
original transparency listed in brackets. In all other
cases, sizes are in centimeters, with height
preceding width. To convert centimeters to inches,
divide the centimeter figure by 2.54.

Frontispiece. Unidentified photographer. *W. H. Hoedt
Studios, Philadelphia.* 1950. Gelatin silver print.
International Museum of Photography/George
Eastman House (IMP/GEH), Rochester, New York.
Gift of 3M Co. Ex-collection Louis Walton Sipley

LENDERS TO THE EXHIBITION 6

ACKNOWLEDGMENTS 8

INTRODUCTION 10

BEGINNINGS 1865–1921 16

VARIOUS MODERNISMS 1922–36 30

REALISM, FEAR, AND COLOR 1929–45 64

AN AMERICAN GOLDEN AGE 1945–65 96

ROMANCE, COOLNESS,
AND LITERACY 1966–86 126

TRIUMPH OF THE IMAGE AND NEW
TECHNIQUES 1980–87 164

BIOGRAPHIES OF THE ARTISTS 192

SELECTED BIBLIOGRAPHY 200

INDEX 206

CONTENTS

LENDERS TO THE EXHIBITION

ALLY GARGANO/MCA ADVERTISING, LTD., NEW YORK

ARNELL/BICKFORD ASSOCIATES, NEW YORK

RICHARD AVEDON INC., NEW YORK

SID AVERY

B COMMUNICATIONS, MILAN

MERRILL C. BERMAN

REBECCA BLAKE

LEO BURNETT U.S.A., CHICAGO

CHANEL, INC., NEW YORK

JOHN CLARIDGE

CLINIQUE LABORATORIES, INC., NEW YORK

COLLETT, DICKENSON, PEARCE AND

PARTNERS, LTD., LONDON

CHRIS COLLINS

PHILIP L. CONDAX

COSIMO

MARIE COSINDAS

GILMAN PAPER COMPANY, NEW YORK

WILLIAM H. HELFAND, NEW YORK

PAUL M. HERTZMANN, INC., SAN FRANCISCO

HIRO

HOLLYWOOD PHOTOGRAPHERS ARCHIVES,

LOS ANGELES

GEORGE HOLZ

RYSZARD HOROWITZ

EIKOH HOSOE

DOMINIQUE ISSERMANN

BISHIN JUMONJI

BARBARA KASTEN

PAUL KATZ

KAZUO KAWAI

TOM KELLEY STUDIOS, LOS ANGELES

ESTÉE LAUDER, INC., NEW YORK

KEITH DE LELLIS

JAY MAISEL

ROBERT MAPPLETHORPE

JESSICA MCCLINTOCK, INC., SAN FRANCISCO

SEYMOUR MEDNICK

ERIC MEOLA

DUANE MICHALS

THE MILLER-PLUMMER COLLECTION

KAZUYOSHI MIYOSHI

NICOLAS MONKEWITZ

SARAH MOON

ANTONIA MULAS

THE MUSEUM OF MODERN ART, NEW YORK

NEVAMAR CORPORATION, ODENTON, MARYLAND

UWE OMMER

ONOFRIO PACCIONE

PARCO COMPANY, LTD., TOKYO

IRVING PENN

PHOTOFIND GALLERY, NEW YORK

PRAKAPAS GALLERY, NEW YORK

PRIVATE COLLECTION

JOHNNY RASMUSSEN

SAN FRANCISCO MUSEUM OF MODERN ART

SANDER GALLERY, NEW YORK

JEFFREY K. SCHEWE

W. MICHAEL SHEEHE

SHISEIDO COMPANY, LTD., TOKYO

TIM SIMMONS

BERT STERN

WALTER STORCK

SUNTORY LIMITED, TOKYO

PAUL TORCELLO

PETE TURNER

STEPHEN WHITE

STEPHEN WILKES

HENRY WOLF

REINHART WOLF

WUNDERMANN, RICOTTA & KLINE, DETROIT

NORIAKI YOKOSUKA

ZABRISKIE GALLERY, NEW YORK

This project was possible only because of the willing and generous assistance of many individuals. Foremost among them, of course, were the artists — those photographers, photo designers, and art directors who contributed their work, their time, and their ideas. It was the photographers who believed that such an exhibition and book were important, but who also provided the inspiration for the project by fashioning those very images that I grew up with, admired, and collected from magazines — and through which I began to appreciate this very special art. I can only hope that I represented these artists and their art with some fairness.

In 1977 the International Museum of Photography at George Eastman House was awarded a National Endowment for the Arts grant to undertake this project. With that agency's support, the preliminary research was begun. It could only have been realized at this date, however, with the primary sponsorship of the Professional Division of Eastman Kodak Company and *American Photographer* magazine. For their faith in the Museum, we are greatly and sincerely appreciative.

A debt of gratitude is owed Patricia R. de C. Jellicoe, whose initial motivation facilitated the completion of this project. The members of our honorary advisory committee are also to be thanked for all that they contributed: Sean Callahan of *American Photographer*; Phyllis Crawley and Peter Diamandis of Diamandis Communications Inc.; Robert Delpire of the Centre national de la photographie; Lou Dorfsman of CBS; Steve Frankfort of Kenyon & Eckhardt; Roy Grace of Grace and Rothschild; F. C. Gundlach of the PPS Gallery; Robert Kirschenbaum of Pacific Press Service; George Lois of Lois, Pitts, Gershon, Pon, GGK; Diane Lyon, former director of the Advertising Photographers of America; Bert Metter of J. Walter Thompson Company; Helen Marcus of the American Society of Magazine Photographers; Masaya Nakamura of the Advertising Photographers' Association of Japan; Al Politi and Ruth Unziger of Eastman Kodak Company; Stan Richards of The Richards Group; Bert Steinhauser of Bert Steinhauser Productions; and Henry Wolf of Henry Wolf Productions. The staffs of the Centre national de la photographie in Paris and of the Pacific Press Service in Tokyo were most helpful in locating information and material in their respective countries.

The following individuals were particularly generous in making the collections under their stewardship available: Pierre Apraxine of the Gilman Paper Company; Toru Arai, Yoshitaka Kawamata, Isamu Hanauchi, and Shoji Yoda of Shiseido Company, Ltd.; Peter Arnell of Arnell/Bickford Associates; Sid Avery of the Hollywood Photographers Archives; Jill Bentley of Collett, Dickenson,

ACKNOWLEDGMENTS

Pearce and Partners Ltd.; Merrill C. Berman; Catherine Evans and John Szarkowski of The Museum of Modern Art in New York; Keith de Lellis; Ralph Delby of Leo Burnett U.S.A.; Diana C. du Pont and former curator Van Deren Coke of the San Francisco Museum of Modern Art; Tetsuya Fukui, Munetaka Inami, and Hiroshi Tani of Suntory Limited; Howard Greenberg of Photofind Gallery; William H. Helfand; Susan Herzig of Paul M. Hertzmann, Inc.; Paul Katz; Tom Kelley, Jr. of the Tom Kelley Studios; June Leaman of Estée Lauder, Inc.; Seymour Mednick; Ellen Merlo of Philip Morris; Steve Noxon of Wundermann, Ricotta & Kline; Dorothy and Gene Prakapas of the Prakapas Gallery; Masayoshi Okura and Hisao Tsushima of Parco Co., Ltd.; J. Randall Plummer of The Miller-Plummer Collection; Gerd Sander; Lyle Sanders of Chanel, Inc.; W. Michael Sheehe; Walter Storck; Dino Betti van der Noot of B Communications; Stephen White; Kat Walker and Monique D. Wilson of Jessica McClintock, Inc.; Tom Wolsey of Ally Gargano/MCA Advertising, Ltd.

Without the help of corporate personnel, studio managers, and assistants, much of the research and practical foundation of this project would not have been achieved. Among many others, we would like to specially thank Rob Atkins of Pete Turner's studio; Jan Adkins of Nevamar Corporation; Sue Bender of Bender and Bender Studio; Kevin R. Brown of Nike Inc.; Paula Claridge for John Claridge; Diana DesVergers and Michelle Mackin of Paccione Photography, Inc.; Suzanne Donaldson of the Robert Mapplethorpe Studio; Shelley Dowell and Norma Stevens of Richard Avedon Inc.; Valerie Fisher of the Sander Gallery; Mari Chihaya of Shiseido (America); Richard Gaul of the Eric Meola Studio; Elyse Goldberg of the John Weber Gallery; Christopher Hunter of Hiro's Studio; Hiroko Ikeshima of Parco Co., Ltd.; Elka Kristo-Nagy of George Holz's studio; Majka Lamprecht of Marek & Associates, Inc.; Ann Lapides of the Zabriskie Gallery; Pei Lok Lo and Suzanne Calkins of C. F. Hathaway Division of Warmaco, Inc.; Yves Macaire for BMW (France); Patricia McCabe of Irving Penn's studio; Carla Mikell of Colgate-Palmolive Company; Fumi Ohsaku of Shiseido Co., Ltd. (Tokyo); Harriet Penenski of Henry Wolf Productions; Anna Marie Sandecki of N. W. Ayer, Inc.; Emily Vickers of Jay Maisel's studio; Julie Weber of Denis Piel's studio; Bette Wilkes and Michelle Graham of Stephen Wilkes's studio; Carol Wilson and Luanne Schnase of Hills Bros. Coffee, Inc.

Others to be thanked include Rolf Fricke, Tony Merkadal, Geoff Tucker, Tim Welsh, and James Zieziula of Eastman Kodak Company; Amy Frankel of L'Oréal, Cosmair, Inc.; Rebecca Gaver; Burt Glinn; Suzanne Goldstein of Photo Researchers; Sakae Haruki of the Photographic Society of Japan; Gen Kaneko, Shozo Iwata, and Eigo Mine of Dentsu Inc.; Tim Kirby of Direction Magazine; N. Boyd Mettee of the Holmes I. Mettee Studios, Inc.; James Moffat of Art & Commerce; Valerie Montalbano and Elizabeth B. Senick of DDB Needham Worldwide, Inc.; Stephen and Elizabeth Myers; Joyce Nereaux; Professor Takesi Ozawa; Carol Philips of Clinique Laboratories, Inc.; Miriam Rothman; Dr. Daniela Palazzoli; Michele S. Saunders; Professor Noriyoshi Sawamoto; Victor Schrager; Cynthia Swank of the J. Walter Thompson Group; Dr. Karl Steinorth of Kodak AG.; Robert Taub of the Ford Motor Co.; and Kristin K. Twedt of Fallon McElligott.

Members of the present staff of the Museum have been fully dedicated to our efforts, namely, the Development Office, especially Susan Kramarsky and Dan Ross; Andrew Eskind, Director of Interdepartmental Services; Ann McCabe and James Conlin of the Registrar's Office; Philip L. Condax of the Technology Department; Del Zogg, Greg Drake, and Sara Beckner of the cataloguing staff; Barbara Puorro Galasso of the Darkroom; Rick Hock, James Via, and Carolyn Zaft of the Exhibitions Department; Michael Hager of the Negative Archives; Kathleen Wolkowicz of the Education Department; Barbara Hall of Publicity; Grant Romer, Director of Conservation, and his staff; Marianne Fulton, Nancy Levin, and Jennifer Greenfeld of the Department of Photographic Collections; David Wooters and Carolee Aber of the Archives; Rachel Stuhlman, Rebecca Simmons, and Barbara K. Schaefer of the Library—to these and others I owe much. Our secretary, Nancy Bosaits, is to be commended for her success at managing many of the project's complications. Robin Blair Bolger was especially giving of her time as a volunteer and as a reader of an early draft of the manuscript. The Museum's director, Robert A. Mayer, has been continually encouraging from the very beginning of the project.

Special consideration must be given Jeanne Verhulst, who has been my assistant throughout the project and the author of the biographical sketches within this publication. Her personal wisdom, grace under pressure, and unstinting devotion to her work are quite unique, as is her tenacity in tracking down elusive images, wending her way through the mazes of corporate and advertising bureaucracies, and obtaining the necessary permissions—all with the utmost charm.

I also owe much to Robert Morton, Director of Special Projects, and Harriet Whelchel at Harry N. Abrams, who so ably and gently turned my convoluted text into something approaching readable.

Finally, I would like to dedicate this book to my wife, Sonja Flavin, who has constantly guided me in matters of design and supported me by her companionship; and to the memory of Professor Elmer Raymond Pearson, who introduced me to the art of advertising while at the Institute of Design some decades ago.

ROBERT A. SOBIESZEK
APRIL 1987

INTRODUCTION

THE WORKER MUST GROW UP THINKING,

"WELL, IT'S A FAIR SOCIETY ON THE WHOLE AND

IF I WORK HARD AND CONTINUE CLOCKING IN

THEN ONE DAY I'LL HAVE A NICE HOUSE AND

MAYBE GO SCUBA DIVING WITH THAT BLONDE

JUST LIKE IN THE MARTINI ADVERT."

—VICTOR BURGIN, ARTIST, 1986[1]

. . . HISTORIANS AND ARCHAEOLOGISTS WILL

ONE DAY DISCOVER THAT THE ADS OF OUR TIMES

ARE THE RICHEST AND MOST FAITHFUL DAILY

REFLECTIONS THAT ANY SOCIETY EVER MADE OF

ITS ENTIRE RANGE OF ACTIVITIES.

—MARSHALL McLUHAN, CRITIC, 1971[2]

I TRY TO GET THE GRAPEFRUIT RIGHT.

—H. I. WILLIAMS, PHOTOGRAPHER, 1931[3]

The house was somewhere in the Philippines. Its one-room interior measured only about three by five meters, but it was home to a Filipino farm laborer. The radio journalist noted, in passing, that the interior was decorated with pictures.[4] Like far less modest homes that have fine prints or paintings hanging on their walls, here too were prints, undoubtedly chosen for the significance they held for the worker and certainly acquired on the basis of what could be afforded. But these prints were hardly "fine"; in fact they were magazine pages. The laborer had raised the most ordinary product of offset printing to a position of popular art, not unlike what occurs in dorm rooms, prisons, and army barracks around the world. But instead of pictures of erotic playmates, portraits of actresses, like Jodie Foster, or criminals, like those the novelist Jean Genet had pasted to the wall of his prison cell, the farmer had pinned up photographic advertisements for hot dogs and other foods. It is probably safe to assume that the ads were not so honored for their witty copy or typographic design, nor were they tacked up because nothing else was available. They were put there simply because the photographs in them were attractive images of recognizable desires—pleasing to look at and reminders of what might be.

One of the failures of modernism, insofar as photography is concerned, has been the illogical separation of what is considered "commercial" from what is considered "art." French writer Henry Murger celebrated *la vie de bohème* in the 1840s, casting the modern artist in the role of starving idealist. In the early twentieth century, American photographer Alfred Stieglitz created the model for subsequent photographic artists, divorced from all but their own aesthetically

"disinterested" expressions. Since then commercial photographers, those whose work is in the service of fashion, architectural and industrial documentation, studio portraiture, and most especially advertising, are rarely considered "pure" enough for inclusion in our histories or museums. (Photojournalists are different: they are cultural heroes, since their business is to bring us important human events, and they risk their lives for little money.) To be fair, a number of commercial photographers have been validated as artists through exhibitions, monographs, and museum collections. But these artists have had to satisfy certain requirements—being either ignored for decades or deceased. Nineteenth-century photographers such as Roger Fenton, Timothy H. O'Sullivan, Gustave Le Gray, and Nadar have been elected to the pantheon of great photographic artists, although theirs were purely commercial practices. The commercial work of Grancel Fitz, Paul Outerbridge, Horst P. Horst, George Hoyningen-Huene, and Maurice Tabard, for example—done primarily in the twenties and thirties—has also been given limited but passionate scrutiny by critics and museums in recent years. But contemporary professional photographers who do not distinguish their personal work from what is done on assignment or commission have little chance of being taken seriously as artists, despite the fact that their images are seen by and affect the lives and emotions of a larger admiring audience than any other kind of photography.

With the exception of a few inspired amateurs, all the great photographers of the last century were commercial; a few even worked as advertising photographers. Edouard-Denis Baldus's photographs of the new Louvre for the government of Louis Napoleon were as much political advertising as the Bisson brothers' landscapes for French real-estate developers were pure advertising photography. Yet, despite the varying expectations and restraints placed upon these photographers by their clients, we have no difficulty in discerning their artistry. Only when we encounter work done in similar circumstances in this century does there seem to be a problem. In the last century professional photographers rarely, if ever, differentiated between photographs done for art and those created in the service of commerce and advertising. They simply made good photographs that won prizes, reflected the values of their period, and are today cherished as important works of art. Contemporary advertising or fashion photographers, on the other hand, seeking the cultural esteem given to other visual artists, almost exclusively have had to publish and exhibit work that was completely different from their professional photography.

For centuries artists have created masterpieces while working under controlled circumstances. Medieval artisans illuminated manuscripts following the careful instruction of more educated monks. Raphael accepted commissions from popes Julius II and Leo X and had to work under the art direction of some very strong-willed cardinals and Neoplatonist scholars while painting the Vatican *stanze*. In 1563 the Council of Trent decreed that "no one be allowed to place or cause to be placed any unusual image in any place or church . . . unless it has been approved by the Bishop."[5] The painter Paolo Veronese most likely felt like many a commercial illustrator or photographer feels today when, in 1573, he was told by the Tribunal of the Inquisition to repaint certain portions of his *Feast in the House of Simon* and to change the painting's title. There is little significant difference between Veronese's relationship with the Tribunal and, for example, the photographer Victor Skrebneski's relationship with his client Estée Lauder, when an entire approach to a campaign was abandoned in favor of another and the model rephotographed from another angle. This is not to suggest that model Willow Bay in the *Beautiful* ad is a twentieth-century Sistine Madonna, but only to caution that we should not ignore an artist's genius because there is a patron or client. No matter how talented and creative the art director may be, no matter how strongly rooted the unformed image may be in the mind of the client, and no matter, really, how restrictive various regulations may be, it is still the imagination and artistry of the photographer that form the final pictorial inventions that have affected what we know, what we believe, and, when these inventions are truly exceptional, what we desire.

In 1927 the British novelist Aldous Huxley wrote a brief but remarkable essay entitled "Advertisement." In it Huxley wrote that he had "discovered the most exciting, the most arduous literary form of all, the most difficult to master, the most pregnant in curious possibilities. I mean the advertisement."[6] While it was a matter of one writer critiquing another form of writing, and in spite of Huxley's somewhat ironic tone, his comments equally relate to the challenge of advertising photography:

IT IS FAR EASIER TO WRITE TEN PASSABLY EFFECTIVE SONNETS, GOOD ENOUGH TO TAKE IN THE NOT TOO INQUIRING CRITIC, THAN ONE EFFECTIVE ADVERTISEMENT THAT WILL TAKE IN A FEW THOUSAND OF THE UNCRITICAL BUYING PUBLIC. . . . A GOOD ADVERTISEMENT HAS THIS IN COMMON WITH DRAMA AND ORATORY, THAT IT MUST BE IMMEDIATELY COMPREHENSIBLE AND DIRECTLY MOVING. BUT AT THE SAME TIME IT MUST POSSESS ALL THE SUCCINCTNESS OF EPIGRAM. . . . NO ONE SHOULD BE ALLOWED TO TALK ABOUT THE <u>MOT JUSTE</u> OR THE POLISHING OF STYLE WHO HAS NOT TRIED HIS HAND AT WRITING AN ADVERTISEMENT OF SOMETHING WHICH THE PUBLIC DOES NOT WANT, BUT WHICH IT MUST BE PERSUADED INTO BUYING.[7]

Huxley was speaking of advertising copy, of course, and at a time when photography was only beginning to be applied to advertising with any frequency, but in one particularly caustic comment he anticipated a thoroughly modern sensibility. "Already," he wrote, "the most interesting and, in some cases, the only readable part of most American periodicals is the advertisement section."[8] Anyone familiar with contemporary fashion and design magazines might well appreciate the justness of this observation.

During the thirties, when arguments raged over whether painted or photographic illustrations were to be preferred in advertising, the British critic Sidney Wicks saw literary parallels in each method:

THE ARTIST SEEKS TO AROUSE THE IMAGINATION – THE SUBCONSCIOUS IF YOU WILL – AND TO CREATE AN ATMOSPHERE THROUGH WHICH YOU WILL SEE THE GOODS. THE PHOTOGRAPHER SEEKS TO MAKE MORE KEEN THE EYES OF THE OBSERVER THAT OUT OF A NEW VISION OF THE GOODS THE OBSERVER'S IMAGINATION MAY BE AROUSED. PUT IN A SHORTER WAY, THE ARTIST EXPLOITS THE GOODS TO STIMULATE HIS IMAGINATION; THE PHOTOGRAPHER USES HIS IMAGINATION TO REVEAL THE GOODS. SPEAKING BROADLY, I LAY IT DOWN THAT AN ARTIST IS ESSENTIAL WHEN THE PURPOSE IS TO AROUSE SOMETHING IN THE SUBCONSCIOUS OF THE READER. THE PHOTOGRAPHER IS ESSENTIAL WHEN THE PURPOSE IS TO APPEAL TO THE CONSCIOUS REASON OF THE READER. IN SHORT, THE ARTIST WRITES POETRY; THE PHOTOGRAPHER WRITES PROSE – AND BOTH ARE FORMS OF LITERATURE. THE ARTIST IS A TENNYSON, THE PHOTOGRAPHER A DARWIN – AND BOTH ARE GREAT THINKERS.[9]

By the end of the article, Wicks had to admit that "photography has the advantage. It has all the ardour of an advancing force. Every month it seems to rejoice in some new exercise of its power."[10] In the ensuing years photography's powers have become the principal force in advertising, so much so that today advertisements exist that contain nothing but a photographic image. This single medium of communication has become dominant, and over the years it has conflated both the poetry and prose Wicks spoke of.

This book, then, is not about the history of photographically illustrated advertising as much as it is about the poetry and prose of those photographs made for or used in advertising. It is about great and intriguing images, not about impressive or necessarily successful ads. Although advertising, like the movies, is a team effort involving conceptualizers, copywriters, layout artists, typographers, and designers, this book examines the contribution advertising photographers have made to our visual experience and their creative responses at different moments to visual problems. Editorial photography has been excluded, as have book, magazine, and record-album covers, simply because the work is fundamentally different from advertising photography. Besides, most photographers distinguish between editorial and advertising, despite the fact that distinctions between them have become progressively murky, as evidenced in the latest Madison Avenue neologism, "advertorials."[11] Similarly, annual report photography has not been included for much the same reason, except for one example by Pete Turner that is comparable to his advertising work for the same client. While the photographs are primarily limited to those made for printed advertising, such as that found in magazines and on posters, two early pieces of point-of-sale advertising and one product package have been added to establish the advertising photograph's presence in our three-dimensional world.

There have been numerous studies of photographic images found in modern advertising. Most of these have been sociological and show a different picture of cultural values than would an art historical study. Most often the images used by sociologists are from realistic, normative ads found in popular, middle-class publications rather than from the idealized and exceptional ads more often seen in luxury and speciality journals. Where most ads simply portray accepted norms of everyday reality, more sophisticated ads tend to stress style as much as image and are as a rule more pictorially progressive. Sociologists and cultural historians explore family dynamics, social role models, therapeutics, women at work, and the like as seen in advertising. Our study will concentrate on the visual qualities of the photograph alone.

For measuring social content, the finished ad is not only sufficient but preferable since it also contains textual copy that can give greater precision to any interpretation of the ad's ultimate meaning. But to appreciate the advertising photograph and to understand what exactly the photographer contributed require an original print or transparency. It is only then that the work of the photographic artist is revealed, that the often subtle nuances of the image appear, and that the evolution of this art form be clearly understood. To that end we have sought to include as many original images as possible, and have selected tearsheets and finished ads only when original images were not available or never existed, as in the cases of some mechanically or electronically assembled composites.

By far the greatest problem in studying these images from a purely photographic point of view is the scarcity of original prints. Unfortunately, more great advertising photographs have been lost than have survived. This is due in part to the photograph being seen only as raw material to be cropped, overpainted, retouched, and otherwise absorbed into the final complex of a printed ad. Once an ad is completed and published, its elements are no longer important. Agencies and their clients remind us they are not in the history business, nor have they the space to maintain all the work they commission. Those agencies that have historical archives tend to collect tearsheets of printed ads and documents such as market surveys and in-house memos. Still, it is dismaying how few agencies can identify the art director who worked on a historical campaign or even the accurate date of a specific ad. Moreover, only recently has the "work-for-hire" rule begun to lose its hold over practicing photographers who, under the rule, had to surrender all rights in their images to the agency and client. Thus, the artists had no control over their pictures nor any lasting claim to their own creative output. History might not have been badly served by this were it not for the fact that while the photographer could not preserve this work, neither would the agencies or clients.

Techniques and materials used in advertising and photography are also to blame for the scarcity of original work. For years prints were mounted on layouts and camera-ready mechanicals with rubber cement, a method of adhesion that guarantees a surprisingly short life span due to chemical deterioration. Much original color photography made after World War II has simply faded away due to the instability of modern color dyes. Color images made in the fifties, sixties, and even the seventies have usually shifted in color balance to an overall pale magenta, unless they were made into relatively expensive dye-transfer or carbro prints before any shift occurred. Presumably, this will be different in the future. Current advances in certain color chemistries and the advent of digitalized imaging, along with the growing awareness that advertising photography is valuable to study both artistically and sociologically, may mean that more will be conserved than before.

More than any other kind of imagery, advertising photography has permeated our cultural consciousness. It reflects what we are and determines what we desire. It informs and offers models of progress and behavior; it seduces and teases with promises of perfection. It feeds our imaginations, whether we permit it or not. For many it may be the only pictorial art form regularly encountered. For others its form and style, syntax and rhetoric have entered the realm of art—so much so that assessing the differences between advertising and fine art is often disarmingly complicated if at all possible. During the 1960s, Andy Warhol appropriated images of commodities into fine art, and Mel Ramos painted photorealist images of nudes alongside popular totems like Coca-Cola signs. In the last decade Conceptual artists such as Robert Morris

and Lynda Benglis posed themselves in "advertisements" and considered these ads to be a form of their artwork. Other artists began a wholesale appropriation of the visual methods of modern advertising. British artist Victor Burgin (fig. 1) was one of the pioneers:

MY WORK FROM 1973 TO 1976 HAD ALL BEEN WHAT TODAY IS CALLED "APPROPRIATED IMAGE" WORK. I WAS RECYCLING ADVERTISING IMAGERY AND REPRODUCING THE RHETORIC OF ADVERTISING COPY. PART OF THE INTENTION WAS TO DECONSTRUCT THE IDEOLOGICAL DIVISION BETWEEN THE INSIDE AND THE OUTSIDE OF THE GALLERY. ON THE ONE HAND, THE WORK ON THE GALLERY WALLS LOOKED LIKE THE SORT OF IMAGE-TEXT CONSTRUCTIONS YOU ENCOUNTER IN THE STREET, AND IN MAGAZINES. ON THE OTHER HAND, I DID DO WORK WHICH WAS PLACED ACTUALLY IN THE STREET, AND IN MAGAZINES. I ALSO TREATED ADVERTISEMENTS FOR MY EXHIBITIONS AS WORKS, SO THAT THE GALLERY WALL DISSOLVED INTO THE PAGE OF THE MAGAZINE. FOR EXAMPLE, MY FIRST SOLO SHOW IN NEW YORK WAS PAGE TEN OF THE JANUARY 1976 ISSUE OF ARTFORUM.[12]

What does possession mean to you?

7% of our population own 84% of our wealth

The Economist, 15 January, 1966

FIGURE 1. VICTOR BURGIN. POSSESSION. 1976.
POSTER. COURTESY JOHN WEBER GALLERY,
NEW YORK

New York artist Barbara Kruger, coming from a background in magazine publishing, fabricated large, museum-scaled tableaux of ambiguous and unsettling photographs combined with provocative copy—works that compel us to question just how we are controlled and motivated by photographic advertising. In one of her pieces (fig. 2), a reprise of sorts of a poster by Max Burchartz for a 1931 exhibition of advertising art,[13] a hand is seen bound with cord and the particularly apt message boldly announces: "We are the objects of your suave entrapments."

What follows is a survey of how photography so suavely entrapped its consumer audience over the last century. Photography's tentative forays into advertising during the last century and the early years of this century gave way, in the twenties and thirties, to the first "golden age" of advertising photography, with links to both modern art and social realism. During the forties and fifties, advertising affirmed its position as a highly influential tool of communication and persuasion and established the photograph as a principal weapon in its arsenal. The steady growth of the advertising industry throughout the last quarter century has been such that the average person now encounters thousands of ads each day, hundreds of which are photographic. Since the sixties, increased sophistication and the needs of gaining attention have prompted another protean era of advertising photography, one that is marked by a unique visual literacy and an unprecedented creative vitality. As a modern art form, advertising photography is not only unavoidable, it is essential. As the first, full-length study of this essential art, what follows is certainly incomplete, but one has to begin somewhere in the hopes that others may build on it.

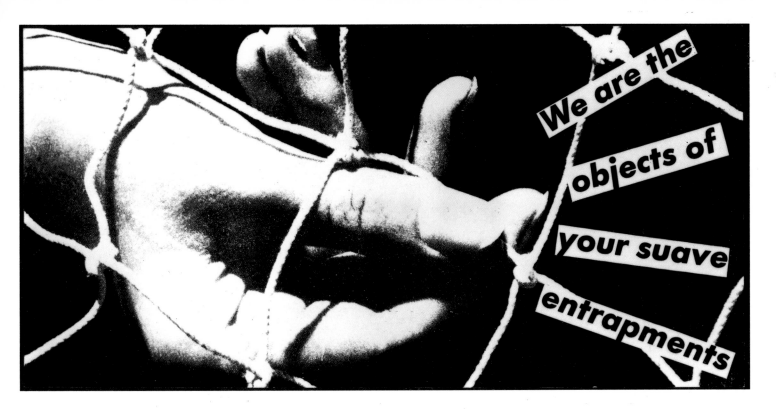

1. Victor Burgin, *Between* (Oxford and New York, 1986), p. 19.

2. Marshall McLuhan, "Ads: Keeping Up With the Joneses," *Understanding Media: The Extensions of Man* (New York, 1971); reprinted in J. S. Wright and J. E. Mertes, eds., *Advertising's Role in Society* (New York, 1974), p. 9.

3. H. I. Williams, photographer, 1931, cited in Lillian Sabine, "H. I. Williams, New York City," *The Commercial Photographer* 7, no. 1 (October 1931): 15.

4. Robert Carty, CBC Radio, "Sunday Morning," broadcast (2 February 1986).

5. Cited in Anthony Blunt, *Artistic Theory in Italy, 1450–1600* (London, 1962), p. 110.

6. Aldous Huxley, "Advertisement," in *Essays: New and Old* (New York, 1927), p. 126.

7. Ibid., pp. 127–28.

8. Ibid., p. 131.

9. Sidney F. Wicks, "Photography in Modern Advertising and Commerce," *The British Journal of Photography* 81, no. 3862 (11 May 1934): 270.

10. Ibid., p. 271.

11. Cf. Maureen McFadden, "What's So Good (or Bad) About Advertorials?," *Adweek*, 28, no. 9 (17 February 1987): 38–42.

12. Victor Burgin, *Between*, p. 12.

13. For an illustration of the Burchartz poster, see Dawn Ades et al., *The 20th-Century Poster: Design of the Avant-Garde* (New York, 1984), p. 164.

FIGURE 2. BARBARA KRUGER. <u>WE ARE THE OBJECTS OF YOUR SUAVE ENTRAPMENTS</u>. 1979. GELATIN SILVER PRINT. COURTESY ANNINA NOSEI GALLERY, NEW YORK

In its most rudimentary form—the spoken announcement—advertising can probably be traced to public cries in ancient Egypt.[2] With the invention of movable type in the fifteenth century, the printed advertisement began to appear; to it were added, over time, images produced by varying techniques—from woodcuts to delicate mezzotints. Wood engraving and, by the beginning of the nineteenth century, lithography furnished illustrations in even greater detail for publication in newspapers, magazines, and on posters. By the end of the last century, journals were filled with pictorial advertising and the streets of large cities were papered with multicolored *affiches* announcing everything from pure soap to less than pure entertainments in dance halls.

The appearance of photography in the 1830s at first had little effect on the world of advertising. Indeed, photography played only a minor role in advertising for nearly a century after its invention. While the photograph was ideal for a clear, direct, and informative image of a product, the means for its use was lacking. Before photography became photomechanical, prints could not be reproduced with any kind of real cost-effectiveness. Even with early techniques, such as photogravure, collotype, and photolithography, photographs still had to be separately printed and mounted on decorative and typographic advertisements. It was only after the invention of the halftone process in the 1880s and offset printing soon after the turn of the century that the photographic image became economically compatible with type and letterpress printing, and could then be included in advertising.

BEGINNINGS
1865-1921

ABOUT THE SIMPLEST RULE I KNOW OF,

IN MAKING PHOTOGRAPHS FOR ADVERTISEMENTS,

IS TO GET THE PICTURE SO THAT IT TELLS A STORY

SO THAT "HE WHO RUNS MAY READ."

IN OTHER WORDS, IT MUST TELL THE STORY

AT A GLANCE AND TELL IT STRONGLY SO AS TO

MAKE AN IMPRESSION.

—L. G. ROSE, PHOTOGRAPHER, 1920[1]

Photographs were principally used in advertising during the second half of the nineteenth century on posters or in promotional volumes such as trade albums, pattern books, and business directories. The earliest notice found in print concerned the sale of real estate around Paris in 1854:

THERE EXISTS AROUND SAINT-GERMAIN TERRACE A CERTAIN NUMBER OF LAND PARCELS THAT DOMINATE THE LANDSCAPE. WISHING TO SELL THEM, THE OWNERS OF THESE PARCELS HAVE HAD THE IDEA OF HAVING A PHOTOGRAPHIC PRINT MADE THAT WOULD GIVE AN IDEA OF THE MAGNIFICENT VIEW THAT THE RESIDENTS OF THE HOMES TO BE BUILT ON THIS LOCATION WOULD ENJOY. THE BISSON BROTHERS, TO WHOM THEY APPLIED, FOUND THERE THE SUBJECT OF A CHARMING PHOTOGRAPH, WHICH THEY HAVE EXECUTED WITH THEIR CUSTOMARY SKILL. TODAY IN ALL THE RAILROAD TICKET OFFICES ONE CAN SEE A POSTER ANNOUNCING THE SALE OF THESE LANDS; THE BISSONS' PHOTOGRAPH FIGURES IN THE MIDDLE OF THE POSTER.

WE ARE PLEASED TO ANNOUNCE THIS NEW APPLICATION OF PHOTOGRAPHY AND ARE CONVINCED THAT IT WILL RENDER MANY SERVICES.

THIS IS NOT THE FIRST TIME THAT THE BISSONS HAVE WORKED IN THIS GENRE. PHOTOGRAPHY APPLIED TO INDUSTRY—THE REPRODUCTION OF CLOCK MODELS, OBJETS D'ART, MACHINES, ETC.— OCCUPIES AN IMPORTANT PLACE IN THE CONSIDERABLE WORK THAT THEY UNDERTAKE EVERY DAY.[3]

Unfortunately, prints from this early campaign do not seem to exist; at least none of the extant landscape images by the Bisson brothers suggest they were used for this purpose.

A poster advertising a $100,000 reward for the assassins of President Abraham Lincoln (plate 1) is similar in style to the Bissons' real-estate ad of 1854. What is exceptional about it is the speed with which it was promulgated. Lincoln was shot on April 14, 1865, and John Wilkes Booth, pictured in the center of the three portraits, died in a barn fire on April 26. The U.S. War Department, then, had less than two weeks to arrange for the graphics, locating and having an unknown number of cartes de visite by the photographer(s) printed, and affixing the prints prior to posting. Fortunately, at least one of these posters, complete with photographs, has survived. But by their very nature, outdoor advertisements such as posters and billboards are not meant to last. There are numerous reports of large photographic posters publicly distributed along city streets during the nineteenth century; most of these have been lost.

CATALOGUES AND DIRECTORIES

Various kinds of trade albums and business directories have survived, however. The German critic W. F. Haug has pointed out that in consumer cultures, of the three groups of commodities that have paved the way to global exchange, the first has invariably been military supplies.[4] Indeed, during the 1870s the French photographer Lafon was commissioned to document an entire line of Hotchkiss repeating rifles and machine guns (plate 2). Similar to the many goods albums of the period, such as those featuring locomotives built by the Baldwin Works of Philadelphia, Lafon's images differ from those in other albums by picturing the products as if they were being used. No dryly documented array of one gun after another, the album instead shows guns being aimed by French soldiers and sailors.

In many larger American cities, the growth of business associations and chauvinistic boosterism gave rise to the photographically illustrated business directory. These would be placed in hotel lobbies, steamers, train stations, or wherever commercial travelers would likely have time to view them. Usually, they included photographs of city street scenes detailed enough to show the shop signs of the various merchants, and in some cases the photograph would be surrounded by the printed business cards of the same merchants (fig. 3). An outstanding example of these directories is Isaiah W. Taber's *View Album and Business Guide, of San Francisco, Photographically Illustrated*, published around 1884. It is one of the earliest instances of a work of photography and advertising copy that heralded the merging of art and commerce. Even more interesting is the fact that the copywriter and photographer— and presumably the "art director"— were the same person. In his introduction to the directory, Taber stated his intentions:

THIS ALBUM IS PRESENTED TO THE PUBLIC BY THE CORPORATIONS AND BUSINESS FIRMS WHOSE ANNOUNCEMENTS APPEAR HEREIN. THE MAIN OBJECT OF THIS WORK IS, TO SO COMBINE ART AND ADVERTISING THAT SOME OF THE MANY THOUSANDS OF BUSINESS MEN BEFORE WHOM THESE ALBUMS WILL COME IN THE HOTELS AND MAIL STEAMERS OF AMERICA, ENGLAND AND AUSTRALIA, WILL BE ABLE TO RELIEVE THE TEDIUM OF TRAVEL, INFORM THEMSELVES ON THE INDUSTRIES AND PRODUCTS OF CALIFORNIA, AND GAIN SOME IDEA OF, OR RENEW THEIR ACQUAINTANCE WITH ITS BEAUTIFUL SCENERY. THE PUBLISHER TAKES THIS OPPORTUNITY OF THANKING THE SUBSCRIBERS FOR THEIR LIBERAL ASSISTANCE, AND BEGS THE PUBLIC TO TREAT THIS BOOK KINDLY.[5]

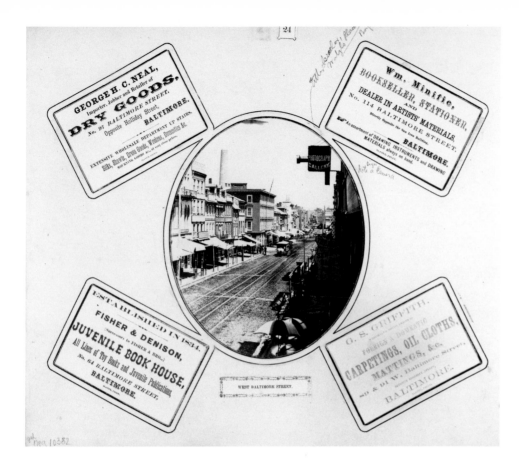

FIGURE 3. UNIDENTIFIED PHOTOGRAPHER.
PAGE FROM HOPKINS' ADVERTISING ALBUM AND
BUSINESS DIRECTORY FOR THE CITY OF BALTIMORE.
1866. ALBUMEN PRINT WITH LETTERPRESS.
IMP/GEH

PRODUCT PHOTOGRAPHY

Closely allied to early advertising photography is the older tradition of documentary product photography. In *The Pencil of Nature*, published between 1844 and 1846, William Henry Fox Talbot had demonstrated that the camera was an excellent tool for documenting sculpture, glassware, and even a sample of lace. By 1858 the British photographic team of Padbury and Dickins specialized in product photography, documenting centerpieces, church furniture, and toast racks on stereographic cards. A member of the Birmingham Photographic Society commented that "customers, when looking at engravings or woodcuts, invariably allow a slight discount for beautiful lines and curves, which exist only in the imagination of the draughtsman, and not in the article itself; but, 'as nature never told a lie,' and never can, a *photograph* of any article *carries conviction with it.*"[6] Photography here was seen as a great boon to the traveling salesman: "Instead of carrying large and heavy samples, a pocket stereoscope, with veracious copies of his wares, frequently answers every purpose."[7]

A cabinet card bearing an albumen print of scientific laboratory equipment offers a fine example of early tabletop photography of a product line (plate 3). A printed inventory on the back of the card appears with the comment: "All goods guaranteed as represented. . . ." An illustrated trade catalogue for Munsing underwear, published in 1890, another instance of product photography (plate 7), is an unsurpassed model of mechanical directness. A photography critic, commenting on this sort of photography in

The phrase "to so combine Art and Advertising" is, in essence, the fundamental role of advertising photography as it has come down to us from more than a century ago. In the version of the album in the collection of the International Museum of Photography at George Eastman House, Taber illustrated a saw-blade manufacturer's goods with an unusual display of circular blades, an iron-and-locomotive works' products with a montage of views within the factory, a newly invented fire-extinguishing grenade with before and after action shots (fig. 4), and the wares of a printing house by superimposing an albumen print showing the interior of the plant atop a lithographic view of the exterior over which is positioned an engraved business card (plate 4). The combined, multiple printing processes, the dynamic composition of the layout, and the conceit of assembled documentary formats—a purely textual business card, a hand-drawn exterior of the factory, and a photographic depiction of the plant's interior—suggest graphic possibilities that would become widely familiar only four decades later.

1917, wrote: "There is a growing tendency on the part of manufacturers of ladies' hats, outdoor and indoor clothing and underwear, to use photographs of their goods taken from the actual articles as worn by a living model, in preference to wash drawings or lithographs. . . . Although graceful posing and effective, if somewhat even, lighting is necessary, it must never be forgotten that the ultimate object is to produce what is more or less a diagram, which will give the fullest possible information as to the construction and material of the garment."[8]

PHOTOGRAPHS WANTED

By the turn of the century a growing demand had arisen for advertising photography and, thus, for photographers who would specialize in the genre. In 1904 Western Camera Publishing Company of Minneapolis ran an ad in the photographic press. The headline "Photographs Wanted" and the copy signaled the dawn of a new profession: "There is a *large demand* for photographs suitable for use in connection with *Modern Advertising.* We are in a position to know what is *acceptable work* and to place it where it will command the *highest price.* Every photographer has among his negatives many subjects, which, if properly handled, and with, perhaps, some 'doctoring' would make valuable advertising illustrations."[9] The copy went on to announce a series of twenty lessons on commercial photography, conducted by the photographer Harvey S. Lewis and published in *Western Camera Notes.*

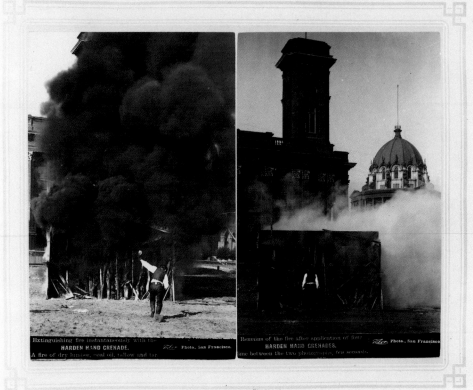

FIGURE 4. ISAIAH WEST TABER. HARDEN STAR HAND GRENADE FIRE EXTINGUISHER, PAGE FROM VIEW ALBUM AND BUSINESS GUIDE, OF SAN FRANCISCO, PHOTOGRAPHICALLY ILLUSTRATED. C. 1884. ALBUMEN PRINT WITH LETTERPRESS. IMP/GEH

Lewis's lessons appeared between October 1904 and July 1905. They were the first extended treatment of advertising photography and its specific problems published in this country. In the fifth lesson Lewis claimed:

IF YOU GLANCE THROUGH THE ADVERTISING PAGES OF MAGAZINES YOU WILL NOTICE THE LARGE PERCENTAGE OF PHOTOGRAPHIC ILLUSTRATION USED . . . A SOAP ADVERTISEMENT WITH A BEAUTIFUL GIRL DAINTILY HOLDING A PIECE OF SOAP THAT IS "FIT FOR ANY HAND," . . . ANOTHER PRETTY GIRL PLAYING FAIRY MUSIC ON A PIANO-PLAYING ATTACHMENT . . . A YOUNG COUPLE WHO HAVE BEEN KIND ENOUGH TO POSE IN THEIR CHAMOIS VEST AND UNDERGARMENTS . . . ANOTHER DOMESTIC SCENE IN WHICH A YOUNG MOTHER IS FONDLING HER BABE WHILE AN EXCEEDINGLY LARGE CAKE OF BLANK'S SOAP LIES AT HER FEET . . . PICTURES OF CUT GLASS DISHES, NEW STYLE COFFEEPOTS, ANTIQUE VASES, NEW SAFETY RAZORS, DIFFERENT MAKES OF AUTOMOBILES AND CARRIAGES, TYPEWRITING MACHINES, REVOLVERS, ETC. IN FACT YOU WILL FIND PHOTOGRAPHIC ILLUSTRATIONS OF ALMOST EVERYTHING YOU CAN THINK OF.[10]

Lewis's articles articulated what would become the overwhelming standard for modern advertising photography for the next eight decades. It was to be clear, striking, and quickly understood:

THE PRINT MUST BE CLEAR AND THE IDEA TO BE EXPRESSED MUST BE CLEAR. THE PHOTO SHOULD POSSESS STRENGTH, NOT ONLY AS REGARDS THE PHOTOGRAPHIC QUALITIES BUT AS REGARDS THE EXPRESSION. IT MUST BE BOLD AND IMPRESSIVE AND MAKE ITSELF SEEN. IT MUST ALMOST TALK. THE IDEA OR IDEAS TO BE EXPRESSED MUST PRESENT THEMSELVES AT THE FIRST GLANCE. NO COMPLICATION—NO GROUPING THAT REQUIRES STUDY TO DISCERN ITS MEANING. LET THE ONE THOUGHT TO BE EXPRESSED BY THE ILLUSTRATION STAND FORTH LIKE A BLACK INK SPOT ON A PIECE OF WHITE LINEN. EVERYTHING IN THE PHOTO MUST LEND SOMETHING TOWARD EXPRESSING THE ONE DESIRED IDEA. ANYTHING IN THE PHOTO THAT DOES NOT LEND ITSELF THUS MUST BE LEFT OUT. ATTRACTIVENESS IS NOT REQUIRED FOR ALL ADVERTISING ILLUSTRATIONS. MANY TIMES THE EXPRESSION OF THE ONE DESIRED IDEA WILL BE ALL THE ATTRACTIVENESS THAT IS REQUIRED. IN SOME CASES IT IS NECESSARY TO ADD COLORS, BORDERS, MARGINS, LETTERING, ETC., TO MAKE THE ILLUSTRATION ATTRACTIVE.[11]

Professionally, advertising photography had become competitive enough for Lewis to advise his readers on how to succeed. "Probably the best method of creating a demand for your work," he wrote, "is to make it either superior to others or to make your work decidedly distinctive. I favor the last method, as you will find it mighty hard to beat the other old timers at their profession—but you, and everyone, have an opportunity of doing work that is different from others. Work that has a style, a feeling—all its own. Work that impresses people as being out of the ordinary."[12] The advertising photographer was as much a businessman as he might be an artist, and in business an appearance of professionalism counts. Therefore, Lewis recommended that the photographer have his own letterhead stationery, a contract for selling his work to advertisers, and membership in a well-known photo-illustration society. "Let them see," he counseled, "that you are seriously in earnest regarding your chase after the dollars and cents and that photography has ceased to be 'a very pleasant recreation.'"[13]

The year before Lewis published these lessons, Alfred Stieglitz had begun publishing the official organ of the Photo-Secession, *Camera Work*, in which this century's most influential ideas on fine art photography appeared. Writing in *Camera Work* in April of 1904, the critic Sadakichi Hartmann opined about what the Secessionists were seceding from: "They object only to such commercial work as is produced for no other purpose than to suit a sitter or a publisher. They wish to be independent artists and not time-pleasing speculators."[14]

It may be possible, therefore, to date the commencement of hostilities between the artist-photographers and the commercial photographers—photography's own version of the "battle between the ancients and moderns"—to this year.

SOME STATISTICS

From 1890 to the 1920s photography's place in advertising steadily advanced. From collectible cigarette cards portraying young women in provocative dress to sentimental images of loving couples (plate 8), and from exhibition posters (plate 5) to hand-colored lantern slides projected in local movie theaters (plate 6), the momentum grew: photography and advertising were inextricably united.

In 1923 a survey found that the use of pen and ink illustrations in newspaper and magazine advertisements fell from slightly more than 90 percent to roughly 20 percent between the years 1895 and 1920. Wash drawings increased from about 3 percent to more than 30 percent, and photography rose from around 4 percent to 17 percent overall, with a peak of around 20 percent in 1910. In the same period, use of color printing in advertising rose from about .5 percent in 1895 to a peak of 25 percent in 1919. Combinations of drawing, washes, and photography, with or without color printing, rose from .3 percent to 28.7 percent during the period.[15]

According to another source, 90 percent of all advertisers in 1920 used some form of pictorial illustration; of these, 30 percent used wash drawings, 17 percent used photography, and 28 percent a combination of the two. The remaining 15 percent apparently were satisfied with more economical pen and ink drawings. By the end of the twenties, the use of photography in advertising illustration would escalate even further: "It is undeniably true that modern practice has found a far more extensive use for photography in advertising than would have been dreamed of fifteen years ago."[16]

"THE HUMANNESS OF IT ALL"

"The good advertising photographer," wrote the editors of *Photo Era* in 1903, "must have the ability to perfect the composition of his picture with material from real life. . . ."[17] The key to effective advertising pictures in the new century was precisely this element of naturalism. Lewis may have taught that in photographing canned goods, the photographer had to position the can's label squarely in front of the camera's lens,[18] but advertisers were quick to discern that if some human interest could be added, the image would be transformed from a boring product shot into a stimulating and effective piece of advertising. Emma Spencer's photograph of a young girl preparing a pie at the kitchen table, on which is a large carton of Metz's mincemeat, not only features the product but situates it within a charming domestic context (fig. 5). As one critic wrote in 1912: "Publicity announces or reminds. Advertising explains and sells."[19]

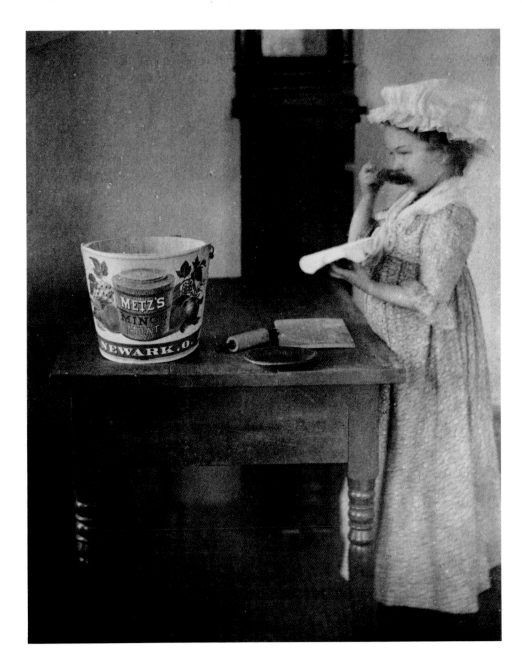

FIGURE 5. EMMA SPENCER. FOR METZ'S MINCEMEAT. 1902. PLATINUM PRINT. COURTESY PAUL KATZ

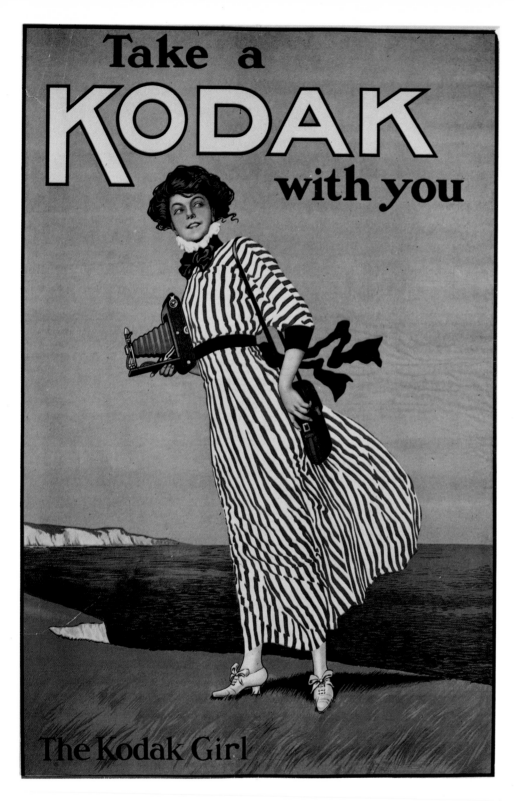

FIGURE 6. UNIDENTIFIED ARTIST. AD FOR KODAK
CAMERAS. C. 1910. POSTER. IMP/GEH

Domesticity and familiarity charac- terized early twentieth-century adver- tising photography. Healthy, smiling children, sporting youths, serious mid- dle-class men, picturesque senior cit- izens, and pretty girls abounded. This was "La Belle Epoque," the era of the Gibson Girl and her fashionable girl friends cavorting across the editorial pages of magazines. It was also the era of the "Kodak Girl," perhaps best remembered as the statuesque young woman standing atop a sand dune, clad in a vibrantly striped summer dress and holding a Model IIIA Kodak folding camera (fig. 6). She was the descendant of all those idealized beauties who graced nineteenth-cen- tury French Salon paintings, those embodiments of art and science found on exposition posters, in the popular chromolithograph *September Morn*, and the bottle-label image of the "White Rock Girl." There were, however, two important differences between the girl in the Kodak ad and her forebears. First, she was fashion- ably upper middle class and, second, she was the natural product of pho- tography.[20] Even when she looked hand drawn, her photographic origins were apparent. The photograph of the Kodak Girl in a striped dress, taken around 1910, was copied by a drafts- man who eliminated all extraneous details. "Now the point in all this," wrote advertising critic Thomas Rus- sell in 1913, "is that the photographic basis of the Kodak Girl is what made her distinctive. . . . The life of the breathing model 'comes through' in some subtle way. . . ."[21]

For more than three quarters of a cen- tury, the Kodak Girl, sometimes alone, sometimes in the company of friends or relatives, sometimes with children (plate 9), but always either photo- graphing or ready to do so, has been one of the most persistent figures in photographic advertising. She was, however, only a part of the cam- paign's use of naturalistic photogra- phy in its advertising. Lewis B. Jones,

advertising manager of Eastman Kodak, was interviewed in 1918, after having directed the company's advertising for twenty-six years. Jones firmly believed in the camera's inherent naturalness, "and that is what we are continually striving for—to get an air of *reality* into our work which will make the reader feel the humanness of it all, and will cause him to respond to it because of his own experiences."[22] "From the very beginning," he added, "down to this day and hour there has been just one purpose in Kodak advertising: to sell the *idea of photography*, the art of making pictures. Everything else is subordinate to putting across the pleasure of Kodakery."[23] To do so the company first used photography in advertising in 1901, and with few exceptions has continued this policy to the present.

The principal photographer used by the company for its national advertising during this period was William Shewell Ellis, who worked in Philadelphia. In 1927 Jones wrote to Ellis saying, "I really don't know whether you made the Kodak Girl famous or whether she made you famous, but this I do know: When we used an Ellis picture, we could always point to it with pride."[24] Whichever was true, the Kodak Girl represents the beginnings of modern advertising photography: clear illustration, the depiction of everyday events, and an atmosphere of attractive normalcy were all combined and directed to a distinctly upper-middle-class consumer market.

1. L. G. Rose, *The Commercial Photographer* (Philadelphia, 1920), p. 130.

2. Cf. Georg Ohlson, "Three Thousand Years of Advertising," *Penrose Annual: 1954* 48 (1954): 71–74.

3. Anon., "Nouvelle applications de la photographie," *La Lumière* 4, no. 38 (23 September, 1854): 151.

4. W. F. Haug, *Critique of Commodity Aesthetics: Appearance, Sexuality and Advertising in Capitalist Society*, trans. Robert Bock (Minneapolis, 1986), p. 18.

5. Isaiah W. Taber, *California Scenery and Industries* (San Francisco, n.d. [1884]), cited in Peter Bacon Hales, *Silver Cities: The Photography of American Urbanization, 1839–1915* (Philadelphia, 1984), p. 127.

6. Rowland Bourne, cited in "Birmingham Photographic Society," *The Liverpool and Manchester Photographic Journal* 12, no. 2 (15 June 1858): 152.

7. Ibid.

8. Practicus (pseud.), "Commercial Photography," *The British Journal of Photography* 64, no. 2971 (13 April 1917): 193.

9. Advertisement in *The Photo-Beacon* (November 1904), p. xv.

10. Harvey S. Lewis, "Commercial Photography," Lesson no. 5, "Photographic Illustrations and Their Adaptations," *Western Camera Notes* 5, no. 12 (December 1904): 329.

11. Harvey S. Lewis, "Commercial Photography," Lesson no. 7, "Principal Requirements of Photo Illustrations," *Western Camera Notes* 6, no. 1 (January 1905): 18.

12. Harvey S. Lewis, "Commercial Photography," Lesson no. 20, "How to Sell and Create a Demand for Your Pictures," *Western Camera Notes* 6, no. 7 (July 1905): 181.

13. Ibid., pp. 181–82.

14. Sadakichi Hartmann (Sidney Allan), "The Photo-Secession Exhibition at the Carnegie Art Galleries, Pittsburgh, Pa.," *Camera Work* 6 (April 1904): 47.

15. Curtis A. Collins, "Art Usage Curves Shoot Up—Watch the Magazine Advertising," *Inland Printer* 70 (March 1923): 857.

16. N. W. Ayer & Son, Inc., *Camera* [promotional brochure] (Philadelphia, n.d. [1929]), p. 3.

17. Anon., "Photography in Advertising," *Photo Era* 10, no. 2 (February 1903): 73.

18. Harvey S. Lewis, "Commercial Photography," Lesson no. 8, "Principal Requirements of Photo Illustrations," *Western Camera Notes* 6, no. 1 (January 1905): 19.

19. Thomas Russell, "The Living Model as an Advertising Basis," *Penrose's Pictorial Annual: 1912–13* (1913), p. 189.

20. Cf. Jean-Claude Gautrand, *Publicités Kodak, 1910–1939* (Paris, 1983), unp.

21. Thomas Russell, "The Living Model," p. 190.

22. Lewis B. Jones, in Bruce Bliven, "An Inside View of Kodak Advertising," *The British Journal of Photography* 65, no. 3021 (29 March 1918): 149.

23. Ibid.

24. Lewis B. Jones to William Shewell Ellis, manuscript letter, 19 October 1927, IMP/GEH, gift of 3M Co., ex-collection Lewis Walton Sipley.

SURRAT. BOOTH. HAROLD.

War Department, Washington, April 20, 1865,

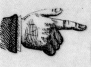 # $100,000 REWARD!

THE MURDERER

Of our late beloved President, Abraham Lincoln,

IS STILL AT LARGE.

$50,000 REWARD

Will be paid by this Department for his apprehension, in addition to any reward offered by Municipal Authorities or State Executives.

$25,000 REWARD

Will be paid for the apprehension of JOHN H. SURRATT, one of Booth's Accomplices.

$25,000 REWARD

Will be paid for the apprehension of David C. Harold, another of Booth's accomplices.

LIBERAL REWARDS will be paid for any information that shall conduce to the arrest of either of the above-named criminals, or their accomplices.

All persons harboring or secreting the said persons, or either of them, or aiding or assisting their concealment or escape, will be treated as accomplices in the murder of the President and the attempted assassination of the Secretary of State, and shall be subject to trial before a Military Commission and the punishment of DEATH.

Let the stain of innocent blood be removed from the land by the arrest and punishment of the murderers.

All good citizens are exhorted to aid public justice on this occasion. Every man should consider his own conscience charged with this solemn duty, and rest neither night nor day until it be accomplished.

EDWIN M. STANTON, Secretary of War.

DESCRIPTIONS.—BOOTH is Five Feet 7 or 8 inches high, slender build, high forehead, black hair, black eyes, and wears a heavy black moustache.

JOHN H. SURRAT is about 5 feet, 9 inches. Hair rather thin and dark; eyes rather light; no beard. Would weigh 145 or 150 pounds. Complexion rather pale and clear, with color in his cheeks. Wore light clothes of fine quality. Shoulders square; cheek bones rather prominent; chin narrow; ears projecting at the top; forehead rather low and square, but broad. Parts his hair on the right side; neck rather long. His lips are firmly set. A slim man.

DAVID C. HAROLD is five feet six inches high, hair dark, eyes dark, eyebrows rather heavy, full face, nose short, hand short and fleshy, feet small, instep high, round bodied, naturally quick and active, slightly closes his eyes when looking at a person.

NOTICE.—In addition to the above, State and other authorities have offered rewards amounting to almost one hundred thousand dollars, making an aggregate of about TWO HUNDRED THOUSAND DOLLARS.

PLATE 1. ANONYMOUS. $100,000 REWARD! 1865. FOR WAR DEPARTMENT, U.S. GOVERNMENT. TYPOGRAPHIC POSTER WITH THREE ALBUMEN PRINTS, 60.5 × 32.9 CM. COLLECTION GILMAN PAPER CO.

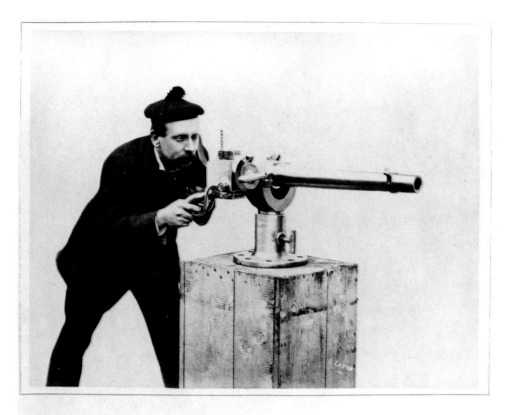

CANON HOTCHKISS A TIR RAPIDE DE 37 ᴹ/ᴹ

PLATE 2. L. LAFON. <u>RAPID FIRE HOTCHKISS
CANNON, 37 MM</u>. 1870S. FOR HOTCHKISS ARMS.
ALBUMEN PRINT, 15.5×20.1 CM. IMP/GEH.
MUSEUM COLLECTION

PLATE 3. ANONYMOUS. <u>CHEMICAL APPARATUS</u>.
1880S. FOR WOOD & COMER, LTD. ALBUMEN
PRINT, 12.5×17.9 CM. IMP/GEH. MUSEUM
COLLECTION

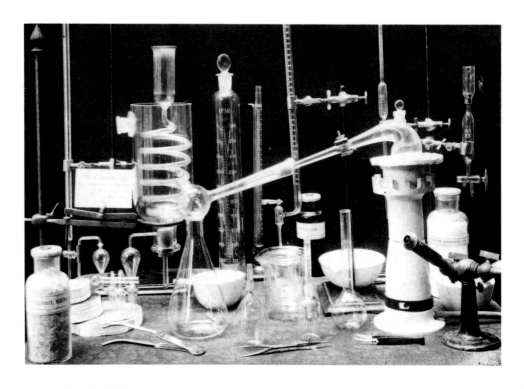

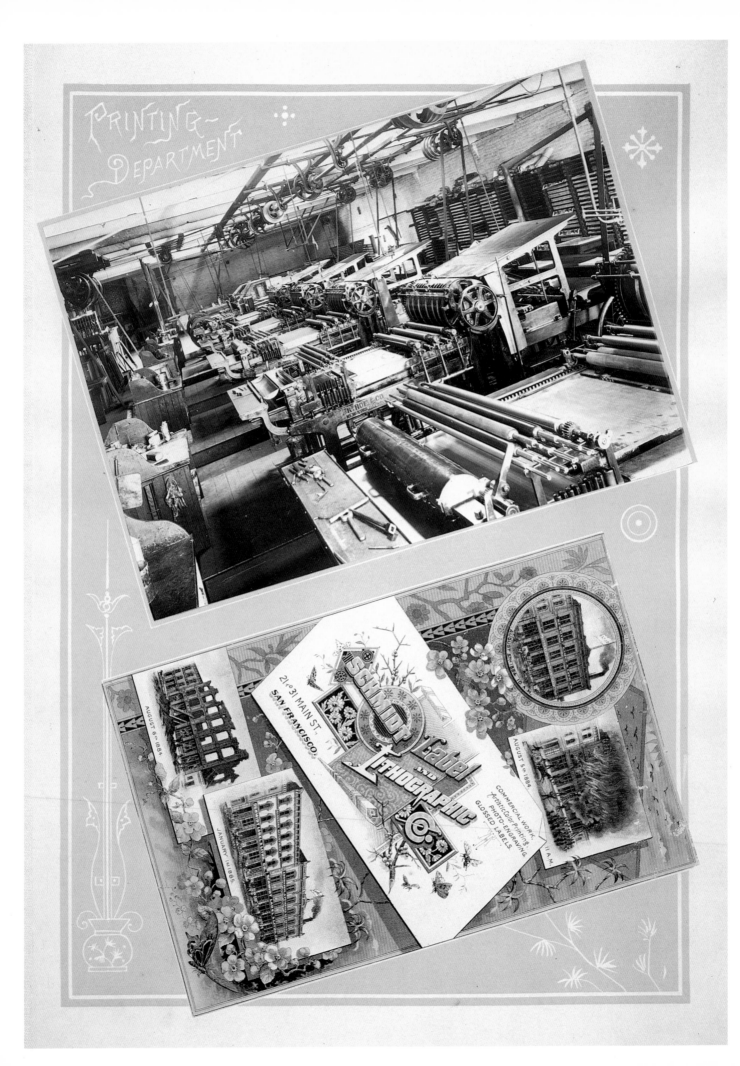

PLATE 4. ISAIAH WEST TABER. FOR SCHMIDT
LABEL AND LITHOGRAPHIC CO. C. 1884. ALBUMEN
PRINT WITH ENGRAVING AND LITHOGRAPHY,
37.6 × 27 CM. IMP/GEH. MUSEUM COLLECTION

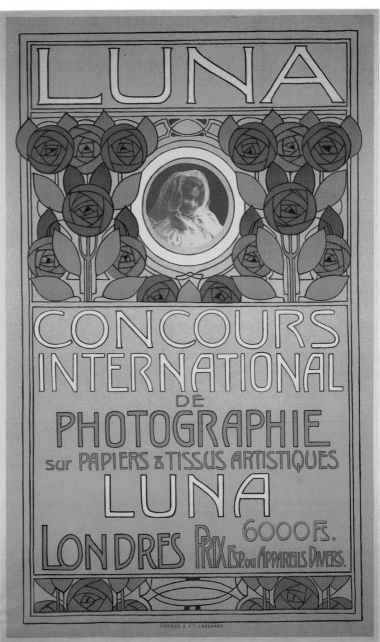

PLATE 6. COLUMBIA SLIDE CO. AD FOR HOOVER
VACUUM CLEANERS. C. 1920. FOR REED & REED
[DISTRIBUTORS]. LANTERN SLIDE, 8.3 × 10.2 CM.
PRIVATE COLLECTION

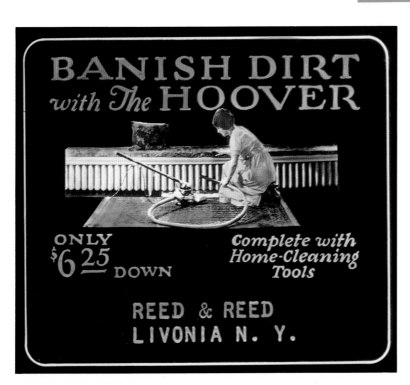

PLATE 5. ANONYMOUS. LUNA INTERNATIONAL
PHOTOGRAPHY COMPETITION. C. 1900. FOR LUNA
PAPIERS ET TISSUS ARTISTIQUES. LITHOGRAPHIC
POSTER WITH PHOTOGRAVURE PRINT, 67.5 × 41.6 CM.
IMP/GEH. MUSEUM COLLECTION

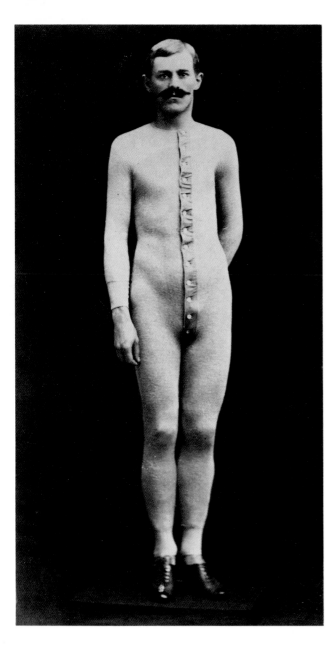

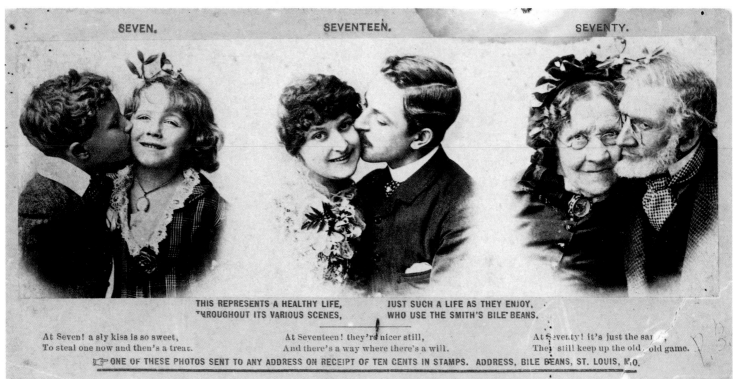

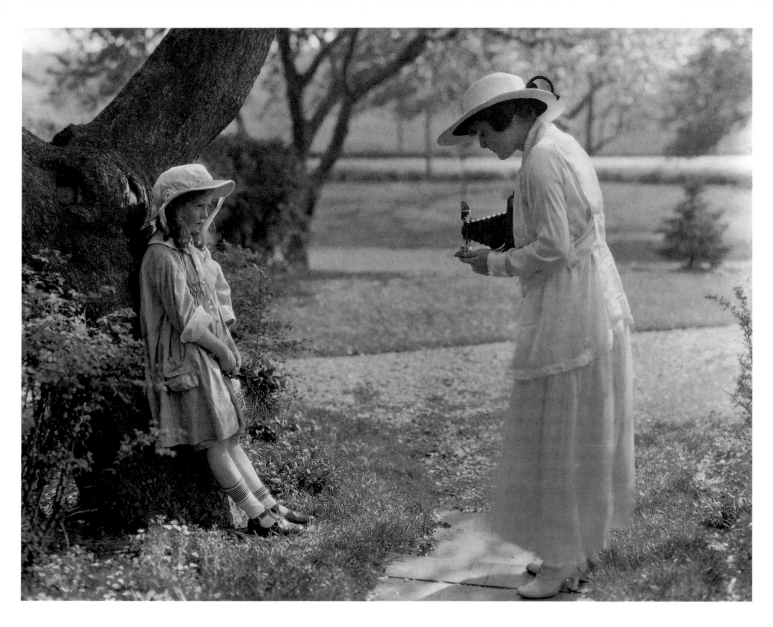

PLATE 9. ANONYMOUS. <u>MABEL ALLEN ACKERMANN</u>.
1916. FOR EASTMAN KODAK CO.; ART DIRECTOR
LEWIS B. JONES [?]. GELATIN SILVER PRINT,
17.2 × 22.6 CM. IMP/GEH. GIFT OF EASTMAN
KODAK CO.

VARIOUS MODERNISMS 1922-36

AN ADVERTISEMENT WITH A PHOTOGRAPH OF WHICH IT ADVERTISES IS MORE EFFICIENT THAN A DRAWING OF THE SAME THEME.

—RUSSIAN ARTIST, 1924[1]

1922: THREE EXAMPLES

It is impossible to date the real appearance of modern advertising photography with any precision. As in most histories there are exceptions to every claim and antecedents to each "first." Yet the year 1922 seems as legitimate as any in which to start. By that year photography had gained enough of a foothold in advertising that it constituted a considerable force; the statistical growth of photographic ads was clearly noticeable in mass-circulation magazines and newspapers; and the Art Directors Club of New York held its second annual exhibition of advertising photography.

Three images dating from 1922 signaled the future of advertising photography: a poster in Japan, a large bank ad from Philadelphia, and a printed advertisement in *Vanity Fair*. Each in its own manner suggested the three salient features of all modern advertising photography: sensuous enticement, active involvement with the advertising copy, and elegance of photographic form.

Up until 1922 sexual beguilement in advertising had been relegated to the collectible cigarette card (fig. 7), visual engagement with copy simply a matter of image above a text, and the photograph merely a dutiful servant of documenting products in the clearest, most artless way. In 1922 the Kawaguchi Photo Studio of Tokyo supplied its client Kotobukiya Ltd. (which was to evolve into the present-day Suntory Ltd.) with the very first photographic nude proferring a product (plate 10). It really does not matter that she is enticing us to purchase Akadama brand

port wine. What matters is that her image was used on a public poster, openly engaging a mass market with her allure. What also matters is that she is the origin of every subsequent advertisement that has used a provocative, sexually charged female as the vehicle for selling any product. Since that time nude, scantily clad, or overtly sensual women have advertised everything from hair tonic and cosmetics (understandable) to pneumatic drills and gas pumps (irrational).

Advertisers recognized the promotional risks inherent in using sexually alluring subjects. A British writer in 1934 was certain that "the object of beauty in an advertisement or a publicity brochure is not to make you love the beauty of the advertisement or the brochure, but to make the goods irresistibly desirable. Some advertisements have beauty but not compulsion; that it is as if a man were to admire a girl's clothes and make-up but refused to marry the girl. The object of any piece of publicity is not to turn prospects into flirtatious Don Juans, but to bind the goods and the customer in the indissoluble bonds of matrimony."[2] The advertisers for Akadama port wine undoubtedly trusted that their audience would recall their product because of its association with this suggestive young woman. For the success of this formal idiom, we need only look at the explosion of Japanese poster advertising that surfaced during the late 1960s and continues today with such advertisers as Shiseido and Parco (plates 99, 102, 114).

The second example is from an advertising campaign designed to encourage personal savings accounts in public banks at a time when such an idea was considered radical by the middle class. It was part of a series of large photographs that presumably would have been hung in a bank's windows or displayed on stands in the lobby. Some in the series bore copy

FIGURE 7. UNIDENTIFIED PHOTOGRAPHER.
CIGARETTE CARD. C. 1900. PRINTING-OUT-PAPER.
IMP/GEH

such as "Mother wants—or always wanted you to save. Of course you know why!" and "A sensible couple—they prefer being their own maid while youth and romance make play of hum-drum duties. At forty they will be financially able to employ all the servants they want." For the most part the photographs that illustrated these ads were adequate but not overly adventuresome. "Mother" was pictured as a kindly, silver-haired, elderly woman, while the "sensible couple" was portrayed as a prototypical Blondie and Dagwood Bumstead smiling inanely as she washes and he dries the evening dishes.

The most dynamic of these ads is one in which an assertive, middle-class man physically knocks the living "L" out of the word "Slave" and transforms it into "Save" (plate 11). The bank, of course, is there to help, but first, the ad seems to say, you must have the courage to stand up and fight for financial security. Charmingly primitive, this is one of the earliest examples where not only does the typography of the copy work with the photograph instead of inertly captioning it, but where the photographic subject is also seen in direct play with the ad's linguistic content. The force lines around the punched "L" may derive from comic strips like Rube Goldberg's *Boob McNutt*, begun in 1918, but the self-conscious trope of a character acting outside of a contained fiction, of rising to the surface of the ad, as it were, instead of remaining within it, would become a convention only later in cartoon animations by Disney and others.

The third image from 1922 that might be singled out is Paul Outerbridge's *Collar*, which first appeared in the pages of *Vanity Fair* for July of that year (plate 18). This was the photographer's first commercial assignment

and has become one of the landmarks of early modernism in photography. Deriving a sense of photographic abstraction from the earlier work of Paul Strand, Outerbridge injected a Precisionist crispness and Cubist space into the aesthetics of product and advertising photography.[3] But where most Precisionist art took the forms of machinery and modern industrial architecture as its subject, Outerbridge applied the same principles to a man's shirt collar. The gentle, organic curves of the collar contrast sharply with the severe squares and right angles of the chessboard pattern over which it appears to hover in tension. Reportedly, the artist Marcel Duchamp tacked this advertisement to his studio wall, where it remained for a number of years.[4] Duchamp was a chess player as well as an advocate of "ready-made" works of art. Thus, he very well might have responded to Outerbridge's fusing together of his two most passionate interests in a single picture: a found object of significant form atop a chessboard.

Collar was a portent in advertising photography. Its simple elegance yet complex geometrics, its compressed, Cubist space and isolation of the product from any naturalistic context would become the mainstay of advanced commercial photography for more than a decade. And, although Outerbridge did not travel to Europe until 1925, this image forecast the advent of international high design and modernism in advertising.

EARLY
MODERNISM

Images of "real life" and naturalistically rendered subjects did not disappear from advertising during the twenties. With increased use of photographic images in ads run in popular magazines, just the opposite happened. Some even became cultural emblems, stereotypes of perfect social roles, such as Edward Steichen's picture of a woman peeling potatoes, shot for Jergens Lotion in

1923 (plate 14), or Lewis Wickes Hine's railroad engineer, taken in 1924 for the Pennsylvania Railroad (plate 12). Actually, the hands of the housewife were those of Mrs. J. Walter Thompson, the wife of the advertising agency's senior officer, whereas Hine's model was a real engineer who claimed to have spent "40 years on the main line . . . and never killed a thing—man or animal."[5]

While naturalism was by far the norm, "modern" photographic images made the greatest impact on advertising during these years. Like Outerbridge's *Collar*, they were essentially studio-designed pictures as opposed to ones taken from nature out in the field or in a familiar setting. They were customarily of luxury consumer items, although even the most common of goods could be given the "modernist" treatment, as in Steichen's eccentrically grouped and theatrically lighted Camel cigarettes of c. 1928 (plate 17). Jack Collins's shot for Durham Duplex razors, which ultimately was used as an advertisement for Eastman Kodak photographic paper in 1934, displayed three partially opened razors arranged along a sharp diagonal and spotlighted with a single, extremely low light, giving the still life more a Broadway than a bathroom look (plate 36). Raking light, floating objects, cutout figures, obviously "faked" sets, irrational scale contrasts, specular highlights, airbrushed backgrounds, photomontage, and motion blurring were modernism's visual arsenal, and the style struck advertising with a vengeance.[6] The rage was for "new camera techniques" that could capture the attention of the consumer in the midst of a naturalistic landscape. Even the cinema entered print advertising, with motion picture frames used to illustrate action or multiple points of view in a single layout[7] (plate 15).

In America modernist advertising took its lead from the principal European art movements of the 1910s and 1920s: Futurism, Synthetic Cubism, Vorticism, and, to a degree, Expressionism. The anonymous bank advertisement with its lines of force displacing the letter "L" was at best a pedestrian, and undoubtedly third- or fourth-generation, take on Futurist graphics. Outerbridge's *Collar* drew its inspiration from Cubist art, and William Shewell Ellis's ad for Houbigant cosmetics from the early twenties was, despite its haunting charm, a reprise of Modigliani-like eroticism (plate 16).

Not all American advertisers were pleased with this new style. Many cited the ease with which "even charlatans" could ape the modernist style; others felt strongly that modernism was essentially foreign, a British and German import that was merely a passing fad in America. One critic, writing in 1929, went so far as to argue that modernism in advertising was inappropriate, since modernism dealt with abstract ideas and spiritual feelings instead of reality.[8] The same critic cited a renowned interior decorator, Edward Machell Cox, as saying: "You cannot use modern art in the general run of advertising. As soon as you start showing the product in any shape or form, you are at once barring the door to modernism. Modernism is not concerned with making portraits of physical things; it deals with the abstract."[9] In spite of these admonitions, however, modernism had become rather commonplace on the American advertising scene by the end of the decade. Articles about modernism's place in rural communities, such as "Is the Small Town Ready for Modernistic Advertising?" or "Modernistic Modes in Montana," were even featured in trade publications.

In 1929 art director J. R. McKinney wrote that modernism in advertising was waning but that from it the lessons of new typographies, formal simplicity, and creative experimentation were learned.[10] To be fair, early modernist advertising in America, with its unthinking appropriations from Futurist or Cubist painting and graphics, was a passing fashion and not a serious threat. Nevertheless, what had been effected during the twenties was the permanent vitalization of advertising photography as a modern art form—progressive, intelligent, and in tune with an international exchange of cultural influences. Fifty magazine and newspaper advertisers were surveyed in 1928 to determine whether large, corporate, and therefore more conservative, advertisers were using modernism in their ads and to what extent. The quality of modernism was not questioned; the real question was the interest in it by the advertiser. Even in a conservative magazine, one-third of the advertisements showed a distinctly modernist look; while in a progressive magazine, more than sixty percent of the ads were in the modernist style.[11] By the early 1930s, in America, the kind of "high-style" advertising look as defined by Outerbridge and Steichen (plate 31) had made it possible for American photographers like Jack Collins, Gordon Coster (plate 37), Anton Bruehl (plate 50), and Alfred Cheney Johnston (plate 39) to compete with the finest examples of European advertising art as seen in the work of Jaroslav Rössler (plate 33) or Maurice Tabard (plate 32).

EUROPEAN MODERNISM

Compared to what transpired in American advertising, European advertising was revolutionized during the twenties. In Russia, Germany, France, and the Netherlands, the image of advertising was transformed, as was most subsequent art and design. Russian Constructivism, Dutch De Stijl,

French *l'Art décoratif*, and the work of the German Bauhaus were all successfully incorporated into the domain of commercial advertising. The elements were the same as those found in American modernism, but the intensity and commitment to the modernist spirit were unparalleled. The raking light, fake studio setups, discordant scale contrasts, and abstraction of natural contexts were similar to those found in American pages. To these elements European designers added negative photography, double exposures, photograms, and photomontage (to a degree not experienced in America). "Any or all," wrote German-born designer Jan Tschichold in 1935, "could be used in the service of graphic expression. They can help to make a message clearer, more attractive and visually richer."[12] Whether the ultimate product was one of pure artistic expression, a public-service announcement, or mercantile advertising, these designers applied stylistically different but similarly strict principles of modernist visions. "We were taken to task," wrote the Constructivist Alexander Rodchenko in the 1920s, "for not recognizing 'pure art,' for being printers, photographers, designers of fabrics and shop displays—because we made graphic layouts for newspapers."[13] Working for the goals of the Revolution, Rodchenko and his fellow artists saw pictorial advertising as a suitable weapon for social change. "In every military victory," noted the poet Vladimir Mayakovsky in 1923, "in every economic success 9/10 is the result of the skill and power of our agitation. Advertising is industrial, commercial agitation."[14]

John Heartfield knew well the potential that mass advertising held for social agitation. As art director for the Malik publishing house in Berlin since 1917 and a pioneer of socially relevant photomontage, Heartfield, who was born Helmut Herzfeld, began designing the front- and back-cover illustrations for the left-wing weekly

werbe-
entwurf
und ausführung

dessau,bauhaus
d

herbert-bayer
b

vdr-kartei der
werbindustrie
februar 1928

FIGURE 8. HERBERT BAYER. EXHIBITION
ANNOUNCEMENT. 1928. POSTCARD. COLLECTION
MERRILL C. BERMAN

A-I-Z, or *Arbeiter-Illustrierte-Zeitung* (*Workers' Illustrated Paper*), in 1929. By 1938 he had completed 238 of these photomontages, which for the most part were strongly critical of the Nazi regime (plate 23). In 1933 his apartment was broken into by Hitler's SA and he fled to Prague, where he remained until Germany's annexation of Czechoslovakia in 1938, and then escaped to England. His works were repeatedly confiscated and burned by the political targets of his vitriolic and satiric attacks. What is significant about Heartfield's work here is that it performed exactly as an advertisement: promoting ideas, marketing a viewpoint, and being placed on the back cover of a journal. He appropriated commerce's essential visual form as his art form, believing that "the important man is not the artist, but the businessman who, in the marketplace, and on the battlefield, holds the reins in his hands."[15] Later, artists such as novelist J. G. Ballard, sculptors Lynda Benglis and Robert Morris, and photographer Johnny Rasmussen would continue this tradition.

In America the advertising designer and photographer operated in a realm divorced from the fine arts; in Europe the distinctions were often blurred. Artists such as László Moholy-Nagy (plate 19), Gustav Klutsis (plate 20), and Salomon Telingater (plate 21) functioned both as art directors and photographic illustrators. In Europe, also, modern design was viewed as a tool for responsible social progress that assumed various forms. At the Bauhaus, perhaps the most progressive design school of the period, the "new vision" was intricately linked to a program of complete cultural renovation—an idealized *Gesamtkunstwerk* in which everything would be designed to be new, challenging, and meaningful (fig. 8). In 1928 typographer and commercial artist Herbert Bayer characterized American advertising as lacking in "design consciousness" and claimed that "to 'design advertising' implies not only designing in good taste; . . . a truly 'objective' approach is the only one that can prove the outward appearance to have deeper causes, that is to say, that the essential aspects of the problem are understood before and during the design process."[16]

Bauhaus designers, along with their colleagues in Russia and The Netherlands, created modern advertising, and their use of photographs—whether made by themselves or appropriated from other sources in collages—established the very foundations on which, even today, all but the most resolutely naturalistic photographic advertising is based. Moholy-Nagy was the first to define a "typology" of the new photography in 1925, and was followed by others like Franz Roh, who in 1929 cited "reality-photos, the photogram, photomontage, photo with etching or painting, and photos with typography" as the principal tools of the modern photographer.[17] These experimental techniques, then, became the norm for what was to become modern advertising.

Roh also said that "the use of photo-montage for advertisements has already spread considerably . . . in spite of the humor, or the merely advertising character, of these things, they should not be looked upon as trifles, or only incidental details, for they can be of demonic-fantastic effect."[18] Far from a trifle, photomontage has permeated advertising more than have any of the other varieties, with the exception of the straight photograph. Even August Sander, known for his clinical documentary style, turned to photomontage for work in advertising (plate 30, figs. 9, 10, 11). The effects of this technique were broadly international. American advertising critic Stanley Brady, writing in 1931, praised its usefulness: "Photomontage is typical of our age. It is modern. It expresses the spirit of motion and speed that is 1931—we not only use the automobile but fly to our destinations. We eat fast, we work fast and our whole lives are spent trying to keep up with the pacemakers. . . . So with Photomontage, the flying civilization of today can take one look as it passes—and understand."[19] He might well have been describing Cesar Domela-Nieuwenhuis's montage for the port authority of Hamburg, done in 1929 (plate 22), when he wrote: "In a similar way the Chamber of Commerce can gather together views of the churches, business section, banks and the main street to show a picture of our town. They will not show all of the City Hall—only the outstanding part—and consideration will be given to the adjoining pictures. Through Photomontage the 'spirit' of the place will be vitalized and personified. It will give a unified impression of industry, activity and prosperity."[20]

FIGURE 9. AUGUST SANDER. <u>CROWD SCENE</u>.
C. 1928. GELATIN SILVER PRINT. COURTESY SANDER GALLERY, NEW YORK

FIGURE 10. AUGUST SANDER. <u>COLOGNE CATHEDRAL</u>. C. 1928. GELATIN SILVER PRINT. COURTESY SANDER GALLERY, NEW YORK

FIGURE 11. AUGUST SANDER. <u>PORTRAIT OF YOUNG GIRL</u>. C. 1928. GELATIN SILVER PRINT. COURTESY SANDER GALLERY, NEW YORK

THE SPRING OF 1931

Brady's article appeared in June of 1931 and was one of the earliest American texts to hail the virtues of European modernism in terms of advertising. In fact, it might be suggested that European modernism was embraced by American advertising in the spring of that year. On March 2 an exhibition of *Foreign Advertising Photography* opened in New York at the Art Center at 65 East 56th Street. Work by fifty photographers from eight nations was shown. Dr. Mehemed F. Agha, art director of Condé Nast Publications; film director D. W. Griffith; Kathleen Howard, fashion editor of *Harper's Bazaar;* and twelve other jurors selected nearly two hundred examples of European advertising photography from the collection of Abbott Kimball. Kimball, a member of the advertising agency Lyddon, Hanford & Kimball, had collected work from England, France, Germany, Hungary, Italy, The Netherlands, Russia, and Sweden. Among the prizewinners were Herbert Bayer, Paul Iribe, and George Hoyningen-Huene; honorable mentions were given to Baron de Meyer, Man Ray, Moholy-Nagy, Alban, and Florence Henri. Man Ray's piece was selected because of its novelty, since, according to one review, "it was not taken with a camera; it was made by holding objects against sensitized paper. The jury believed that this 'photogram' technique is something that should be studied by American photographers and advertisers because of the peculiar effects that it is possible to secure with it."[21]

Three different points of view were represented by the jury: those of the "advertising man, the photographer, and the artist designer."[22] And while there was no intent to stage a comparative examination of European and American advertising photography, the contrasts were obvious. European advertisements were more cultured, more sophisticated, and "characterized by surprising *simplicity*." Frank Crowninshield, editor of *Vanity Fair*, is frequently cited as having given the opening lecture, but one source also mentions that Agha gave the opening address. Reportedly, Agha stressed the differences between the two cultures: "When a French advertiser wants to advertise fire insurance, all he has to show is a match. Whereas, in America you must show a skyscraper, flames, fire engines and somewhere in the background, sex appeal. This sex appeal business is also treated from a different viewpoint in Europe. Sex is apparently limited to private life and to burlesque; they do not use it in advertising railroads, as we do here."[23]

In July of 1931 *Printers' Ink Monthly* ran an article entitled "Five Camera Methods for the Advertiser." The author, P. R. Smith, art director of the Wm. H. Rankin Co., named George Grosz, Moholy-Nagy, and Man Ray as "tireless experimenters in the graphic arts," and listed their work with that of photojournalists as potential new sources for advertising photography.[24] The article's debt to the German new vision is clear, however, when not only is Willi Baumeister's photomontage of soccer players illustrated from Werner Graff's *es kommt der neue fotograf!* of 1929 (fig. 12), but the author's five camera techniques—"the reality photograph, the photomontage, the photo painting, the photo type, and the photogram"—are lifted from Franz Roh's text in *foto-auge* of the same year. And again, the failure of modernism to take hold in American advertising was repeated: ". . . of these five classes the first or 'reality photo' is practically the only one that has been used in American advertising."[25]

From 1931 to the present, modernism's visual vocabulary has been a consistent source for vital, progressive, and even American advertising, despite the pessimism of certain critics during the thirties. There have been periods where its presence might seem less than obvious, but there have been other times, such as this decade, when its heritage is quite apparent. Like Voltaire's god, if it did not exist it would have to be invented. But modernism was created during the twenties and early thirties, and it still exerts a forceful influence on such distinctly different art directors and photographers as Henry Wolf (plate 141); Arnell/Bickford, with Torkil Gudnason (plate 146); and Ryszard Horowitz (plate 145).

1. Anon., "Photomontage," *LEF* 4 (1924), in Olga Makhroff and Stanislas Zadora, *Art et poésie russes: 1900–1930, Textes choisis* (Paris, 1979), p. 222.

2. Sidney F. Wicks, "Photography in Modern Advertising and Commerce," *The British Journal of Photography* 81, no. 3862 (11 May 1934): 270.

3. Cf. Karen Tsujimoto, *Images of America: Precisionist Painting and Modern Photography* (Seattle and London, 1982), p. 96.

4. Graham Howe and G. Ray Hawkins, eds., *Paul Outerbridge Jr: Photographs* (New York, 1980), p. 11.

5. Caption written on verso of print.

6. Cf. Thomas F. Walsh, "Tailoring the Photograph to Produce Unusual Results," *Printers' Ink Monthly* 17 (July 1928): 42–43, 98, 101.

7. W. Livingston Larned, "When the Camera Proves Your Talking Point," *Printers' Ink* 145 (November 1928): 93–100.

8. Brian Rowe, "There Is No Modern Art in American Advertising," *Printers' Ink Monthly* 18 (February 1929): 47–49, 128–36.

9. Ibid., p. 48.

10. J. R. McKinney, "What Has Happened to Modern Art in Advertising?," *Printers' Ink Monthly* 19 (November 1929), passim.

11. Don Gridley, "A Statistical Glass Applied to Modernism," *Printers' Ink Monthly* 17 (December 1928): 44–46.

12. Jan Tschichold, *asymmetric typography* (Basel, 1935), trans. by Ruari McLean (New York and Toronto, 1967), p. 85.

13. Cited in Szymon Bojko, *New Graphic Design in Revolutionary Russia*, trans. by Robert Strybel and Lech Zembrzuski (New York, 1972), p. 19.

14. Vladimir Mayakovsky, untitled mss., 1923, trans. in Christina Lodder, *Russian Constructivism*, (New Haven and London, 1983), p. 199.

15. Cited in Douglas Kahn, *John Heartfield: Art and Mass Media* (New York, 1985), p. 35.

16. Herbert Bayer, "Typography and Commercial Art Forms," *bauhaus* 2, no. 1 (1928), trans. in Hans M. Wingler, *The Bauhaus: Weimar, Dessau, Berlin, Chicago* (Cambridge and London, 1969), p. 135.

17. Franz Roh, "mechanism and expression: the essence and value of photography," in *foto-auge* (Stuttgart, 1929), trans. in *Camera* 46, no. 4 (April 1967): 46.

18. Ibid., p. 51.

19. Stanley A. Brady, "A New Art from Europe," *Printed Salesmanship* 57 (June 1931): 310.

20. Ibid., p. 309.

21. "What Foreign Advertising Photographers Are Doing," *Printers' Ink* 154 (24 February 1931): 70–72.

22. "Awards Announced in Exhibition of Foreign Advertising Photography at Art Center, New York City," *The Commercial Photographer* 6, no. 7 (April 1931): 419.

23. Cited in Aesop Glim, "European Advertising Art—In Europe and in America," *Printers' Ink* 154 (19 March 1931): 41.

24. P. R. Smith, "Five Camera Methods for the Advertiser," *Printers' Ink Monthly* 23 (July 1931): 40.

25. Ibid., p. 41.

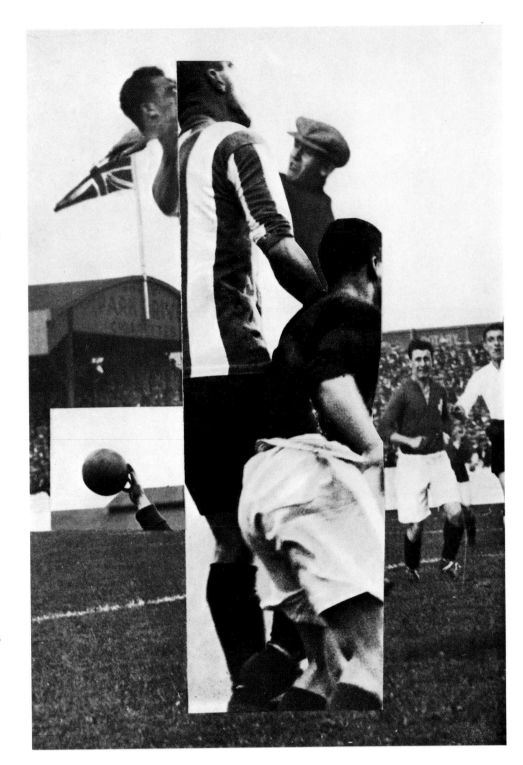

FIGURE 12. WILLI BAUMEISTER. SPORTS POSTER, FROM WERNER GRAFF, ES KOMMT DER NEUE FOTOGRAF! 1929. IMP/GEH LIBRARY

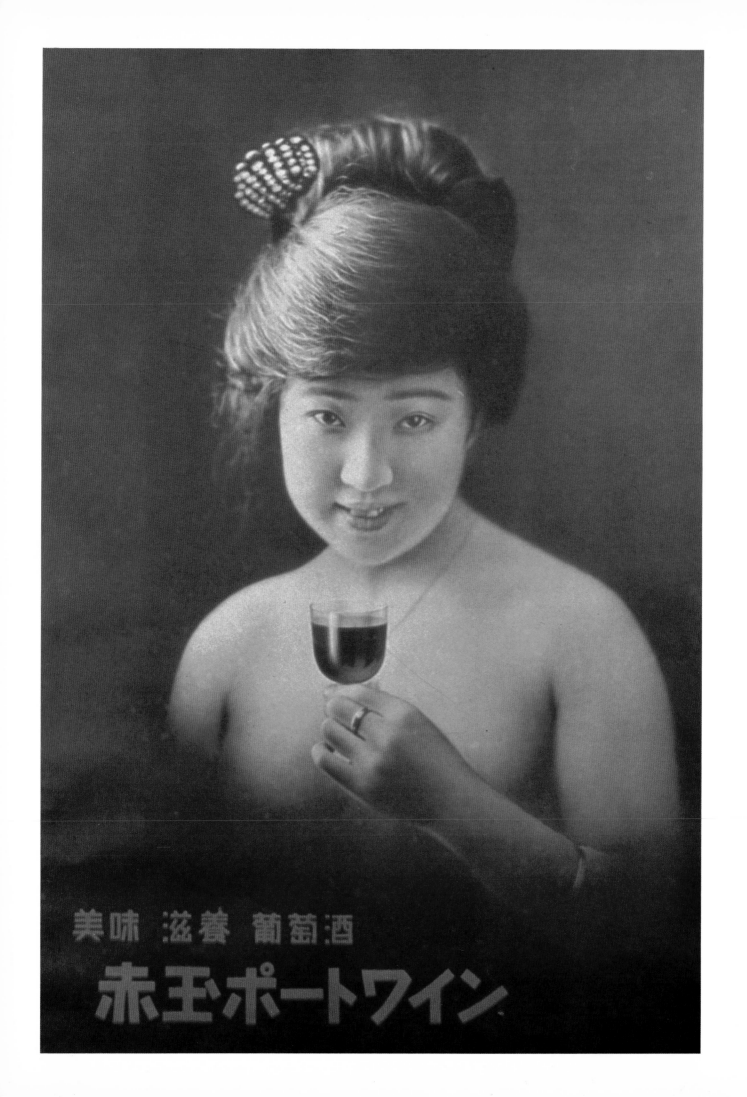

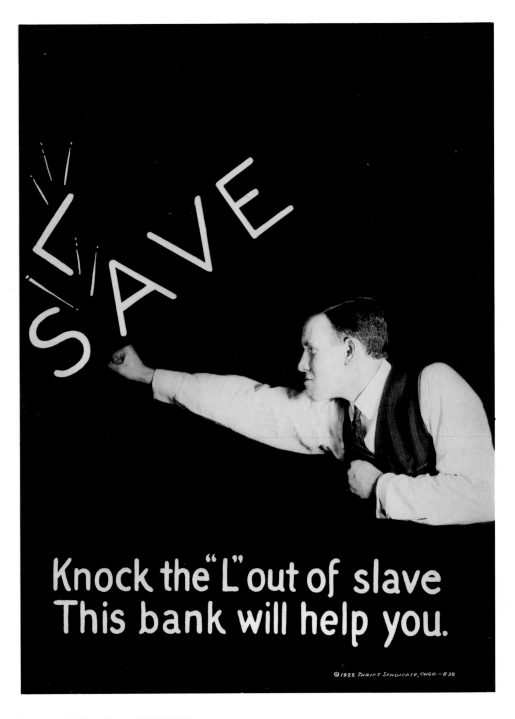

PLATE 11. ANONYMOUS. AD FOR THRIFT
SYNDICATE [SAVINGS ACCOUNTS]. 1922. GELATIN
SILVER PRINT, 60.8×45.9 CM. THE MILLER-PLUMMER
COLLECTION

PLATE 10. KAWAGUCHI PHOTO STUDIO. <u>AKADAMA
PORT WINE</u>. 1922. FOR KOTOBUKIYA LTD. [NOW
SUNTORY LTD.]. PHOTOLITHOGRAPHIC POSTER,
79×65 CM. COLLECTION SUNTORY LTD.

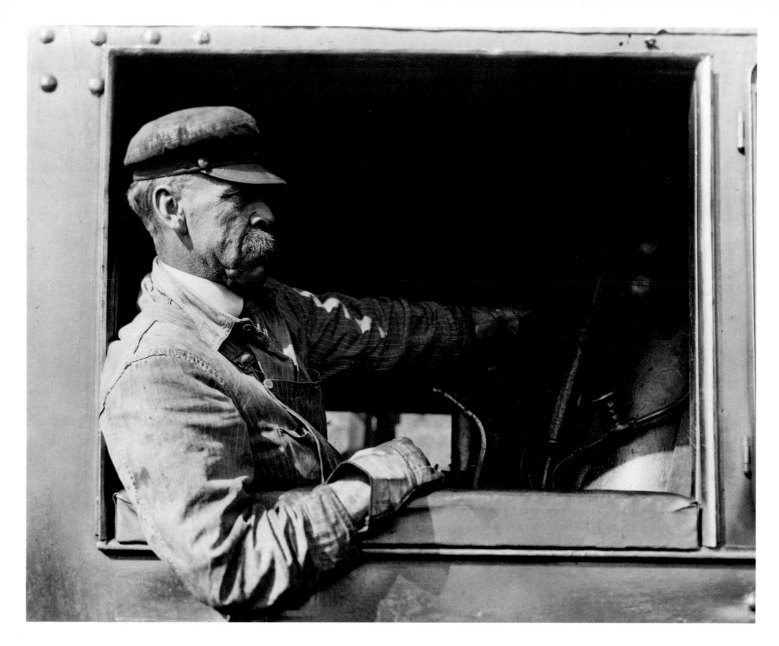

PLATE 12. LEWIS WICKES HINE. <u>IN THE CAB—P.R.R.</u>
1924. J. WALTER THOMPSON CO. [?] FOR
PENNSYLVANIA RAILROAD. GELATIN SILVER PRINT,
19.1 × 24.2 CM. IMP/GEH. LEWIS W. HINE
COLLECTION. GIFT OF THE PHOTO LEAGUE

PLATE 13. ANONYMOUS. <u>COME IN!</u> C. 1929–32.
FOR GRAFLEX CAMERAS. GELATIN SILVER PRINT
MOUNTED ON WOODEN STAND WITH FOLDING
LEGS, 45.8×52.8×2.7 CM. IMP/GEH. MUSEUM
COLLECTION

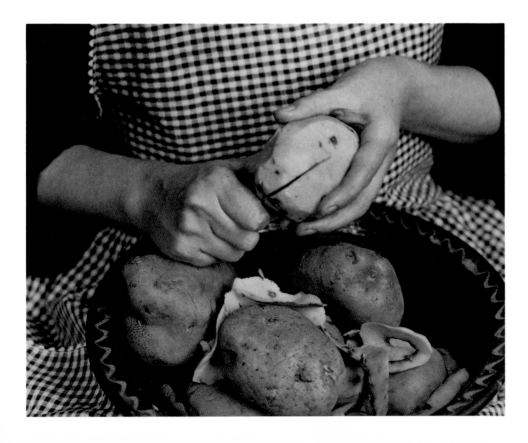

PLATE 14. EDWARD STEICHEN. <u>PEELING POTATOES.</u>
1923. J. WALTER THOMPSON CO. FOR ANDREW
JERGENS CO. [HAND LOTION]. GELATIN SILVER
PRINT, 19.5×24.5 CM. IMP/GEH. BEQUEST OF
EDWARD STEICHEN BY DIRECTION OF JOANNA T.
STEICHEN

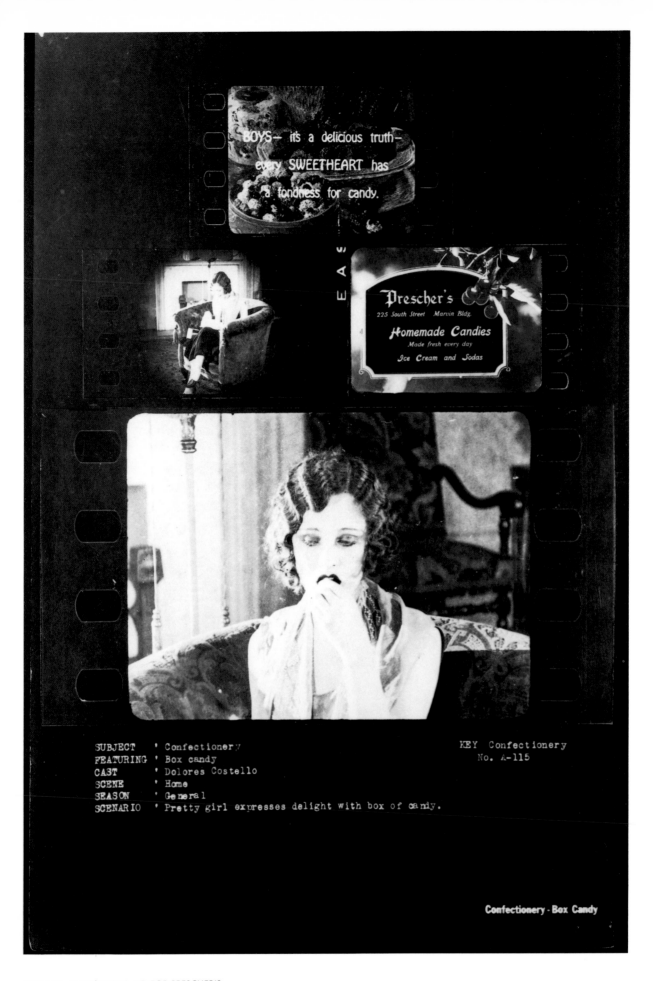

PLATE 15. ANONYMOUS. AD FOR PRESCHER'S
HOMEMADE CANDIES. 1926. GELATIN SILVER PRINT,
PRINTED FROM FILMSTRIPS; 25.2×15.2 CM.
THE MILLER-PLUMMER COLLECTION

PLATE 16. WILLIAM SHEWELL ELLIS. <u>HOUBIGANT
COSMETICS</u>. EARLY 1920S. H. W. KASTOR & SONS
ADVERTISING CO. FOR HOUBIGANT, INC.
PHOTOMONTAGE OF THREE GELATIN SILVER
PRINTS, 47 × 38 CM. IMP/GEH. GIFT OF 3M CO.
EX-COLLECTION LOUIS WALTON SIPLEY

PLATE 17. EDWARD STEICHEN. <u>CAMEL CIGARETTES</u>.
AFTER 1927. FOR R. J. REYNOLDS TOBACCO CO.
GELATIN SILVER PRINT, 27.7×35.3 CM. IMP/GEH.
BEQUEST OF EDWARD STEICHEN BY DIRECTION OF
JOANNA T. STEICHEN

PLATE 18. PAUL OUTERBRIDGE, JR. <u>COLLAR</u>. 1922.
FOR GEO. P. IDE & CO., INC., TROY, NY. GELATIN
SILVER PRINT, 11.5×9.2 CM. THE MUSEUM OF
MODERN ART, NEW YORK. GIFT OF THE
PHOTOGRAPHER. REPRODUCED COURTESY G. RAY
HAWKINS GALLERY

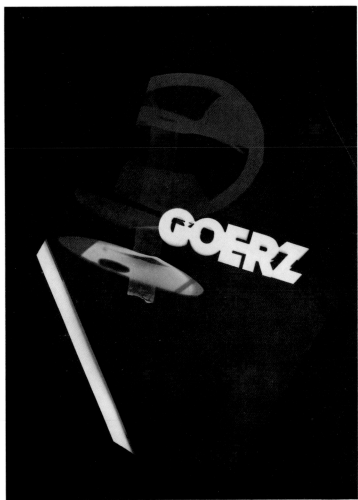

PLATE 19. LÁSZLÓ MOHOLY-NAGY. GOERZ. 1922.
FOR GOERZ OPTICAL. POSITIVE AND NEGATIVE
GELATIN SILVER PRINTS; 29.9×22.3 CM., 30.1×22.5
CM., RESPECTIVELY. IMP/GEH. MUSEUM
COLLECTION

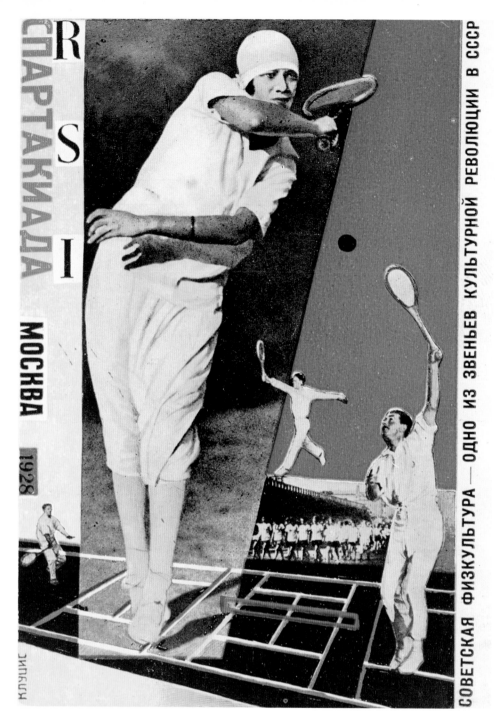

PLATE 20. GUSTAV KLUTSIS. <u>TENNIS</u>. 1928. FOR
ALL UNION SPARTAKIADA. PHOTOLITHOGRAPHIC
POSTCARD, 14.6×10.8 CM. COLLECTION MERRILL
C. BERMAN

PLATE 21. SALOMON TELINGATER. <u>HATS</u>. C. 1929.
FOR UNKNOWN CLIENT. PHOTOMECHANICAL
COLLAGE WITH TYPOGRAPHY, 35.6×23.5 CM.
COLLECTION MERRILL C. BERMAN

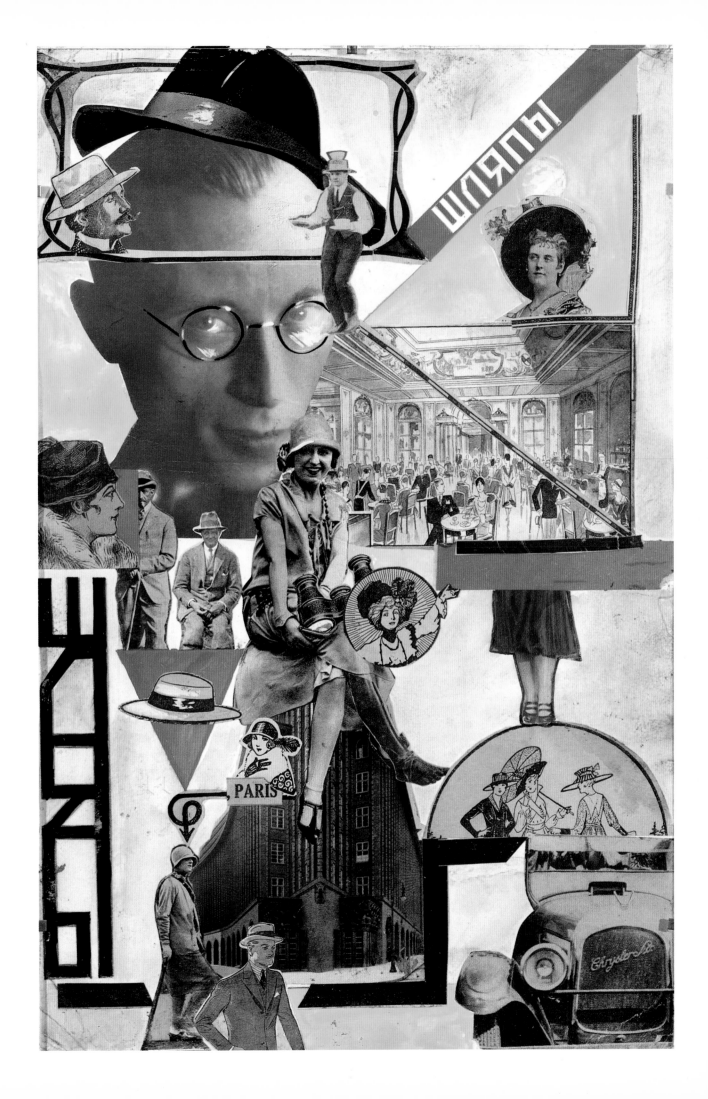

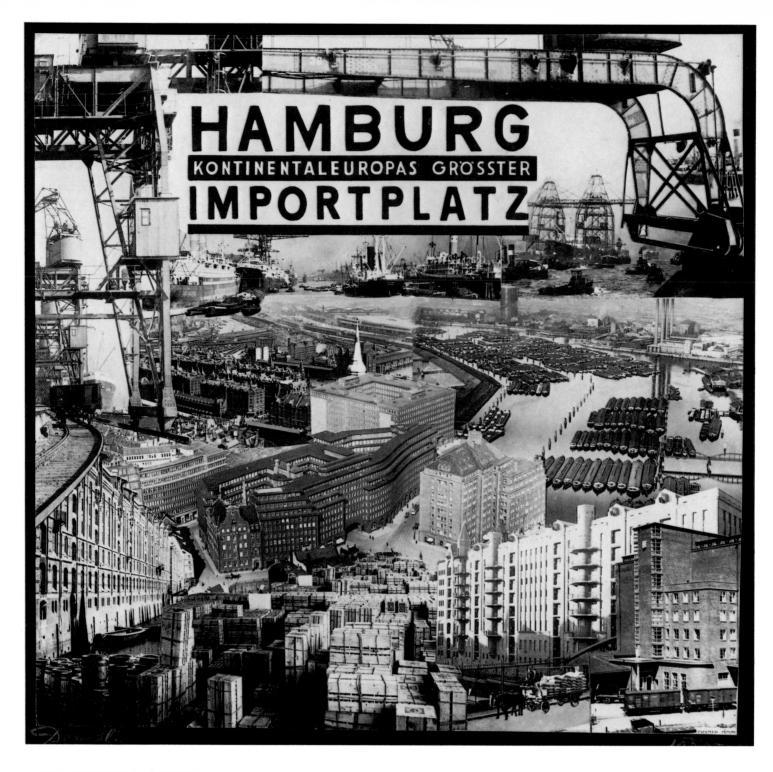

PLATE 22. CESAR DOMELA-NIEUWENHUIS.
HAMBURG IMPORTPLATZ. 1929. FOR PORT
AUTHORITY OF HAMBURG. GELATIN SILVER PRINT
OF A PHOTOMONTAGE, 22.1 × 22.8 CM.
THE PRAKAPAS GALLERY

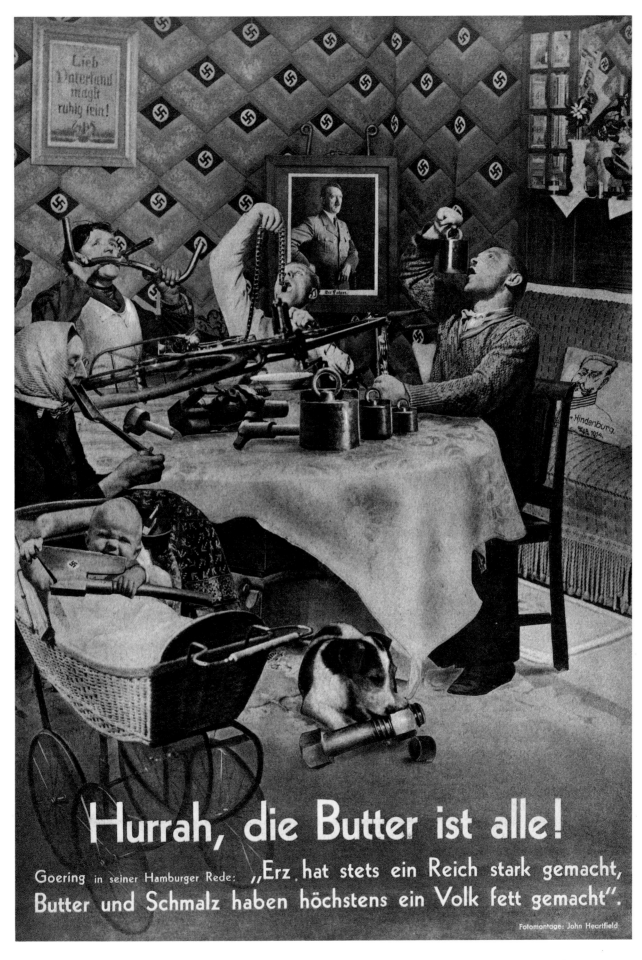

Hurrah, die Butter ist alle!

Goering in seiner Hamburger Rede: „Erz. hat stets ein Reich stark gemacht, Butter und Schmalz haben höchstens ein Volk fett gemacht".

Fotomontage: John Heartfield

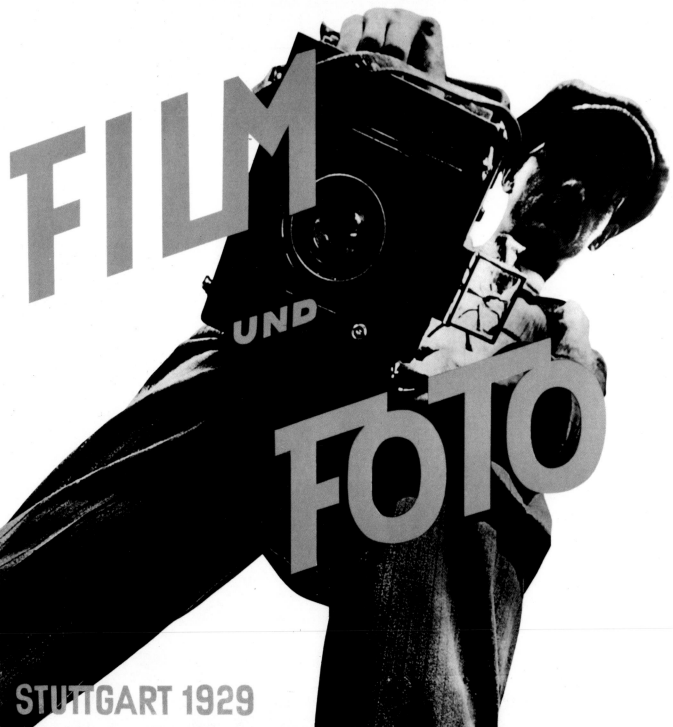

INTERNATIONALE AUSSTELLUNG
DES DEUTSCHEN WERKBUNDS

FILM UND FOTO

STUTTGART 1929
FOTO-AUSSTELLUNG VOM 18. MAI BIS 7. JULI
IN DEN NEUEN AUSSTELLUNGSHALLEN AUF DEM INTERIMTHEATERPLATZ
FILM-SONDERVORFÜHRUNGEN VOM 13. BIS 26. JUNI
IN DEN KÖNIGSBAULICHTSPIELEN

PLATE 24. ANONYMOUS. <u>FILM UND FOTO</u>. 1929.
FOR DEUTSCHER WERKBUND.
PHOTOLITHOGRAPHIC POSTER, 82.6×57.8 CM.
COLLECTION MERRILL C. BERMAN

PLATE 25. ATTRIBUTED TO PAUL SCHUITEMA.
<u>PHILIPS ½ WATT LIGHTBULBS</u>. EARLY 1930S. AD FOR
PHILIPS ELECTRICAL. GELATIN SILVER PRINT WITH
APPLIED COLOR, 30×21.2 CM.
THE PRAKAPAS GALLERY

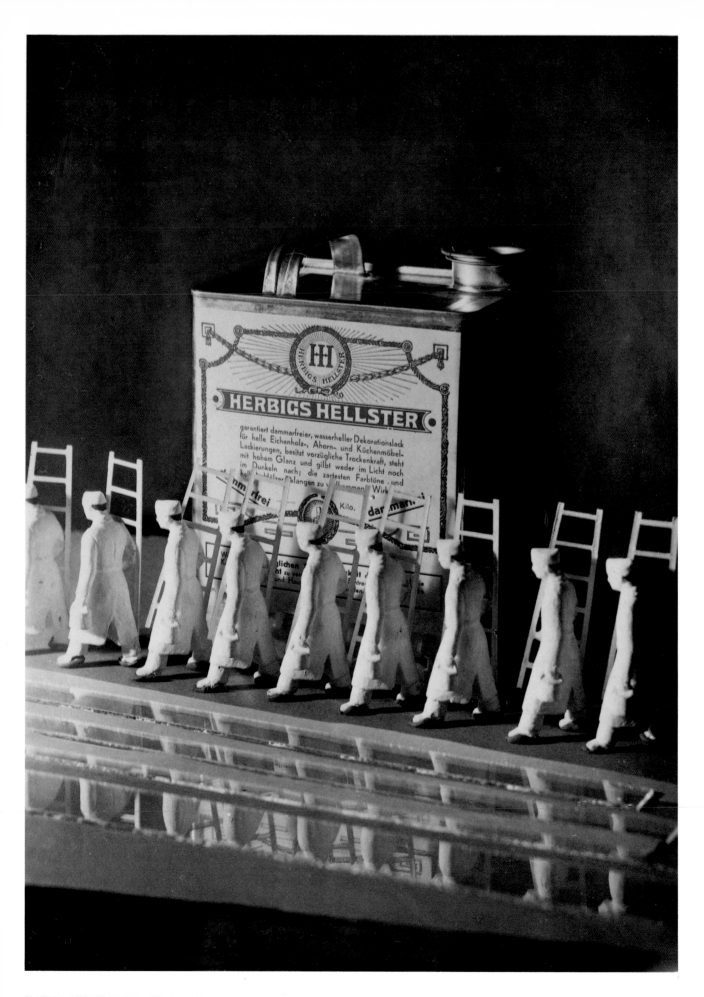

PLATE 26. AUGUST SANDER. FOR HERBIGS
HELLSTER [PAINT REMOVER]. 1920S. GELATIN SILVER
PRINT, 16.6×12 CM. THE SANDER GALLERY

PLATE 27. PIET ZWART. FOR BEVERWIJKSCHE
CONSERVENFABRIEK [CANNED GOODS]. C. 1933.
GELATIN SILVER PRINT, 17.1 × 12.5 CM.
THE PRAKAPAS GALLERY

PLATE 28. PAGANO & CO. ABSORBINE JR. EARLY
1930S. FOR W. F. YOUNG, INC.; ART DIRECTOR
PAGANO & CO. GELATIN SILVER PRINT,
8.8×11.5 CM. IMP/GEH. MUSEUM COLLECTION

PLATE 29. GRETE STERN. PÉTROLE HAHN. 1928.
FOR PÉTROLE HAHN [HAIR LOTION]. GELATIN
SILVER PRINT, 23.7×28 CM. COURTESY
SAN FRANCISCO MUSEUM OF MODERN ART

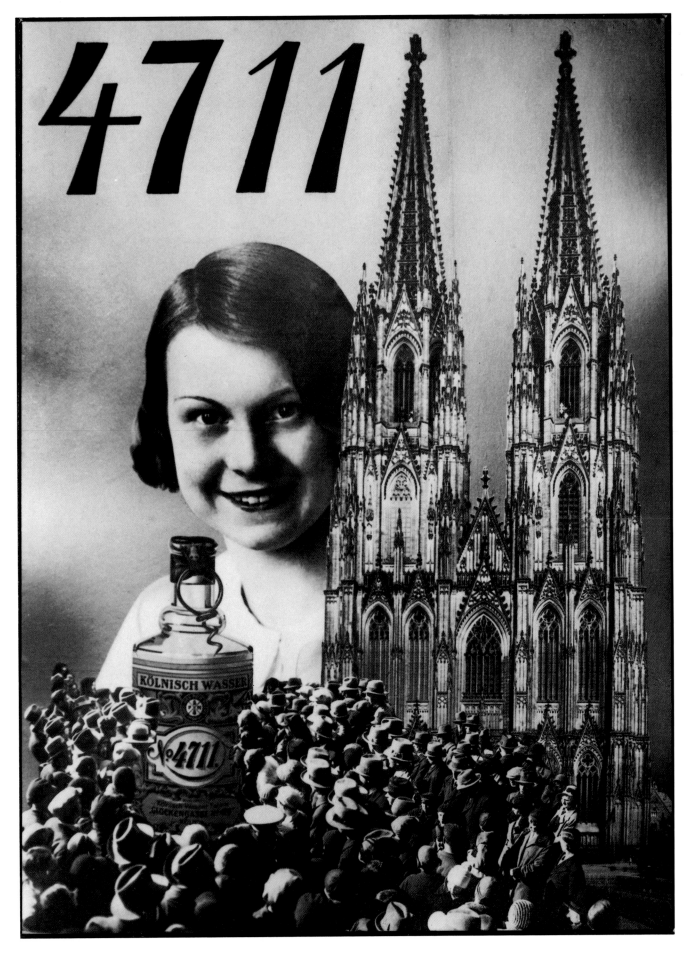

PLATE 30. AUGUST SANDER. <u>COLOGNE 4711.</u>
C. 1928. FOR KÖLNISCH WASSER 4711. GELATIN
SILVER PRINT OF A PHOTOMONTAGE, 19×14 CM.
THE SANDER GALLERY

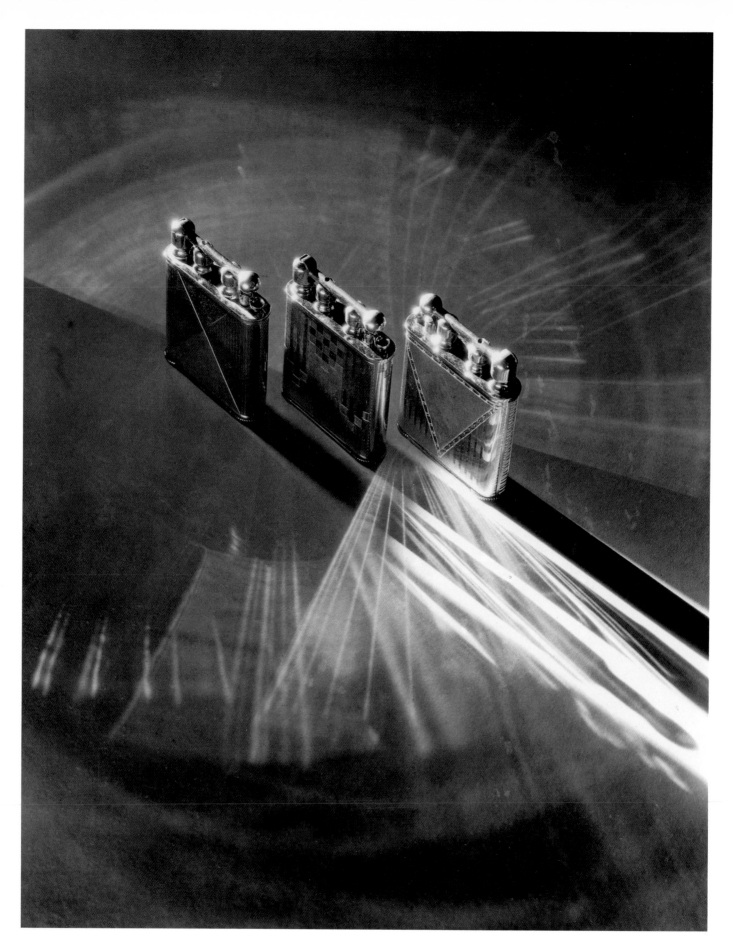

PLATE 31. EDWARD STEICHEN. <u>DOUGLAS</u>
<u>LIGHTERS.</u> 1928. J. WALTER THOMPSON CO.
FOR DOUGLAS LIGHTER. GELATIN SILVER PRINT,
24 × 19.5 CM. IMP/GEH. BEQUEST OF EDWARD
STEICHEN BY DIRECTION OF JOANNA T. STEICHEN

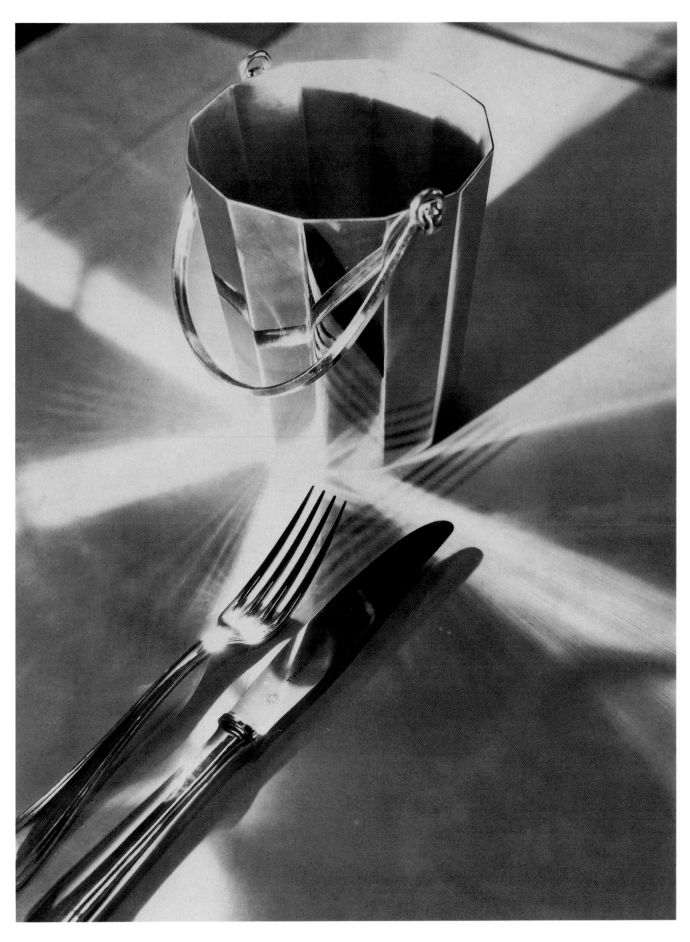

PLATE 32. MAURICE TABARD. FOR CHRISTOFLE
SILVER. LATE 1920S. GELATIN SILVER PRINT,
23×17.2 CM. THE SANDER GALLERY

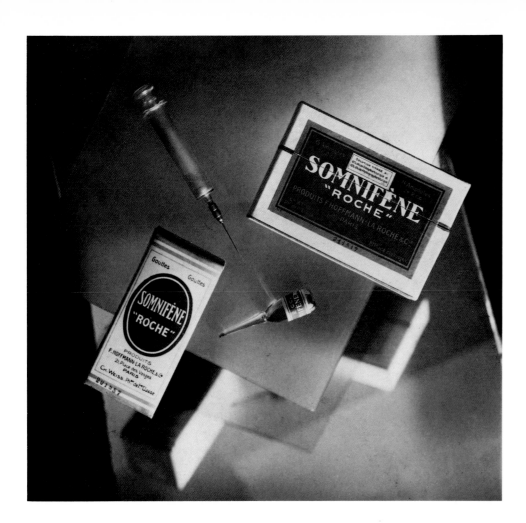

PLATE 33. JAROSLAV RÖSSLER. <u>SOMNIFÈNE</u>.
C. 1930. FOR F. HOFFMANN-LA ROCHE & CIE
[PHARMACEUTICALS]. GELATIN SILVER PRINT,
13.2 × 13.9 CM. THE SANDER GALLERY

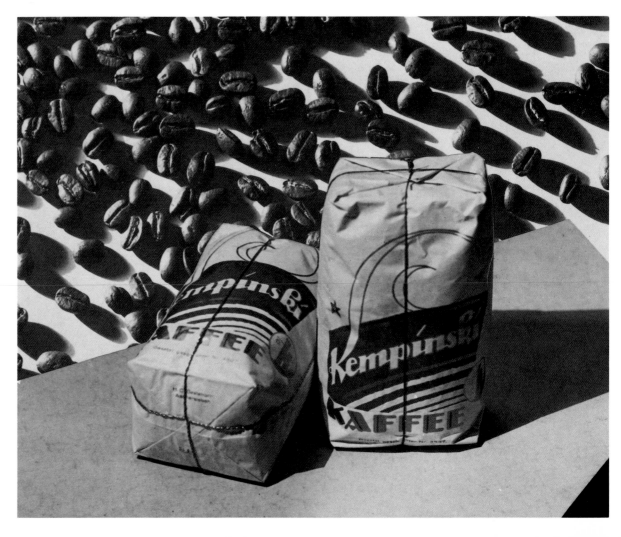

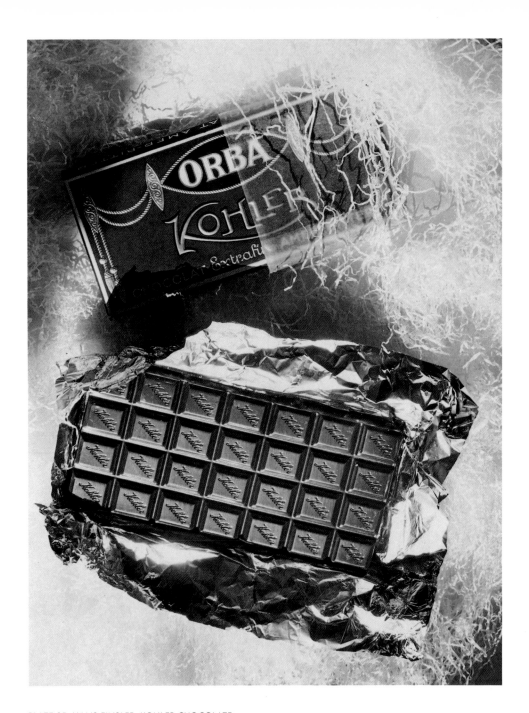

PLATE 35. HANS FINSLER. <u>KOHLER CHOCOLATE</u>.
C. 1935. FOR KOHLER CHOCOLATE. GELATIN
SILVER PRINT, 23.5 × 18.2 CM. COLLECTION
STEPHEN WHITE

PLATE 34. LOTTE JACOBI. <u>KEMPINSKI COFFEE</u>.
C. 1930. FOR KEMPINSKI KAFFEE. GELATIN SILVER
PRINT, 16.7 × 20.5 CM. COLLECTION STEPHEN
WHITE

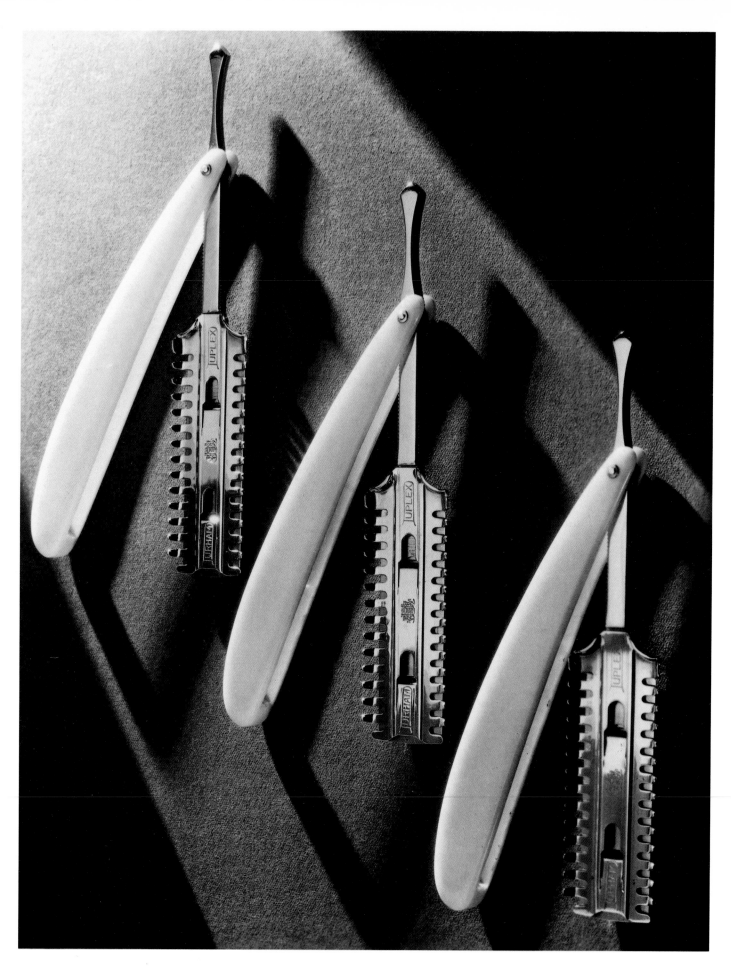

PLATE 36. JOHN F. COLLINS. DUPLEX RAZORS. 1934.
FOR EASTMAN KODAK CO. GELATIN SILVER PRINT,
23.8×18.7 CM. COURTESY PHOTOFIND GALLERY

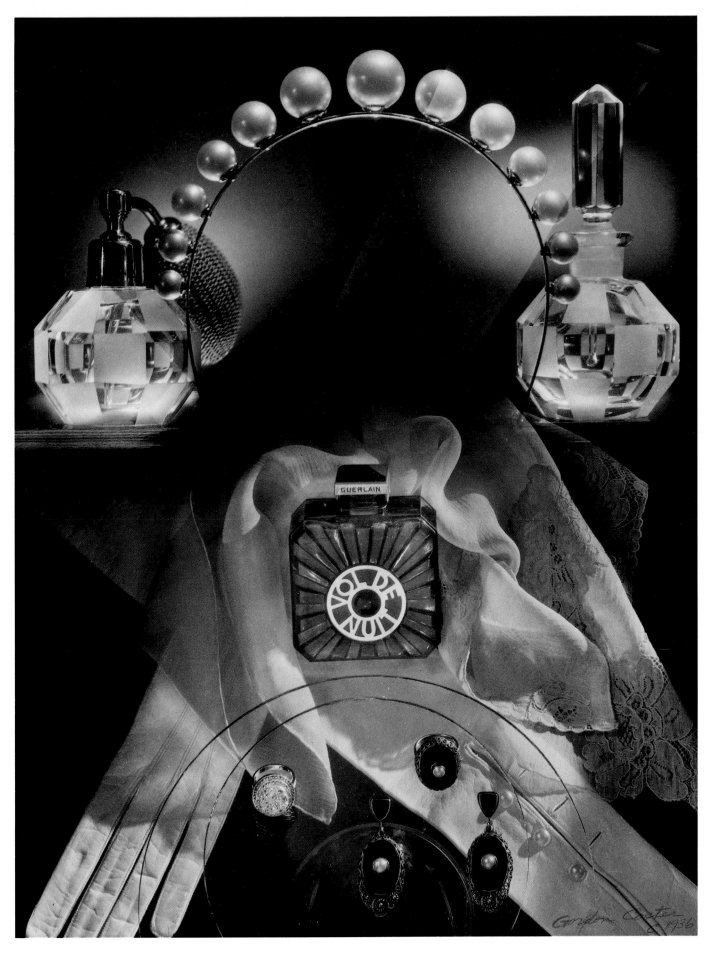

PLATE 37. GORDON COSTER. <u>VOL DE NUIT</u>.
1936. FOR GUERLAIN. GELATIN SILVER PRINT,
35.7 × 27.6 CM. COLLECTION KEITH DE LELLIS

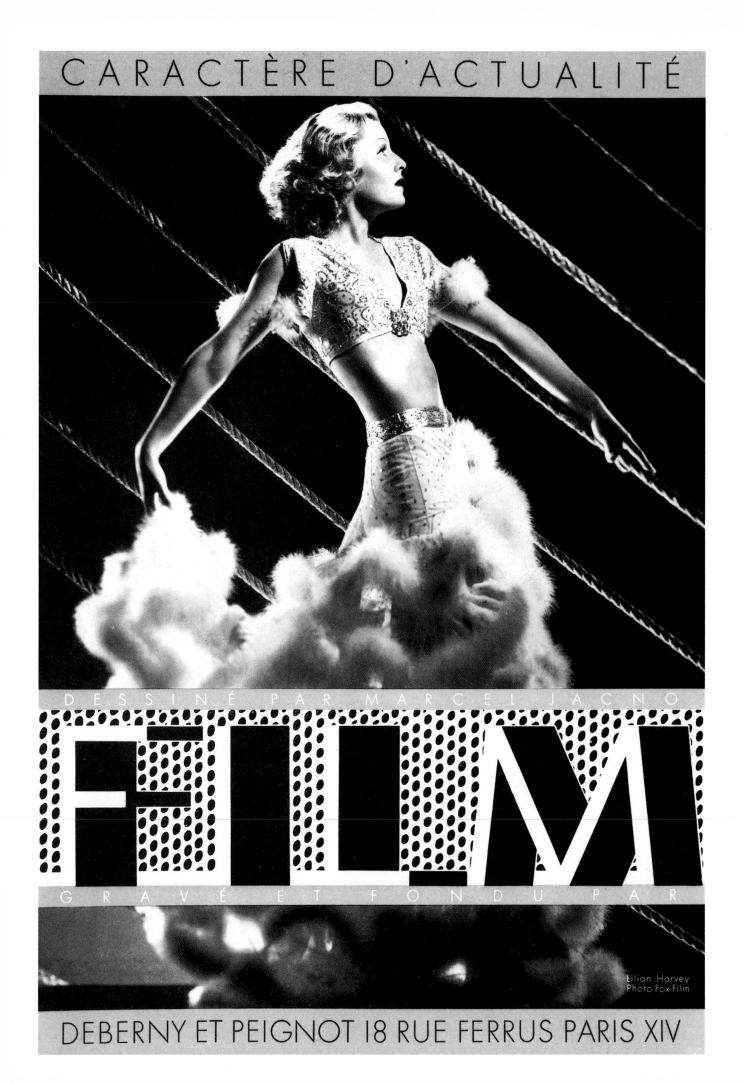

CARACTÈRE D'ACTUALITÉ

DESSINÉ PAR MARCEL JACNO

FILM

GRAVÉ ET FONDU PAR

Lilian Harvey
Photo Fox-Film

DEBERNY ET PEIGNOT 18 RUE FERRUS PARIS XIV

PLATE 38. STUDIO DEBERNY PEIGNOT. FOR STUDIO
DEBERNY PEIGNOT [NEW TYPEFACE CALLED FILM].
1932. PHOTOGRAVURE PRINT FROM MAGAZINE,
INCORPORATING PHOTOGRAPH OF LILLIAN
HARVEY BY FOX-FILM; 27.3 × 18.8 CM. PRIVATE
COLLECTION

PLATE 39. ALFRED CHENEY JOHNSTON. FOR
UNKNOWN CLIENT [CIGARETTES]. 1934. GELATIN
SILVER PRINT, 41 × 33.2 CM. COLLECTION PAUL
KATZ

REALISM, FEAR, AND COLOR 1929–45

MY WORK IS ENTIRELY COMMERCIAL....

I THINK IN ORDER TO BE A COMMERCIAL

PHOTOGRAPHER, YOU'VE GOT TO BE A

DRAMATIST AND AN INVENTOR AND AN

ENGINEER.

—H. I. WILLIAMS, 1931[1]

REALISM

The decade of the thirties was a period of reactions, extremes, and re-appraisals in advertising photography. The modern style had been defined during the previous era—modern art had been appropriated for mass consumption, experimental imagery had entered advertising's vocabulary, and the attractions of glamorous refinement had become commonplace. The former Bauhaus graphic artist Xanti Schawinsky and the British artist John Havinden promoted high-style consumer products with a sophisticated coolness (plates 42, 40); François Kollar in France gave even the most ordinary macaroni a humorously burlesque treatment (plate 41); and in Switzerland Herbert Matter created the modern travel poster (plate 43), using the language of photomontage in such a way as to influence photographic posters for several generations. Modernism's impact had become truly international. Swiss-born Schawinsky brought the lessons of the German Bauhaus to Italy in 1933 and by 1936 had relocated to the United States, where both Matter and the German typographer Herbert Bayer were teaching.

Consumers were dazzled and seduced, but they were also, at least in the minds of some advertisers, confused. Clarity had been lost in the midst of art, products were often sacrificed to esoteric designs or progressive compositions, and unsophisticated readers felt alienated by a failure to find their own reflections in advertising. Victor Keppler's award-winning photograph for Johnson & Johnson was a brilliant discourse on the shape of a new toothbrush, but its pictorial, rebuslike message was not immediately grasped (plate 44). Lejaren à Hiller's shot of a man paging through fingerprint files was simply unfathomable as an illustration for a radio manufacturer without the aid of the ad's copy (plate 45).

While the allure of glamour would never totally disappear, advertisers during the 1930s sought alternative ways of using photographs to sell their clients' wares in printed media increasingly saturated with photographs. Primary among these ways were a rebirth of naturalism, human drama, and the realism of color. Advertising, according to a British editorial in 1937, "has lost some of the rose hopes and enthusiasms which, in the era of prosperity, made it experimental and adventurous. It has come back to a practical outlook. The basic fact has been firmly reiterated that advertising must sell goods, that it is no use if it does not sell goods, and that there is no excuse for it, however otherwise attractive, if it does not."[2]

By far the principal change was reactionary. As an antidote to modernism, the new naturalism that developed addressed the middle class not in terms of their real aspirations but in terms of an idealized reality. (Naturalism in advertising should not be confused with artistic naturalism, for advertising's subjects—and its audience, of course—are rarely those of the slums,

the poor, or the derelict.) Sociologist Michael Schudson has labeled what transpires in most advertising as "capitalist realism," and finds in it many of the same elements that are found in socialist realism. Studying Soviet art, he finds strong parallels between what socialist art is meant to do and what advertising intends. Like socialist realism, advertising

SIMPLIFIES AND TYPIFIES. IT DOES NOT CLAIM TO PICTURE REALITY AS IT IS BUT REALITY AS IT SHOULD BE—LIFE AND LIVES WORTH EMULATING. IT IS ALWAYS PHOTOGRAPHY OR DRAMA OR DISCOURSE WITH A MESSAGE—RARELY PICTURING INDIVIDUALS, IT SHOWS PEOPLE ONLY AS INCARNATIONS OF LARGER SOCIAL CATEGORIES. IT ALWAYS ASSUMES THAT THERE IS PROGRESS. IT IS THOROUGHLY OPTIMISTIC, PROVIDING FOR ANY TROUBLES THAT IT IDENTIFIES A SOLUTION IN A PARTICULAR PRODUCT OR STYLE OF LIFE. IT FOCUSES, OF COURSE, ON THE NEW, AND IF IT SHOWS SOME SIGNS OF RESPECT FOR TRADITION, THIS IS ONLY TO HELP IN THE ASSIMILATION OF SOME NEW COMMERCIAL CREATION.[3]

In a speech given to the Art Directors Club of Philadelphia in 1930, the artist Nathaniel Pousette-Dart claimed that "illustrators find that if they wish to compete with photographers, and hold their own, they must make their work more realistic, better organized and more powerful. . . . Realism is returning again to advertising, but it is a new type of realism. The old photographic, naturalistic, literary variety of English tradition has gone forever."[4] The shift can easily be seen in automobile advertising, for example. Anton Bruehl's prizewinning photograph of 1929 (plate 50) of a chrome-plated Cadillac differential casing is clearly within a modernist syntax—dynamic, decontextualized, mechanomorphic, and nearly abstract. On the other hand, Nickolas Muray's color print (plate 46) of a 1933 Dodge displayed in a showroom contains real people (although rather elegantly attired) examining a car as they might in real life. The shift from modernism to realism can also be found in the increased incidence of thirties advertising images that portrayed scenes of middle-class home life, including its anxieties and traumas.

DRAMA AND FEAR APPEAL

Highly dramatic and histrionic imagery complemented the naturalism in thirties advertising. Throughout the decade scenes of violent confrontation, household disasters, aggressive behavior, and episodic "film noir" mysteries were used to advertise everything from appliances to insurance companies.[5] Grancel Fitz's photograph made in 1933 (plate 48) shows a scene of spectators in evening dress viewing something beyond the frame of the picture. Only the advertisement's copy indicates that their rapt attention is directed toward the newest Chevrolet, which is not portrayed. With nearly Pirandellian irony, Fitz reveals the audience but not the play, the fans but not the star—quite the opposite from his earlier image of corporate excitement over a new Oldsmobile engine, staged as though it were a scene from a play (plate 49). Edward Steichen depicted an ensemble of actors poised on a darkened stage (plate 53) for the Travelers Aid Society in 1932. Steichen accepted the first twenty homeless women exiting one of the Society's lodging houses and hired them as models:

IT WAS A HEARTBREAKING EXPERIENCE TO SEE THESE LOVELY PEOPLE IN SUCH A HOPELESS SITUATION, ESPECIALLY SINCE THE GROUP INCLUDED SO MANY AGES AND STAGES—THE LITTLE CHILD AND THE AGED, WHITE-FACED WOMAN WHOSE GLAZED EYES SEEMED TO BE STARING AT DEATH, THE YOUNG WOMEN WITH THE HARD, RESENTFUL FACES, AND THE INNOCENT TEEN-AGER WHO HAD BEEN FOUND BY THE TRAVELERS AID SOCIETY WANDERING AIMLESSLY ABOUT GRAND CENTRAL STATION.[6]

They were found framed in doctors' offices and one reporter noted that "at least one big hospital has a corridor hung like a gallery with the entire series in chronological order: a pictorial history of sutures in surgery."[8] For the most part, Hiller's historical dramas were unabashed excuses for sexual titillation. His *Etienne Gourmelen* (fig. 13) of about 1933, depicting the sixteenth-century French physician caring for plague victims, shows all the dead or dying males fully clothed while every woman seen is voluptuous and unclad. On a quieter note, *Aspasia* (plate 54) depicts a consultation between the purported first female surgeon and her Periclean nymphs.

Hiller's partially clad nymphs and heroic physicians represent only one form of sexist advertising in the thirties. Far more insidious was the trend toward "scare appeal" or "fear appeal." "The new realism of outlook," wrote a British advertiser in 1937, "was accompanied for a while by a new vogue for sensationalism. The scare type of advertisement acquired a sinister prominence."[9] "The scare appeal," wrote an American critic in 1932, "addresses itself with a powerful directness to that oldest, deepest and most easily aroused of human emotions—fear. Consequently, this method of copy approach, when properly utilized, undeniably results in effective advertising."[10] Photographers like John Scott, Ewing Galloway, Nathan Lazarnick, Underwood & Underwood, and Victor Keppler specialized in views of anxious or downright fear-struck women. Their clients were most frequently telephone companies (security in being able to call for help), medical companies (aid in treating family illnesses), and home protection systems (again, family security). That these advertisements and their images played on a popular stereotype of the helpless female is apparent in such advertising trade comments as ". . . the fear appeal is more frequently used in advertising designed to appeal to women than in advertising planned for the male eye.

Probably the most notorious examples of histrionics in thirties advertising was Lejaren à Hiller's *Surgery Through the Ages*, begun in 1927. Hiller fabricated a serial tableau of the great moments in surgical history for Davis & Geck, Inc., a manufacturer of hospital supplies, who had hired him to create "dramatic photographs representing the lives and careers of the great men who have made surgical history from the earliest Egyptian records down to the present day." So popular were these images that they appeared in every issue of all seventeen principal medical publications in America for more than six years.[7]

This may be because what was once called the weaker sex is considered more susceptible to the fear impulse or, to explain it in simpler terms, more easily scared."[11]

The stereotypical view of the frightened woman was often blended with that of the caring mother, concerned for the health and safety of her family. There was an exceptionally high incidence of mothers tending to children in advertising during this period.[12] Sentimental images, like that of a mother treating a cut on the finger of her young daughter (plate 47), sometimes appeared as point-of-sale displays. Keppler's photograph for a print ad of a worried mother phoning a doctor about her child's temperature emphasized a moment of fear and apprehension with the heightened immediacy of a scene in a Hitchcock film (plate 58, fig. 14).

Hiller had evoked the flavor of a thirties detective thriller when he shot a pair of hands leafing through fingerprint records for Bosch Radio around 1930. John Paul Pennebaker showed Chicago motorcycle police careening out of the picture space in an ad for Standard Oil (plate 59). For General Electric, Ralph Bartholomew used harsh tabloid lighting to capture the domestic terror of a couple discovering a dangerously flooded basement (plate 57). Newspaper advertisements, constructed as photo romances or cartoon strips, carried emotional monologues, such as "I Hate Him . . . I Hate Him . . . I *Hate* Him" for Cashmere Bouquet soap, or "I Thought I Had Him Hooked!" for Colgate toothpaste (fig. 15). And, of course, World War II brought its own sense of urgent drama and human passion in posters for the war effort and charitable appeals (plates 64, 65).

The little glass tube that knows more than mother...

A WAIL in the night from the nursery. A mother's cool hand on a brow that feels too warm. Fever? Wait. The clinical thermometer will *know*. Everywhere, in ever increasing numbers, mothers are learning that when it comes to the delicate matter of gauging family health, the clinical thermometer knows best. Often, by signaling sickness in the early stages, it brings the doctor in time to arrest a more serious development. In Corning, New York, in a huge chimney-like tower 185 feet high, great gobs of red hot glass are drawn into thermometer tubing with an inside bore one-third the diameter of a human hair. It is the only tower of its kind in the world. It was built to insure the fine accuracy required in this special form of glass. Thermometer tubing is important, but only one of many Corning products. A new and exciting one is fibrous glass. This is a modern insulating material soft as eiderdown, snowy white as surgical cotton, rich in industrial possibilities. Others are "Pyrex" brand glasses, glass bulbs for electric lamps, lenses that help make travel safer. And yet all of these represent but a small fraction of Corning Research activities in the immensely absorbing, endlessly fascinating realm of glass.

For more of the story of glass research, send for free booklet, "Corning Glass Works presents..." Corning Glass Works, Corning, N. Y.

CORNING *means* Research in Glass

FIGURE 14. VICTOR KEPPLER. AD FOR CORNING GLASS WORKS. 1938. PRINTED PAGE. IMP/GEH. GIFT OF THE ARTIST

THE ADVENT OF COLOR

Color photography began to be discussed, often with heated rhetoric, in the early thirties. Some critics and photographers simply did not believe natural-color photography would ever be good enough technically; others felt that if color was wanted in an advertisement, an illustrator should be hired to paint the image. In a speech to the Art Directors Club of New York in 1931, Edward Steichen was one of the first to suggest that its real role was approaching. About this speech,

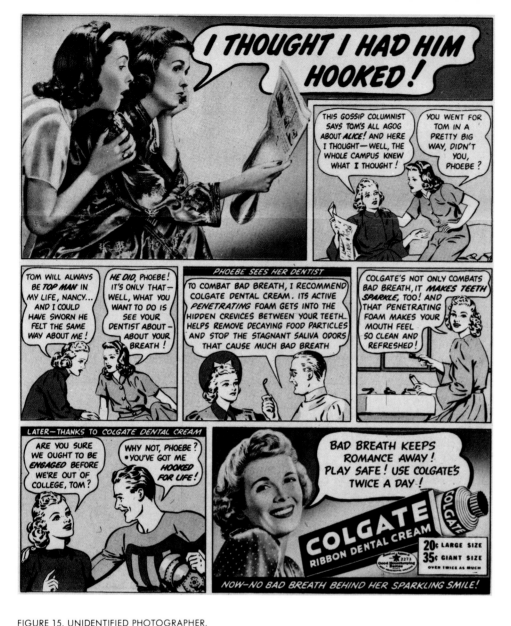

FIGURE 15. UNIDENTIFIED PHOTOGRAPHER.
AD FOR COLGATE RIBBON DENTAL CREAM, FROM
THE NEW YORK TIMES. 1939

one reporter wrote: "Regarding color photography, [Steichen] said that there was a real demand, and the demand would eventually be met. He thought it still a long way from perfect, but predicted that as soon as the proper experimentation and thought are given to the subject it will be solved."[13]

By 1936 it was clear that color photography would play an important role in advertising. An unsigned article in the American advertising press asserted: "Color photography has at last demonstrated a versatility practically equal to black-and-white photography. The long-awaited prophecy of the color photographers that 'anything that can be photographed in black and white can be photographed in color' seems to have reached its fulfillment." Citing the Chicago *Evening Standard*, the same article spotlighted the Ford Motor Company as among the first national advertisers to take advantage of "the new process, which means as much to the graphic arts as the transatlantic flight of the Hindenburg means to transportation."[14] Also pointed out were Hiller's color shot of a greengrocer superimposed by an image of Voltaire for the Scripps-Howard newspaper chain and Margaret Bourke-White's color still lifes printed by the Similetone four-color process for *Delineator* magazine.

Why the sudden success of color advertising photography in 1936? The graphic-arts industry had proved itself capable of printing three- and four-color images since the turn of the century. The New York photographer William Kurtz published a full-color photoengraving (a relief printing process similar to letterpress) as early as 1893, the same year the French magazine *L'Illustration* included a number of three-color photoengravings in its Christmas issue. In the same decade, Viennese photographer Karl Klietsch began perfecting color photogravure, or intaglio printing. And in 1910 an American printer, William C. Huebner, reproduced a full-color photograph of

flowers in four colors by offset lithography, a planometric process.[15] The problems of producing the three or four separate plates by which the primary colors, and sometimes black, could be printed in register were essentially solved for each of the principal printing processes before the First World War.

While the printing industry could technically print full-color photographs, it was still not very convenient for the photographer to furnish the printer with separation negatives; that is, black-and-white negatives separately exposed through colored filters, from which the individual printing plates could be made. A minimum of three exposures of the subject had to be made either sequentially by changing the filters and film holders for each exposure, or concurrently by using a fairly specialized color-separation camera that recorded each of the primary colors on separate negatives. Between 1925 and 1936 a number of color-separation cameras became available from manufacturers on both sides of the Atlantic, most notably, the National One-Shot from America, the OV2 from France, and the Bermpohl and Jos-Pe three-color beam splitters from Germany. Although cumbersome to use, they were the only means by which commercial photographers could provide their clients with color imagery.

Nor was it easy to make a color print that could be given to a printer who would then make separation negatives from it. The most popular technique during the early thirties was color carbro printing, a color process that required more than eighty precisely controlled steps and could take as long as ten hours to produce a single print. Despite its exacting and costly procedure, however, the results were the most permanent of all color photography and yielded what are,

perhaps, the richest color prints ever made. The first color carbro print to be published in a magazine was a fashion shot by Nickolas Muray that appeared as early as 1931 in the *Ladies' Home Journal.* In 1932 The Coca-Cola Company ran Muray's color print of Claudette Colbert and Frederic March; his Dodge photograph appeared in 1933, and his color work for Lucky Strike cigarettes dates from 1934 to 1936—all from original color carbro prints made from negatives taken with either a Bermpohl or a Reckmeier and Schunemann color-separation camera.[16]

FIGURE 16. NICKOLAS MURAY. AD FOR ROGERS BROS. SILVERPLATE. 1939. TEARSHEET. IMP/GEH. GIFT OF MICHAEL BROOKE MURAY, NICKOLAS CHRISTOPHER MURAY, AND GUSTAV SCHWAB

FIGURE 17. VICTOR KEPPLER. AD FOR LUCKY
STRIKE CIGARETTES. C. 1938. TEARSHEET. IMP/GEH.
GIFT OF THE ARTIST

Other forms of color photography were introduced during the mid-thirties. In 1935 Eastman Kodak announced its Wash-Off Relief color process for photographic prints, an earlier version of the Dye Transfer process of 1946 and one that had a production time of about one hour per print.[17] The same year, the Defender Photo Supply Company marketed Chromatone, the simplest and least expensive color print process of the period, and Eastman Kodak brought out Kodachrome, a fully integrated color transparency film and the first of the modern dye-coupler or chromogenically developed films. While 35-millimeter Kodachrome was not marketed until 1937 and professional sheet film only in late 1938, the process's announcement in 1935—and that of Agfacolor the following year—marked the beginning of the modern era of color photography. In Victor Keppler's highly influential manual of color photography, *The Eighth Art*, of 1938, the photographer wrote, "The cost of reproducing color photographs will decrease steadily, and the quality of the reproductions will rise just as steadily. This is why I am sure that eventually black and white photography will be obsolete. Color photographs will lure you from every magazine, book, and poster."[18] Keppler illustrated his book with a number of his color advertising photographs, including those made for General Electric, Hamilton Watch, Seagram Distillers Company, and the American Tobacco Company. His *Witnessed Statement* ads for Lucky Strikes (plate 51, fig. 17) presented a serialized set of encounters featuring a real person in a real-life situation extolling the qualities of the cigarette's tobacco. To the realism of the decade's advertising was added the ultimate realism of color.

In truth, there was no sudden appearance of color in advertising photography in 1936. Its advent was slow and deliberate, based on decreasing production costs, more convenient color-separation cameras, easier printmaking, and a heightened public taste for color imagery. What critics saw that year was simply the overwhelming acceptance by the advertising community of color photography's practicality and popularity. For the British annual *Modern Publicity*, of that year, the American photographer Harold Haliday Costain reported: "The most noticeable recent change in advertising tendencies is the widespread use of color photography for all types of illustrations. The American advertisers, realising that over 75 per cent. [*sic*] of all purchases were made by our women, set about to further appeal to them by means of colour, and the great increase in its general use proves beyond doubt its claim to success."[19] By this time American photographers like Keppler, Muray (plate 61, fig. 16), Holmes I. Mettee (plate 56), and H. I. Williams (plate 55) and Europeans like F. W. Westley (plate 52) were fashioning highly realistic, vibrant, and alluring color photographs, and using color in ways that remain unequaled.

1. H. I. Williams, cited in Lillian Sabine, "H. I. Williams, New York City," *The Commercial Photographer* 7, no. 1 (October 1931): 11.

2. F. A. Mercer and W. Gaunt, "Foreword," in *Modern Publicity: The Annual of "Art and Industry"* (London and New York, 1937–38), p. 7.

3. Michael Schudson, *Advertising, The Uneasy Persuasion: Its Dubious Impact on American Society* (New York, 1984), p. 215.

4. Nathaniel Pousette-Dart, "Modern Art—Its Genesis and Destination," *Printers' Ink* 153 (23 October 1930): 150–52.

5. Cf. Frank S. Ennis, "Dramatized Photography in Insurance Advertising," *Printed Salesmanship* 60 (October 1932): 161–65.

6. Edward Steichen, *A Life in Photography* (New York, 1963), unp.

7. In 1935 Valentino Sarra staged similar medical histories as Hiller's. Cf. his "Studio Shot for Abbott Laboratories Depicting Use of Opium as Early Anesthetic," in *Art Directors Club Annual*, 14th edition, 1935, unp.

8. "Camera Studies in Medical History," *Printing Art* 60 (January 1933): 401.

9. F. A. Mercer and W. Gaunt, "Foreword," p. 7.

10. "The Fear Appeal," *Printers' Ink Monthly* 24 (June 1932): 26.

11. Ibid., p. 27.

12. It is suggested that this increase is linked to the then popular notion that women were to stay at home and not compete with men for jobs during the Depression years. See Bruce W. Brown, *Images of Family Life in Magazine Advertising: 1920–1978* (New York, 1981), pp. 42–43.

13. "Artist or Photographer?," *Printers' Ink* 157 (26 November 1931): 64.

14. "Color Photography's Newest Accomplishments," *Printing Art Quarterly* 66, no. 3 (1936): 45.

15. Louis Walton Sipley, *A Half Century of Color* (New York, 1951), passim. Also cf. Clarence P. Hornung and Fridolf Johnson, *200 Years of American Graphic Art* (New York, 1976), p. 175.

16. Inventory list of Muray's equipment, Technology Archives, George Eastman House.

17. Louis Walton Sipley, *A Half Century of Color*, pp. 106–7.

18. Victor Keppler, *The Eighth Art: A Life of Color Photography* (New York, 1938), p. 18.

19. Harold Haliday Costain, "Photography," *Modern Publicity 1935–6* (London, 1936), p. 20.

PLATE 40. JOHN HAVINDEN. COMPASS CAMERA.
1937. FOR LECOULTRE WATCH CO. GELATIN SILVER
PRINT WITH GOUACHE LETTERING, 36.1 × 25 CM.
THE PRAKAPAS GALLERY

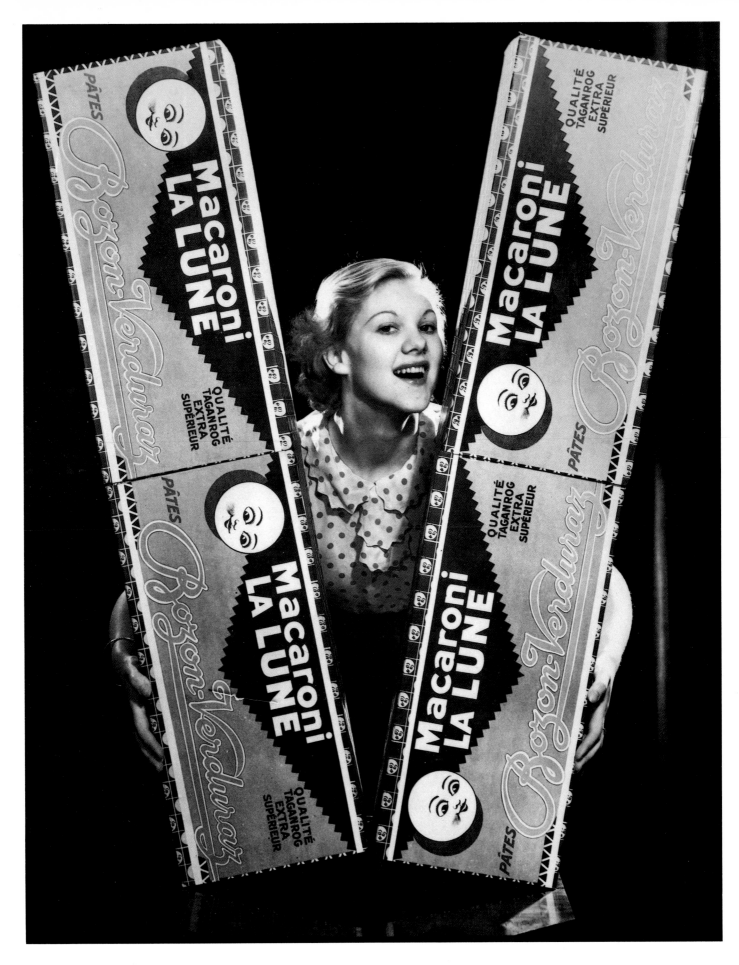

PLATE 41. FRANÇOIS KOLLAR. LA LUNE MACARONI.
1934. FOR ROZON-VERDURAZ. GELATIN SILVER
PRINT, 27.8 × 21.6 CM. THE ZABRISKIE GALLERY

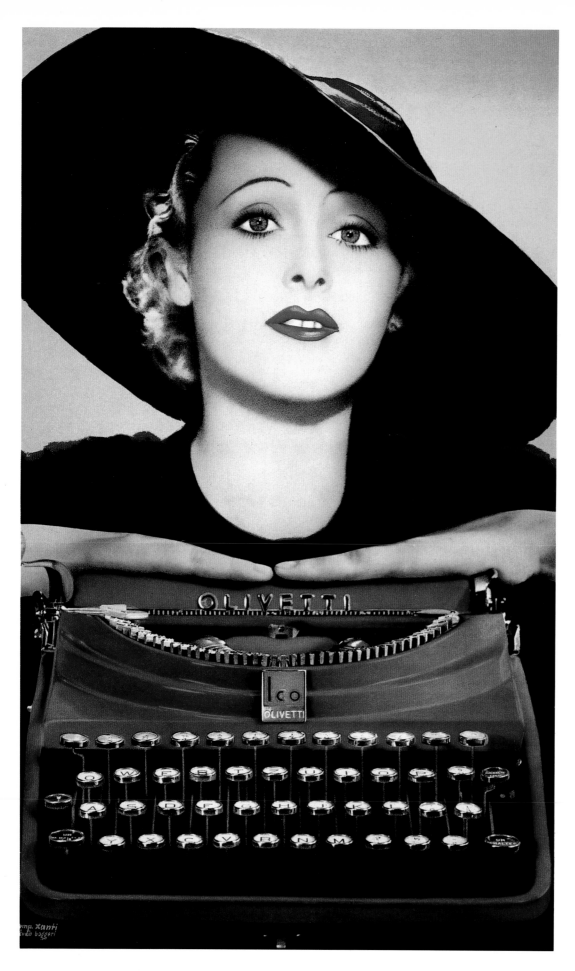

PLATE 42. XANTI SCHAWINSKY. <u>OLIVETTI</u>. 1934.
FOR OLIVETTI TYPEWRITERS. PHOTOLITHOGRAPHIC
POSTER, 52 × 34.3 CM. COLLECTION W. MICHAEL
SHEEHE

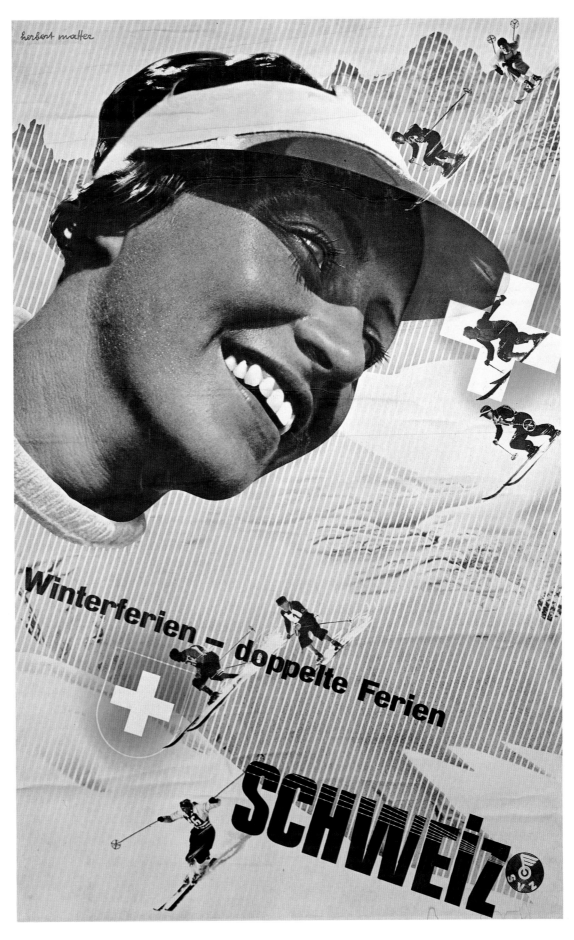

Winterferien – doppelte Ferien

SCHWEIZ

PLATE 43. HERBERT MATTER. <u>WINTER VACATION—</u>
<u>DOUBLE VACATION</u>. 1934. FOR SWISS NATIONAL
TOURIST OFFICE. COLOR PHOTOGRAVURE POSTER,
101 × 64.1 CM. THE MUSEUM OF MODERN ART,
NEW YORK. GIFT OF G. E. KIDDER SMITH

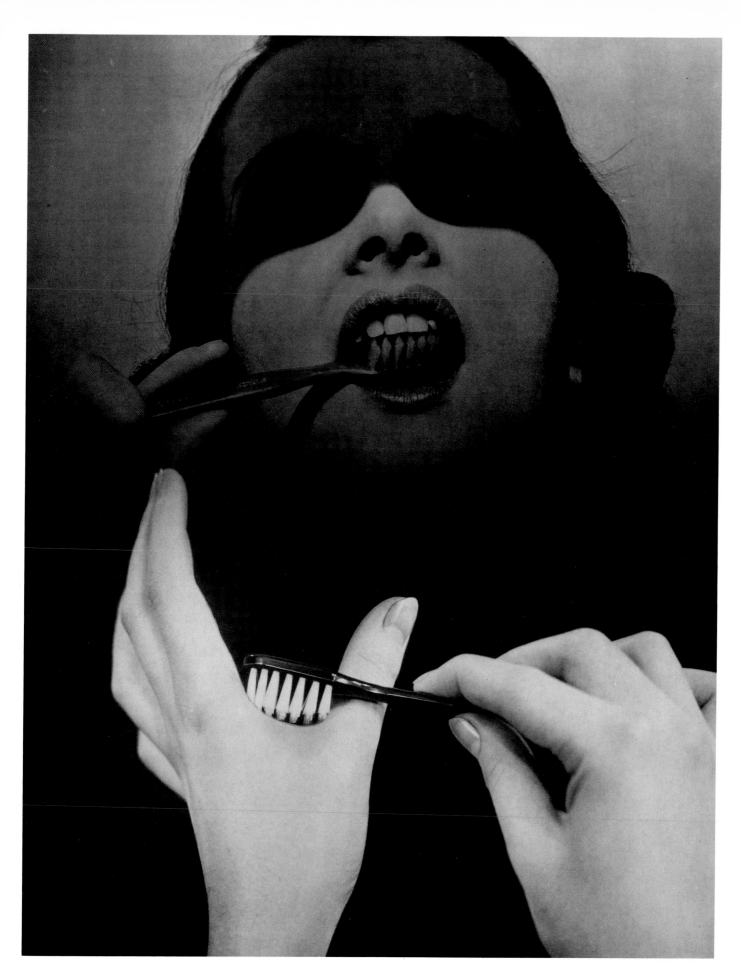

PLATE 44. VICTOR KEPPLER. <u>BETTER SHAPE</u>. 1932.
FERRY-HANLY ADVERTISING CO. FOR JOHNSON &
JOHNSON. GELATIN SILVER PRINT, 24.1×18.8 CM.
IMP/GEH. GIFT OF THE ARTIST

PLATE 45. LEJAREN À HILLER. FOR BOSCH RADIO
AD. C. 1929–30. GELATIN SILVER PRINT, 33×25.2 CM.
COLLECTION KEITH DE LELLIS

PLATE 46. NICKOLAS MURAY. <u>DODGE</u>. 1933. FOR
CHRYSLER CORP., DODGE DIVISION. COLOR
CARBRO PRINT, 23.8×33.8 CM. IMP/GEH. GIFT OF
MICHAEL BROOKE MURAY, NICKOLAS
CHRISTOPHER MURAY, AND GUSTAV SCHWAB

PLATE 47. ANONYMOUS. <u>MERCUROCHROME</u>.
C. 1931. FOR H. W. & D., INC. DEPTH-O-GRAPH
LENTICULAR TRANSPARENCY, HAND COLORED,
WITH ILLUMINATED DISPLAY STAND;
30.2×22.6×23.5 CM. IMP/GEH. MUSEUM
COLLECTION

PLATE 48. GRANCEL FITZ. <u>CHEVROLET</u>. 1933.
CAMPBELL-EWALD CO. FOR GENERAL MOTORS
CORP., CHEVROLET MOTOR CAR DIVISION; ART
DIRECTOR HALSEY DAVIDSON. GELATIN SILVER
PRINT, 35.5 × 28 CM. COLLECTION KEITH DE LELLIS

PLATE 49. GRANCEL FITZ. <u>OLDSMOBILE</u>. 1929. FOR
GENERAL MOTORS CORP., OLDSMOBILE MOTOR
CAR DIVISION. FOUR GELATIN SILVER PRINTS, EACH
15.3 × 23.8 CM. COLLECTION PAUL KATZ

PLATE 50. ANTON BRUEHL. <u>CADILLAC</u>. 1929. FOR
GENERAL MOTORS CORP., CADILLAC MOTOR CAR
DIVISION. GELATIN SILVER PRINT, 25.5 × 20.3 CM.
COLLECTION PAUL KATZ

PLATE 51. VICTOR KEPPLER. <u>LUCKY STRIKE</u>.
C. 1938. LORD & THOMAS FOR AMERICAN
TOBACCO CO.; ART DIRECTOR JOSEPH
HOCHREITER. COLOR CARBRO PRINT,
41.3 × 36.2 CM. IMP/GEH. GIFT OF THE ARTIST

PLATE 52. F. W. WESTLEY. FOR UNKNOWN CLIENT
[CANNED GOODS]. 1939. VIVEX PRINT, PRINTED BY
D. A. SPENCER AND FRANK COPPIN; 53.8 × 38 CM.
IMP/GEH. GIFT OF DR. AND MRS. WALTER CLARK

PLATE 53. EDWARD STEICHEN. <u>HOMELESS</u>
<u>WOMEN</u>—THE DEPRESSION. 1932. J. WALTER
THOMPSON CO. FOR TRAVELERS AID SOCIETY.
GELATIN SILVER PRINT, 34.5×27 CM. IMP/GEH.
BEQUEST OF EDWARD STEICHEN BY DIRECTION
OF JOANNA T. STEICHEN

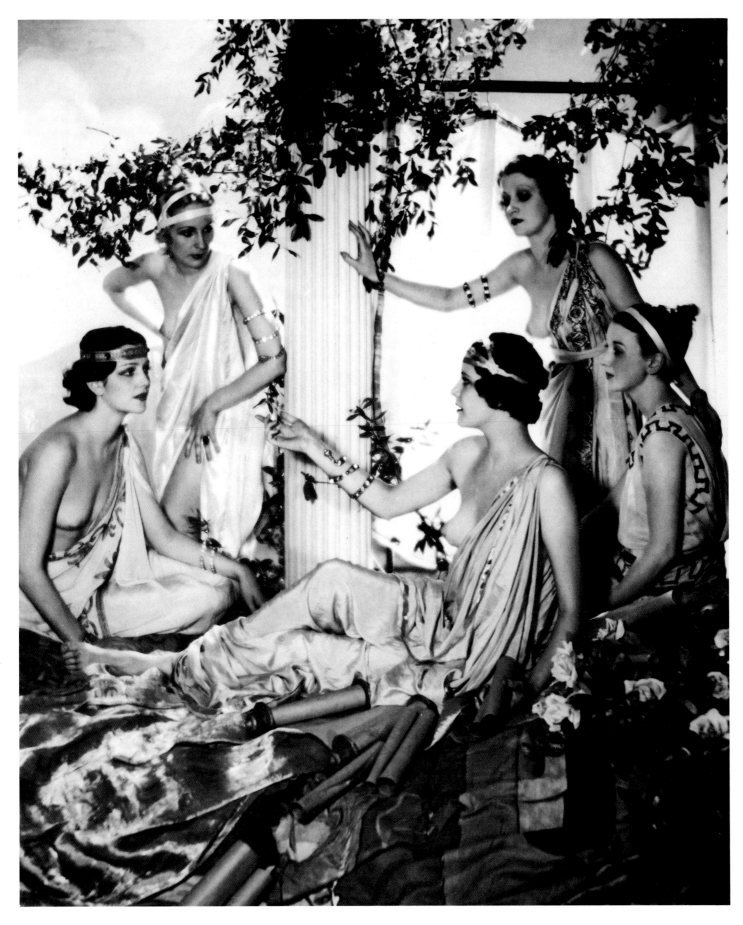

PLATE 54. LEJAREN À HILLER. ASPASIA. 1933.
IN-HOUSE AGENCY FOR DAVIS & GECK, INC.
GELATIN SILVER PRINT, 45.5×37.9 CM. IMP/GEH.
GIFT OF 3M CO. EX-COLLECTION LOUIS WALTON
SIPLEY

PLATE 55. H. I. WILLIAMS. FOR AMERICAN MEAT
INSTITUTE. 1943. LEO BURNETT CO., INC.; ART
DIRECTOR JOHN E. OLSON. COLOR CARBRO PRINT,
30.3×38.5 CM. COLLECTION KEITH DE LELLIS

PLATE 56. HOLMES I. METTEE. <u>KITCHEN INTERIOR</u>.
1940. FOR ARMSTRONG CORK. COLOR CARBRO
PRINT, 38 × 32.5 CM. COLLECTION KEITH DE LELLIS

PLATE 57. RALPH BARTHOLOMEW. FOR GENERAL
ELECTRIC. C. 1940S. NEWELL EMMET AGENCY.
GELATIN SILVER PRINT, 25.7×31 CM. COLLECTION
KEITH DE LELLIS

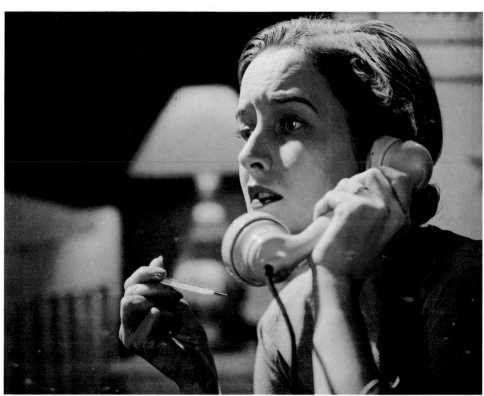

PLATE 58. VICTOR KEPPLER. FOR CORNING GLASS
WORKS [THERMOMETER]. 1938. GELATIN SILVER
PRINT, 27.3×35 CM. IMP/GEH. GIFT OF THE ARTIST

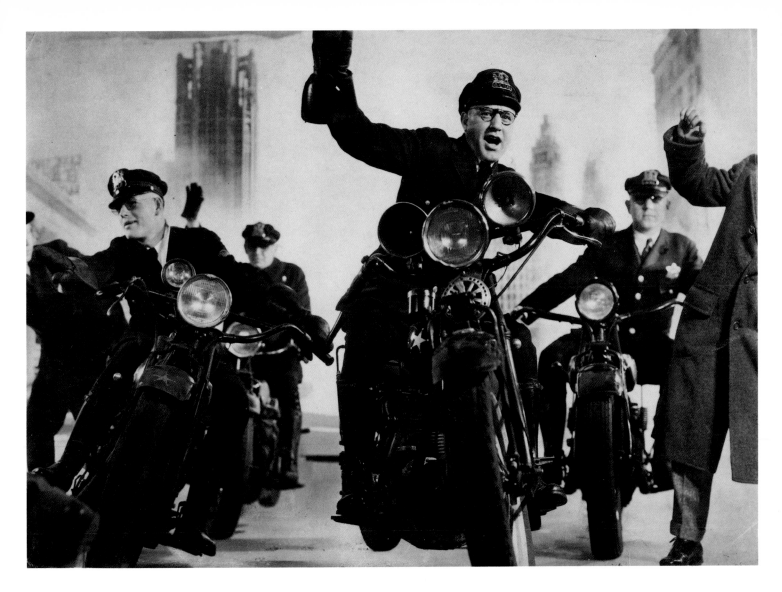

PLATE 59. JOHN PAUL PENNEBAKER. <u>TRAFFIC COP</u>.
C. 1933–34. MCCANN-ERICKSON, INC. FOR
STANDARD OIL, INC. GELATIN SILVER PRINT,
29.2 × 41.1 CM. IMP/GEH. GIFT OF 3M CO.
EX- COLLECTION LOUIS WALTON SIPLEY

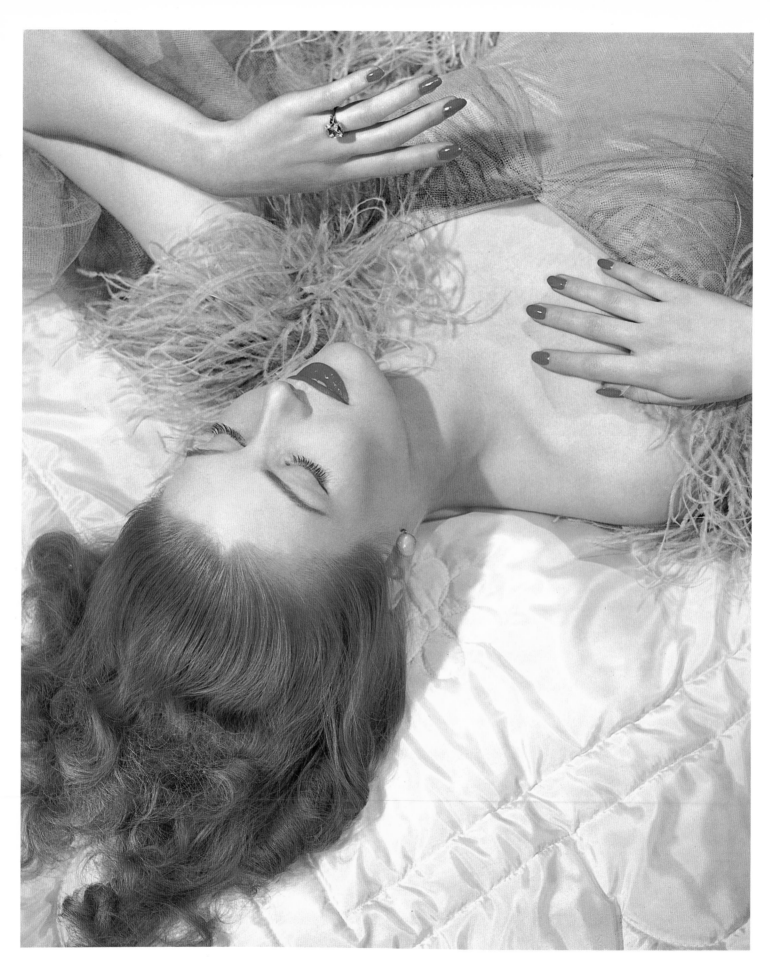

PLATE 60. RUZZIE GREEN. FOR COLGATE-
PALMOLIVE-PEET CO. 1942. ART DIRECTOR WALTER
L. STOCKLIN. COLOR CARBRO PRINT, 46.2×38.5 CM.
COLLECTION KEITH DE LELLIS

PLATE 61. NICKOLAS MURAY. 1847 ROGERS BROS.
[VARIANT]. 1939. FOR INTERNATIONAL SILVER CO.
COLOR CARBRO PRINT, 33 × 41.3 CM. IMP/GEH.
GIFT OF MICHAEL BROOKE MURAY, NICKOLAS
CHRISTOPHER MURAY, AND GUSTAV SCHWAB

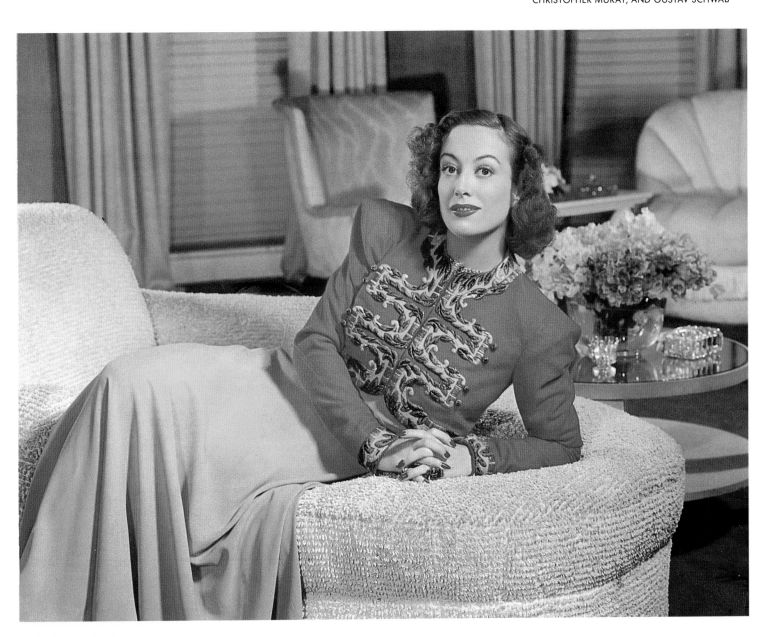

PLATE 62. GRANCEL FITZ. <u>LINCOLN ZEPHYR</u>. 1936.
FOR FORD MOTOR CO., LINCOLN DIVISION.
GELATIN SILVER PRINT, COMBINATION PRINTED;
32.6 × 23.3 CM. COLLECTION GILMAN PAPER CO.

PLATE 63. EUGENE HUTCHINSON. <u>PARACHUTES</u>.
C. 1944. FOR VANITY FAIR MILLS, INC. GELATIN
SILVER PRINT, 45.4×37.7 CM. IMP/GEH. GIFT OF 3M
CO. EX-COLLECTION LOUIS WALTON SIPLEY

PLATE 64. LEJAREN À HILLER. <u>CHILDREN'S</u>
<u>CLOTHING APPEAL</u>. C. 1944. KENYON & ECKHARDT,
INC. FOR AMERICAN RED CROSS AND NATIONAL
NEEDLECRAFT BUREAU. GELATIN SILVER PRINT,
34.1 × 26.8 CM. COLLECTION WALTER STORCK

PLATE 65. VICTOR KEPPLER. <u>DON'T GET HURT</u>. 1943.
FOR U.S. TREASURY DEPARTMENT. PHOTO-OFFSET
POSTER, 97.5×69.2 CM. IMP/GEH. GIFT OF THE
ARTIST

AN AMERICAN GOLDEN AGE 1945–65

THE <u>SUBJECT</u> OF YOUR ILLUSTRATION IS MORE IMPORTANT THAN ITS <u>TECHNIQUE</u>. AS IN ALL AREAS OF ADVERTISING, SUBSTANCE IS MORE IMPORTANT THAN FORM. IF YOU HAVE A REMARKABLE IDEA FOR A PHOTOGRAPH, IT DOES NOT REQUIRE A GENIUS TO CLICK THE SHUTTER. IF YOU HAVEN'T GOT A REMARKABLE IDEA, NOT EVEN IRVING PENN CAN SAVE YOU.

—DAVID OGILVY, AGENCY HEAD, 1963[1]

A CREATIVE REVOLUTION

The period between 1945 and 1965 was special in American advertising. The tremendous growth of material culture this country enjoyed occurred nowhere else. While Europe and Japan were still rebuilding after World War II (a situation that would change dramatically during the 1970s), in the United States the war machine turned to the home front and devoted its energies to the manufacture of consumer products. To assist the American public in taking advantage of its prosperity, many advertising agencies grew to accommodate the plethora of goods and services on the market. To be sure, large agencies like N. W. Ayer & Son[2] and J. Walter Thompson Company[3] had been in business since the late nineteenth century, but there was little that anticipated the phenomenal growth of advertising's social and economic power in the postwar era. Firms like Ogilvy, Benson & Mather; Doyle Dane Bernbach; McCann-Erickson; Papert, Koenig, Lois; and Young & Rubicam were, if not exactly household names, the leaders of a revolution that affected every household. Commenting in the mid-sixties, Daniel & Charles chairman Charles Goldschmidt stated: "Most agencies today have consciously or unconsciously developed an acute awareness of the need to reevaluate their communication techniques. That is why there are increasing agency efforts to communicate more interestingly with the consumer.... While it may be called a creative revolution, it is more a reshaping of American industry."[4]

The growth of this industry is easily traced by examining annual American advertising expenditures between 1940 and 1960. Even discounting those areas, like television and radio, that do not account for any significant use of still photography, the amount spent on national print advertising in

newspapers and magazines more than doubled from just over a billion dollars in 1940 to more than $2.5 billion in 1950, which in turn nearly doubled by 1960 by a figure of more than $4.5 billion. While this amount is far less than the nearly $18 billion spent in 1980, it is 515 percent greater than what was expended in 1935.[5]

AN ERA OF ART DIRECTORS

With the growth of powerful agencies came a rise in commanding art directors. These were the creative talents who developed some of the most notable campaigns in history, made fortunes for their clients, established ethical and business guidelines for their profession, and in large measure controlled the visions of the photographers they hired. They were men like Hershel Bramson, Lou Dorfsman, Steve Frankfurt, Roy Grace, George Lois, Helmut Krone, and Bert Steinhauser, who firmly held to the belief expressed by creative director William Bernbach in 1947: "Advertising is fundamentally persuasion and persuasion happens to be not a science, but an art."[6] Their often inspired artistry, along with often brilliant copywriting, led to campaigns such as those featuring Avis's pride in being second place, Volkswagen's small thinking and lemons (fig. 18), the ecumenical "You don't have to be Jewish to love Levy's" rye bread, and a solitary martini filled with Cold War Russian vodka. And, of course, there were the now classic ad campaigns by David Ogilvy, such as those featuring Commander Whitehead arriving with his quinine water (fig. 19) and Baron Wrangell sporting a Hathaway shirt and black eye patch (plate 87).

This Volkswagen missed the boat.
The chrome strip on the glove compartment is blemished and must be replaced. Chances are you wouldn't have noticed it;. Inspector Kurt Kroner did.
There are 3,389 men at our Wolfsburg factory with only one job: to inspect Volkswagens at each stage of production. (3000 Volkswagens are produced daily; there are more inspectors than cars.)
Every shock absorber is tested (spot checking won't do), every windshield is scanned. VWs have been rejected for surface scratches barely visible to the eye.
Final inspection is really something! VW inspectors run each car off the line onto the Funktionsprüfstand (car test stand), tote up 189 check points, gun ahead to the automatic brake stand, and say "no" to one VW out of fifty.
This preoccupation with detail means the VW lasts longer and requires less maintenance, by and large, than other cars. (It also means a used VW depreciates less than any other car.)
We pluck the lemons; you get the plums.

FIGURE 18. WINGATE PAINE. AD FOR VOLKSWAGEN OF AMERICA. 1959. TEARSHEET. COURTESY DDB NEEDHAM WORLDWIDE

These campaigns are memorable but in each, with its colorful copy, its puns, its witty put-downs, and its double entendres, it is the entire advertisement that is unforgettable. By and large, the photographs in these ads are not that extraordinary. They are predictable, technically competent illustrations very much in line with what the art director had envisioned. As such they fulfilled commercial photographer Walter Nurnberg's two rules for good advertising photography. "An advertising photograph," he had written in 1940, "has to translate a given idea into concrete form—clearly conveyed to the beholder, [and] . . . represent that which is to be sold in a manner calculated to enhance its appeal."[7] The degree to which the "idea" for the photographic image

had been formed in the imagination of the art director, and the degree to which the photographer was allowed to "translate" this idea, to interpret it, and to freely follow his or her own imagination, of course, determined the photographer's precise role in the joint creation of the finished image.

FIGURE 19. PAUL RADKAI. FOR SCHWEPPE'S QUININE WATER AD. C. 1958. TRANSPARENCY. IMP/GEH. GIFT OF THE ARTIST

Coming out of the thirties, Nurnberg understood that the advertising photograph could be a work of artistic expression and that its form worked together with the ad's content:

THIS IMPLIES FOUR IMPORTANT CONSIDERA-TIONS: FIRSTLY THAT EMOTIONAL EXPERIENCE MUST NOT BE CONFUSED WITH ROMANTIC PER-CEPTION. THIS IS SOMETIMES DONE BECAUSE ROMANTICISM MAKES EMOTIONAL EXPERIENCE EASIER FOR THE AVERAGE AUDIENCE TO DIS-COVER. . . . SECONDLY THAT "EXPRESSION" MUST NOT BE CONFUSED WITH "EXPLANATION." TO EXPLAIN IS TO DEFINE. TO EXPRESS IS TO MAKE PERCEPTIBLE INDIVIDUAL EXPERIENCES. THIS MEANS THAT THE PHOTOGRAPHER – IF HE IS AN ARTIST – MUST BECOME CONSCIOUS OF A VERY LATENT DETAIL OF THAT WHICH HE WISHES TO CONVEY, AND "EXPRESS" IT TO HIS BEHOLDERS, SO THAT THEY FEEL AND UNDERSTAND IT IN THE SAME WAY. THIRDLY THAT THE REACTION OF THE PUBLIC TO A WORK OF ART-PROPER IS INCALCUL-ABLE AND NOT A PRECONSIDERED INCIDENT. FOURTHLY THAT, IN A WORK OF ART, CONTENT AND FORM ARE EVOLVED AS ONE SINGLE UNIT, INSEPARABLY LINKED TOGETHER; FORM BEING AN INTRINSIC PART OF THE ARTISTIC EXPRESSION.[8]

Contrast this attitude with the first commandment of Ogilvy, Benson & Mather in 1963. "What really decides consumers to buy or not to buy," wrote David Ogilvy, "is the *content* of your advertising, not its form. Your most important job is to decide what you are going to say about your product, what benefit you are going to promise."[9] In the new era of mega-agencies advertising was defined as a form of literary invention and the image took second place to words. For Ogilvy, photographs merely illustrated the copy: "The headline is the most important element in most advertisements. It is the telegram which decides the reader whether to read the copy."[10] If Ogilvy felt the photographs that Doyle Dane Bernbach used for Volkswagen were "in a class by themselves" and showed the agency's "unique genius in illustrating advertisements," it was most likely because they competed so little with the linguistic message. After all, DDB had already fashioned the ultimate minimalist photographic advertisement in 1961, presenting a blank page with the headline: "No point showing the '62 Volkswagen. It still looks the same."

EDITORIAL STYLE

Not every art director was as cool to photography. Among a younger generation, Onofrio Paccione, Bert Stern, and Henry Wolf began their careers doing both photography and art direction or would eventually combine the two roles. Not only were they convinced of the image's inordinate power to attract viewers, but they also trusted that, given a superlative photographic illustration, a successful advertisement might include a bare

minimum of copy, thereby anticipating today's wordless ads. In an article written in 1961, Paccione admitted a debt to prewar advertising photography and its similarity to what is commonly called "editorial" photography:

ADVERTISERS IN THE THIRTIES AND FORTIES ACCEPTED PHOTOGRAPHY AS A MEDIUM, AND A DESIRE TO BE DIFFERENT AROSE. TO CREATE AN "IDENTITY" DIFFERING FROM THEIR COMPETITORS, ART DIRECTORS PICKED UP ON THE "EDITORIAL LOOK." THEY MIMICKED THE INVENTIONS OF THE EDITORIAL PHOTOGRAPHERS AND FOUND THAT READERS NOT ONLY ACCEPTED THESE PHOTOGRAPHIC INNOVATIONS, BUT BOUGHT AS WELL. SO THE LEVEL OF ADVERTISING WAS RAISED, AND CREATIVE PHOTOGRAPHY PROVED TO BE ENTERTAINING, INFORMATIVE AND COMPELLING.[11]

Editorial photography is customarily distinguished from advertising work. The editorial photographer is asked to create a specific image illustrating an essay or even a piece of fiction, as in the fashion pages of *Vogue* or for a short story in *Playboy*. Any text is either subordinate to the image or separate from the illustration. Furthermore, the editorial photographer is chosen for his or her personal style and interpretation with usually little, if any, direction from an art director. The traditional advertising photographer, on the other hand, is much more restricted. It is not uncommon for an art director to "assist" at a session in the photographer's studio and literally direct the shooting. The advertising photographer also has to work within a certain prestructured idea for the final layout, accommodating the image to the placement of the copy, the art director's conception of the picture, and the client's notions of taste and corporate image.

Ways in which the various styles of editorial photography could be used for advertising were suggested by a number of exceptional photographers of the thirties, such as Outerbridge (fig. 20) and Steichen, and continued

into the fifties by artists like Lejaren à Hiller and Ralph Bartholomew. Hiller's Wheaties advertisement (made with Eugene Hutchinson) of the late 1940s or early 1950s (plate 66), for example, could as easily be an editorial illustration for a short story about an accident-prone sign painter. Bartholomew, perhaps one of the most innovative of these photographers, was well known for tableaux of active lifestyles, as in his shot of teenagers jitterbugging, made for a deodorant advertisement (plate 78). In a memorable image promoting the Eastman Kodak Ciné camera during the fifties, Bartholomew depicted a diner interior in a staged scene that might have come right out of a grade B detective movie (plate 77). Instead of a simple product shot that might have been lost among others featured in a magazine, he created a totally unexpected and arresting pictorial fiction.

Crossovers from editorial imagery are found throughout printed advertising of the period. In part, this may have come about by a strategy on the part of advertisers to confuse the issue so that the ads would be equated with the editorial substance of the periodical. Ruth Bernhard's surreal close-up of a mask, lipstick, and compact (plate 73) or Ruzzie Green's photograph of an elegantly attired woman entering an equally elegant room (plate 70) are the same kind of photographs found in the editorial pages of women's fashion publications. And Paul Radkai's photograph of a suave Baron Wrangell seated in a dentist's chair (plate 87) is one of the great men's fashion images of the century. Representations of food, as in Luther Hoffman's classic kitchen still life for Pream (plate 84) or Nickolas Muray's wonderfully lurid view of Dole fruit cocktail (plate 81), were indistinguishable from the recipe pages of, say, *Ladies' Home Journal* or *McCalls*. Leslie Gill's distinctive still lifes (plate 75) evolved from editorial assignments for *Harper's Bazaar* and *Flair*, but frequently found their way into advertising, influencing an entire generation of photographers, including, among others, Henry Wolf and Irving Penn.

A DRY MARTINI

The most influential instance of a break with traditional advertising photography was a campaign begun in 1953 by the L. C. Gumbiner agency for Smirnoff vodka. The problem was complex: how to market a Russian vodka to an American public in the Cold War era. According to one source it was an agency manager who asked: " 'Why does an ad have to look like an ad?' The solution was to give the 'ad' something of the excitement that had always been reserved for a magazine's editorial pages."[12] Art director Hershel Bramson, along with the photographer Bert Stern, developed a series of layouts designed to depict the idea "Driest of the Dry." The first ad was photographed in New Mexico and showed a tuxedoed man holding a drink while sitting in a chair in the middle of a desert. Subsequent images continued in a similar vein (fig. 21). In 1955 Stern convinced the agency that a shot had to be made in the Egyptian desert near the pyramids at Gizeh: ". . . people will remember the ad if they hear I went all the way to Egypt for it. On top of that, I think they have an instinct that tells them when something is fake."[13] Stern's image of a single martini with a twist (plate 86), placed in the sand in front of a looming pyramid whose top is optically inverted within the martini itself, stands as one of the great advertising photographs of all time, showing us, as Stern said, "something in a way not seen before."[14] Surprise, novelty, and exoticism are combined here with an invention that is totally photographic and honest.

FIGURE 20. PAUL OUTERBRIDGE, JR. THE COFFEE DRINKERS [FOR 8 O'CLOCK COFFEE]. C. 1938. COLOR CARBRO PRINT. THE METROPOLITAN MUSEUM OF ART, NEW YORK. THE FORD MOTOR COMPANY COLLECTION. GIFT OF FORD MOTOR COMPANY AND JOHN C. WADDELL, 1987

LIFE-STYLES AND ICONS

To attract the purchasing power of the growing and increasingly affluent postwar consumer market, advertising turned more and more toward depicting what have been called "life-style" ads. In these ads, average people engage in a variety of leisure or everyday activities that feature the product being promoted, the idea being to somehow associate this product with a carefully depicted style of social behavior. Life-style presentations had been used in earlier advertising, but never with such an insistent focus on middle-class activities. Instead of portraying a fashionably attired audience examining a Dodge in a showroom as Nickolas Muray had in 1933, the

Greb Studio pictured happy vacationers along the Intracoastal Waterway in Fort Lauderdale conversing with the driver of a Ford convertible (plate 68). The upper-middle-class passengers in Robert Bagby's picture for Grace Cruise Lines are clearly enjoying a happy moment on their holiday (plate 71). Bartholomew's jitterbugging teens are directly out of a typical suburb, and the fellow having his car serviced by a "man from Texaco" (plate 90) is a very ordinary businessman. Life-style ads have continued in their popularity, reaching a kind of apogee in mid-1980s "real-life" print ads (and television commercials) for everything from blue jeans and sports equipment (plate 130) to automobiles and coffee.

Coexisting with life-style ads, though radically different from them, are what might be called "iconic" advertisements, even if they, too, sometimes feature ordinary social "types." Like religious figures pictured in an altarpiece, these images embody certain recognized characteristics or qualities. In most instances, iconic ads show a single figure or small group wearing, holding, looking at, or otherwise involved with a product in a presentational sense. The fundamental aspect of such ads is the fact that they are overwhelmingly pictorial. One recent study defined this kind of advertisement:

WE USE IT TO REFER TO PICTORIAL REPRESENTATIONS OF THOSE SECULAR VALUES THAT HAVE A SPECIAL PLACE OR HIGH STATUS IN OUR CULTURE ("MOTHER" AND "FATHER" IN OLDER TIMES, "BEING MODERN" AND "BEING SOPHISTICATED" TODAY). THUS THE ICONIC MODE OF COMMUNICATION REFERS TO ADS WHEREIN THE PICTORIAL OR VISUAL ELEMENT IS CLEARLY PREDOMINANT IN THE MESSAGE AS A WHOLE, INCORPORATING ONLY A FEW WORDS OF WRITTEN OR SPOKEN TEXT IN ASSOCIATION WITH DRAMATIC VISUAL IMAGERY. BY ITS VERY NATURE, VERBAL IMAGERY IS DISCURSIVE WHILE VISUAL IMAGERY IS NON-DISCURSIVE. IMPLICIT IN THE FORMER IS AN ARGUMENT OR A CASE FOR THE ASSOCIATION OF THE IMAGE WITH WHAT IT REFERS TO, SO THAT ONE COULD, IF ASKED, SPELL OUT THE RELATIONSHIP IN A MORE EXTENSIVE WRITTEN TEXT. IN VISUAL IMAGERY THERE IS OFTEN AN ABRUPT "IMAGINATIVE LEAP" AND A FREER PLAY OF ASSOCIATIONS THAT IS DIFFICULT TO PUT INTO WORDS.[15]

The iconic advertising photograph did not suddenly appear in the 1950s; it had been with advertising from the start. The Kawaguchi Photo Studios ad promoting port wine in Japan in 1922 was perfectly iconic. So was Grete Stern's photograph showing a mannequin holding a bottle of Pétrole Hahn (plate 29), and François Kollar's amusing shot of a young woman holding giant boxes of macaroni. But in the postwar era two factors distinguish this mode. The first is a greater use of males. Whereas earlier ads pictured a pretty girl almost exclusively, advertisers began to be equally interested in the handsome man. This, added to the repeated use of the same individual over a lengthy campaign, tended to create types whose image not only became identified with a specific product but also imparted a social status to that product and its users. The most famous of these male stereotypes were, of course, the debonair Commander Whitehead and the unflappable Hathaway man. To these must be added one of the most longlasting symbols of American male virility and independence, the tattooed "Marlboro Man" (plate 95) — developed by adman David Lyon in the mid-fifties,[16] promoted by the Leo

Burnett agency since then, and photographed by many over the past quarter century.

The second distinguishing feature of iconic advertising photography at that time was a formal motif taken from advanced fashion photographs of the late forties, a device that emphasized the figures' removal from real-life concerns—the lack of a background. Up to that time, except in photographic posters, advertising figures were usually pictured in a context—an interior or landscape—that helped establish their identity or create product associations. Now, they were placed before blank backgrounds of pure white or vividly colored light. Like votive figures, as it were, proffering their secular goods, engaging our attention, and urging us to consume, they were seen (not unlike medieval icons with gilded fields) in a seamless empyrean. The girl holding a Coca-Cola soft drink is perhaps best recalled (plate 76), but there are others, from rosy-cheeked children with orange juice to dirty-faced young boys with peanut-butter sandwiches (plates 67, 82). The progeny of ads like Edward P. Fitzgerald's image of a model clothed in brilliant red synthetic fibers (plate 72) include such noteworthy later icons as Richard Avedon's photograph of Brooke Shields in Calvin Klein jeans and Hiro's rendition of Isabella Rossellini wearing Hanae Mori fashions (plate 115).

OLD FORMS, NEW FORMS

During this period older forms of experimental imagery maintained a consistent, albeit less popular, usage in advertising. Earl Roper's heavily airbrushed photomontage of aluminum machine screws and modern technologies (plate 79) is right out of a thirties vision of utopian progress. Muray's photomontage of a woman's hand being X-rayed projected a space-age look in order to illustrate

OUT OF THE BLUE CAME A NEW KIND OF THIRST-QUENCHER
A drink glacier-blue and glacier-cold. A drink with the bittersweet taste of quinine water and the subtle uplift of Smirnoff Vodka! It's quick and easy to make . . . and even easier to take. There's nothing more thirst-quenching, no drink more satisfying than a Smirnoff vodka and tonic. Make it like gin and tonic, but use Smirnoff Vodka instead of gin. *Smirnoff*, we said.

the vodka of vodkas

Smirnoff
THE GREATEST NAME IN **VODKA**

80 AND 100 PROOF. DISTILLED FROM GRAIN. STE. PIERRE SMIRNOFF FLS. (DIVISION OF HEUBLEIN), HARTFORD, CONN., U.S.A., FRANCE, ENGLAND, MEXICO.

the latest instrumentation in radiography (plate 88). Sol Mednick's photogram of birds, butterflies, pussy willows, and leaves (plate 74) is formally derived from early twenties cameraless imagery by Man Ray and Moholy-Nagy. Its imagery—advertising Carrier home air conditioning—is, however, completely naturalistic, implying fresh air and a natural environment, and associating a bird's nest with home.

Beginning in the late forties, Louis Walton Sipley promoted a primitive but fascinating form of three-dimensional photography called VitaVision for commercial display purposes and department-store portraiture. A full-sized transparency was twice exposed through a thin lenticular screen placed

FIGURE 21. BERT STERN. AD FOR SMIRNOFF VODKA. C. 1954. TEARSHEET. COURTESY THE ARTIST

in front of a lens containing two apertures spaced at the pupillary distance of human eyes. Between exposures, the camera or the model was moved so that the second shot would record a different perspective. The finished transparency (or opaque print) was viewed through a similar lenticular screen, resulting in a fair semblance of depth (plate 69). VitaVision and other similar processes, such as Akravue and Trivision, had limited success; it was impossible to retouch images produced by these means, nor were they able to be reproduced in

FIGURE 22. ELIZABETH CONNORS AND WILLIAM J. MOLTENI, JR. PACKAGE ILLUSTRATION FOR POLAROID ONYX CAMERA. 1987. WHITE-LIGHT "MIRAGE" HOLOGRAM. COURTESY POLAROID CORP.

print. In essence, however, VitaVision was an outgrowth of Frederic E. Ives's early-twentieth-century Parallax Stereogram and Ernest Draper's Depth-O-Graphs of the thirties (plate 47); and they all anticipated the similar use of a holographic image on recent Polaroid camera packaging (fig. 22).[17]

Probably the most important technical achievement in advertising photography during the period was the introduction of stroboscopic lighting, a technique taken for granted today. First introduced by Harold Edgerton in 1931, the use of strobe for stopping action began to appear in commercial photography by the late thirties and early forties. New York photographer Gjon Mili photographed his cat Blackie with strobe for an Army Commando manual in 1943.[18] Other photographers certainly utilized this technique prior to 1953, but none produced images that have remained as memorable as Irving Penn's Jell-O ads of that era (fig. 23). For the first time the ordinary acts of pouring milk or spooning viscous pudding were frozen by preternatural lighting and treated to the "quiet perfection"[19] that has characterized all of Penn's work to date. His "bright, full toned transparencies"[20] of this humble subject were done with strobe simply to better "document" the packaged pudding

mix; but other photographers quickly adopted stroboscopic lighting to depict time-lapse action, as in Bartholomew's Texaco ad, or for visually communicating a range of color choices available in a product, as in Sid Avery's *Adams Briefs* of about 1959 (plate 91).

AMERICAN ADVERTISING

For two decades following the Second World War, American cultural styles dominated the world of advertising. Monies spent by both consumers and agencies were phenomenal. The critic Thomas Hine has best summarized this moment in our past as

ONE OF HISTORY'S GREAT SHOPPING SPREES, AS MANY AMERICANS WENT ON A BAROQUE BENDER AND ADORNED THEIR MASS-PRODUCED HOUSES, FURNITURE AND MACHINES WITH ACCOUTREMENTS OF THE SPACE AGE AND OF THE AMERICAN FRONTIER. . . . WHAT THEY BOUGHT WAS RARELY FINE, BUT IT WAS OFTEN FUN. . . . PRODUCTS WERE AVAILABLE IN A LURID RAINBOW OF COLORS AND A STEADILY CHANGING ARRAY OF STYLES. COMMONPLACE OBJECTS TOOK EXTRAORDINARY FORM, AND THE NOVEL AND EXOTIC QUICKLY TURNED COMMONPLACE.[21]

It was a period of mass homogenizing and the triumph of white middle classes whose material acquisitions validated their sudden prosperity and faith in the future. It was also a period of mass-marketed tastes, which were "often at odds with what was considered to be good taste, or educated tastes."[22] Perhaps in this there is a clue to the fact that while there were

OF COURSE, THERE'S A **DIFFERENCE** IN CHOCOLATE PUDDINGS!

1. That's why more children eat Jell-O Puddings than any other!
2. Jell-O Pudding treats are so simple* to make!
3. They're double-feature wonders—make glorious puddings or pies that dads love . . . and for mere pennies, too!

Simple for Summer!
Your grocer has many Simple for Summer specials now! Look for them!

JELL-O IS A REGISTERED TRADE-MARK OF GENERAL FOODS CORPORATION

JELL-O PUDDING and PIE FILLING

FIVE FLAVORS

Vanilla
Chocolate
Butterscotch
Lemon
Coconut Cream

PHOTO BY PENN

many exceptionally talented photographers at the time, most of the photography done for advertising was visually unsophisticated. Without disparaging the art directors of the period, nor the great graphic designers like Paul Rand, Serge Chermayeff, and Saul Bass, when it came to photographic illustration, most advertisers failed to heed Walter Nurnberg's earlier caution against confusing uninspired explanation with inspired expression.

FIGURE 23. IRVING PENN. AD FOR JELL-O PUDDING. C. 1953. TEARSHEET. COURTESY THE ARTIST

1. David Ogilvy, *Confessions of an Advertising Man* (New York, [1963] 1980), pp. 115–16.

2. See Ralph M. Hower, *The History of an Advertising Agency* (Cambridge, 1939), passim.

3. Cf. William Leiss, Stephen Kline, and Sut Jhally, *Social Communication in Advertising: Persons, Products, and Images of Well-Being* (London, 1986), pp. 104–8.

4. Cited in Larry Dubrow, *When Advertising Tried Harder* (New York, 1984), p. 40.

5. From figures prepared for *Advertising Age* by Robert J. Coen of McCann-Erickson, Inc., cited in Michael Schudson, *Advertising, The Uneasy Persuasion* (New York, 1984), p. 67.

6. Cited in Larry Dubrow, *When Advertising Tried Harder*, p. 20.

7. Walter Nurnberg, *The Science and Technique of Advertising Photography* (London and New York, 1940), p. 18.

8. Ibid., p. 19.

9. David Ogilvy, *Confessions*, p. 93.

10. Ibid., p. 104.

11. Onofrio Paccione, "Advertising Photography," in Arthur Hawkins and Edward Gottschall, eds., *Advertising Directions Two: Trends in Visual Advertising* (New York, 1961), p. 30.

12. "Advertising and Fashion Photography: A Short Survey," *The British Journal of Photography* 128, no. 6295 (20 March 1981): 313.

13. Bert Stern, in Jim Cornfield, *The Photo Illustration: Bert Stern* (Los Angeles, 1974), p. 26.

14. Ibid., p. 28.

15. William Leiss, Stephen Kline, and Sut Jhally, *Social Communication*, p. 239.

16. See Karen Singer, "Ex-Adman Has Untargeted Audience—in the Bag," *Adweek* 27, no. 18 (14 April 1986): 54.

17. For further details on the earlier techniques, see Louis Walton Sipley, *A Half Century of Color* (New York, 1951), pp. 193–205.

18. Cf. Sean Callahan, "Photography as Theology," *American Photographer* 4, no. 5 (November 1980): 43.

19. John Szarkowski, *Irving Penn* (New York, 1984), p. 31.

20. Williard Clark, "A Look at Irving Penn," *Camera 35* 2, no. 2 (1958): 125.

21. Thomas Hine, *Populuxe* (New York, 1986), p. 3.

22. Ibid., p. 6.

PLATE 66. EUGENE HUTCHINSON AND LEJAREN À
HILLER. <u>WHEATIES</u>. LATE 1940S, EARLY 1950S. FOR
GENERAL MILLS, INC. DYE-TRANSFER PRINT,
48.5×33.9 CM. IMP/GEH. GIFT OF 3M CO.
EX-COLLECTION LOUIS WALTON SIPLEY

PLATE 67. HERBERT LYMAN EMERSON. FOR
SUNKIST, INC. [ORANGE JUICE]. C. 1950. COLOR
CARBRO PRINT WITH PAINT AND VARNISH,
34.8×26.1 CM. SAN FRANCISCO MUSEUM OF
MODERN ART. GIFT OF ELIZABETH EMERSON

PLATE 68. GEORGE GREB STUDIOS. <u>FORD</u>. 1952.
FOR FORD MOTOR CO. VINTAGE TRANSPARENCY,
[8 × 10"]. IMP/GEH. MUSEUM COLLECTION

PLATE 69. ATTRIBUTED TO LOUIS WALTON SIPLEY.
<u>CHEVROLET</u>. 1948. FOR GENERAL MOTORS CORP.,
CHEVROLET MOTOR CAR DIVISION. VITAVISION
LENTICULAR COLOR TRANSPARENCY, 35.7 × 28.2 CM.
IMP/GEH. GIFT OF 3M CO. EX-COLLECTION LOUIS
WALTON SIPLEY

PLATE 70. RUZZIE GREEN. FOR PERSONAL
PRODUCTS CORP. [MODESS]. 1950S. YOUNG &
RUBICAM, INC. VINTAGE TRANSPARENCY, [8 × 10"].
COLLECTION KEITH DE LELLIS

PLATE 71. ROBERT BAGBY. FOR GRACE CRUISE
LINES. LATE 1940S, EARLY 1950S. DYE-TRANSFER
PRINT, 32.2×41.5 CM. COLLECTION PHILIP L.
CONDAX

PLATE 72. EDWARD P. FITZGERALD. <u>CHROMSPUN</u>
[VARIANT]. 1952. FOR TENNESSEE EASTMAN CO.
[SYNTHETIC FIBER]. DYE-TRANSFER PRINT,
46.8×33.6 CM. IMP/GEH. GIFT OF
TENNESSEE EASTMAN CO.

PLATE 73. RUTH BERNHARD. <u>BULLOCKS, LOS
ANGELES</u>. 1950. FOR BULLOCKS-WILSHIRE
DEPARTMENT STORE. GELATIN SILVER PRINT,
25.1 × 19.4 CM. PAUL M. HERTZMANN, INC.

PLATE 74. SOL MEDNICK. FOR CARRIER AIR
CONDITIONING. 1948. N. W. AYER, INC.; ART
DIRECTOR MILTON WEINER. GELATIN SILVER PRINT,
41 × 33.9 CM. COURTESY SEYMOUR MEDNICK

PLATE 75. LESLIE GILL. FOR EASTMAN KODAK CO.
1949/50. DYE-TRANSFER PRINT, 38.7×31 CM.
IMP/GEH. MUSEUM COLLECTION

PLATE 76. UNDERWOOD & UNDERWOOD
COMMERCIAL. FOR PAPER CONTAINER
MANUFACTURER [?]. 1950S. VINTAGE COLOR
CARBRO TRANSPARENCY, 51.4×36.6 CM.
COLLECTION WALTER STORCK

PLATE 77. RALPH BARTHOLOMEW. <u>KODAK CINÉ
CAMERA</u>. 1954. J. WALTER THOMPSON CO. FOR
EASTMAN KODAK CO. GELATIN SILVER PRINT,
18.7 × 49.5 CM. COLLECTION KEITH DE LELLIS

PLATE 78. RALPH BARTHOLOMEW. <u>FRESH</u>. 1945.
FOR FRESH DEODORANT. GELATIN SILVER PRINT,
34 × 36 CM. COLLECTION KEITH DE LELLIS

PLATE 79. EARL C. ROPER. <u>ALUMINUM</u>. C. 1950.
FOR UNKNOWN CLIENT. GELATIN SILVER PRINT,
40.6 × 32.9 CM. IMP/GEH. MUSEUM COLLECTION

PLATE 80. ANONYMOUS. FOR GENERAL ELECTRIC
CO. [?]. 1950S. DYE-TRANSFER PRINT, PRINTED BY
LOUIS M. CONDAX; 40×32.5 CM. IMP/GEH.
GIFT OF PHILIP L. CONDAX

PLATE 81. NICKOLAS MURAY. <u>FRUIT COCKTAIL</u>.
1957. FOR DOLE. COLOR CARBRO PRINT,
27.8×35.3 CM. IMP/GEH. GIFT OF MICHAEL
BROOKE MURAY, NICKOLAS CHRISTOPHER MURAY,
AND GUSTAV SCHWAB

PLATE 82. TOM KELLEY. FOR UNKNOWN CLIENT.
C. 1955. COLOR CARBRO PRINT, 33.5×41 CM.
COURTESY TOM KELLEY STUDIOS

PLATE 83. PAUL HESSE. <u>SOPHIA LOREN</u>. 1950S. FOR
TWA AIRLINES. VINTAGE TRANSPARENCY, [8 × 10"].
COURTESY HOLLYWOOD PHOTOGRAPHERS
ARCHIVES

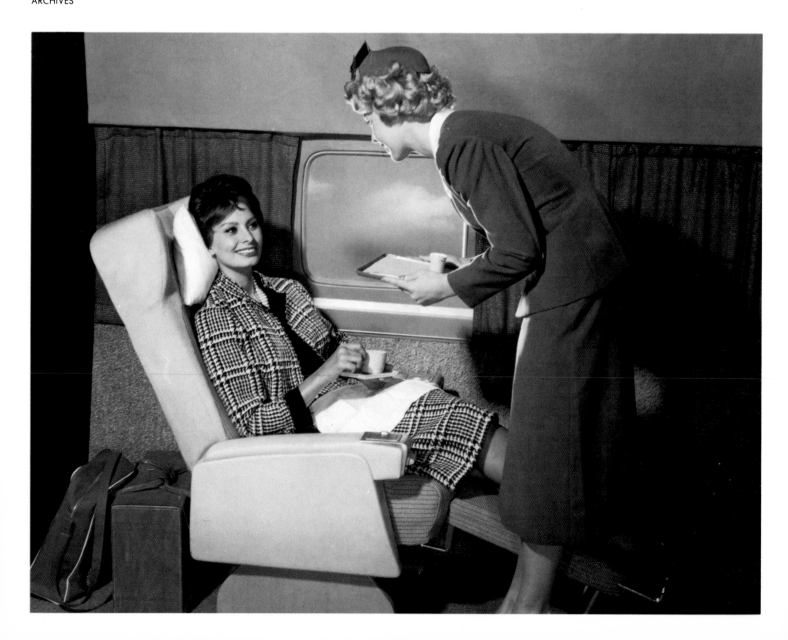

PLATE 84. M. LUTHER HOFFMANN. <u>PREAM.</u>
C. 1950. W. H. HOEDT STUDIOS FOR ABBOTTS
LABORATORIES; ART DIRECTOR SARAH WATTS.
DYE-TRANSFER PRINT, 43×34.8 CM. IMP/GEH. GIFT
OF 3M CO. EX-COLLECTION LOUIS WALTON SIPLEY

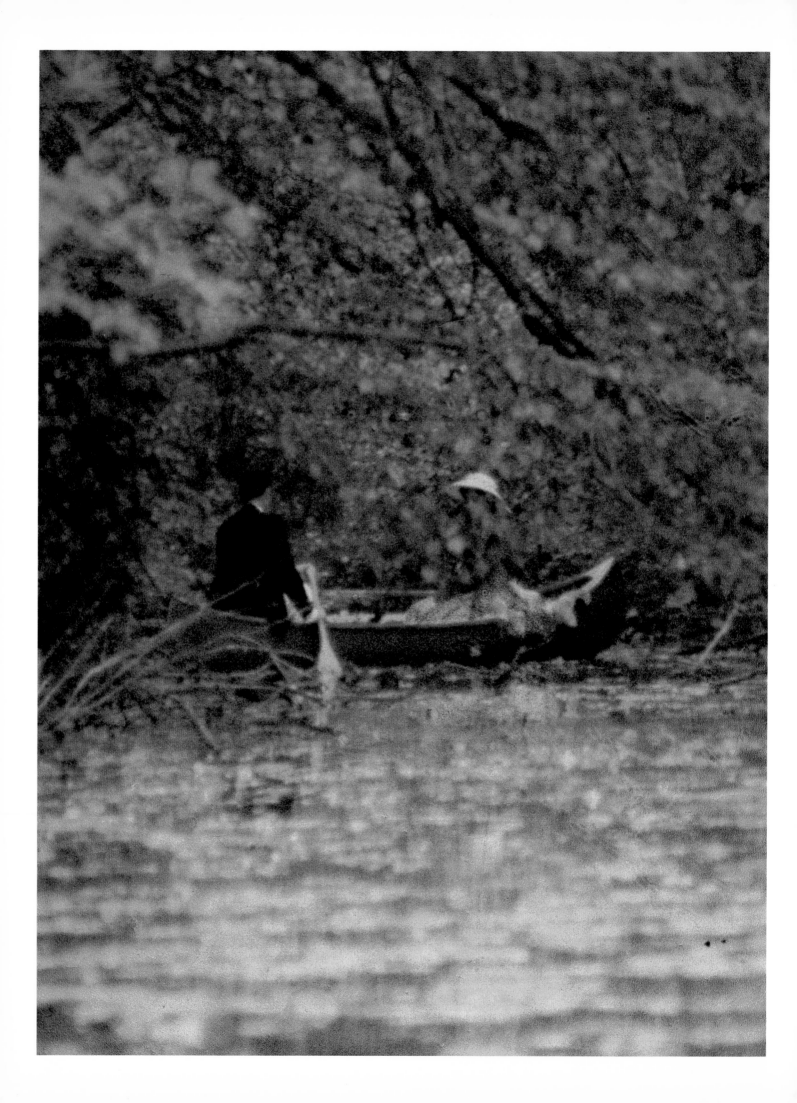

PLATE 85. IRVING PENN. <u>TWO IN A CANOE</u>. 1954.
N. W. AYER, INC. FOR DEBEERS CONSOLIDATED
MINES, LTD. [DIAMONDS]; ART DIRECTOR PAUL
DARROW. TYPE-C PRINT, 48.8×39.4 CM.
COURTESY THE ARTIST

PLATE 86. BERT STERN. <u>MARTINI AND PYRAMID</u>.
1955. FOR SMIRNOFF VODKA. L. C. GUMBINER;
ART DIRECTOR HERSHEL BRAMSON. DYE-TRANSFER
PRINT, 39.8×40 CM. COURTESY THE ARTIST

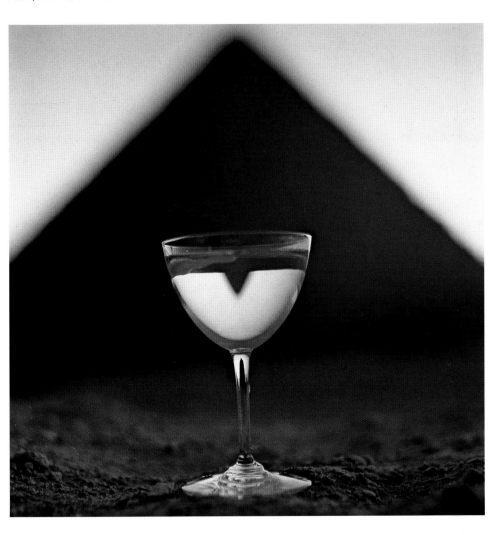

PLATE 88. NICKOLAS MURAY. X-RAY HAND. 1962.
FOR GENERAL ELECTRIC CO. [?]. COLOR CARBRO
PRINT, 26.6 × 28.5 CM. IMP/GEH. GIFT OF MICHAEL
BROOKE MURAY, NICKOLAS CHRISTOPHER MURAY,
AND GUSTAV SCHWAB

PLATE 87. PAUL RADKAI. FOR HATHAWAY SHIRTS
[VARIANT]. 1958. OGILVY, BENSON & MATHER.
VINTAGE TRANSPARENCY, [8 × 10"]. IMP/GEH. GIFT
OF THE ARTIST

PLATE 89. SID AVERY. FOR UNITED STATES STEEL
CORP. [VARIANT]. 1965. BATTEN, BARTON,
DURSTINE & OSBORN, INC.; ART DIRECTOR RON
LAYPORT. TYPE-C PRINT, 48.2×39.2 CM.
COURTESY THE ARTIST

PLATE 91. SID AVERY. <u>ADAMS BRIEFS</u>. C. 1958–60.
FOR MUNSINGWARE [?]. DYE-TRANSFER PRINT,
32 × 49.8 CM. COURTESY THE ARTIST

PLATE 90. RALPH BARTHOLOMEW. FOR TEXACO,
INC. 1957. COLOR CARBRO PRINT, 32.8 × 49.7 CM.
IMP/GEH. MUSEUM COLLECTION

"The fifties were an exciting time for advertising in the States," wrote Bob Brooks, art director at Doyle Dane Bernbach, in 1969. "The sixties are proving to be the same for the advertising world of Europe. Advertising pages of the major European magazines have shown a tremendous change in the past four or five years . . . and, make no mistake, their advertising is almost entirely photographic. Europe with its long tradition of graphic illustration and design has moved very slowly and grudgingly towards photography, but now, finally, the new medium has come into its own."[2] Two years later the photographer and picture editor Allan Porter would include Japan in discussing the expansion of modern advertising photography beyond American shores.[3] Since then the internationalism of advertising photography has become complete. In fact, for the past two decades, it has not been unusual for photographers to travel to foreign countries on assignment for clients in yet other lands. As corporations have become multinational, so have the photographers who work for them. Recently, for example, Serge Lutens, a French photographer working in Paris, developed and executed a number of photographic campaigns for a Tokyo-based cosmetics firm, Shiseido Company, and these ads appear in the latest issues of American magazines like *Vogue* (plate 149).

ROMANCE, COOLNESS, AND LITERACY 1966-86

. . . IN EFFECT, LIKE THE DREAM IN FREUD'S DESCRIPTION, PHOTOGRAPHIC IMAGERY IS TYPICALLY LACONIC—AN EFFECT REFINED AND EXPLOITED IN ADVERTISING.

—VICTOR BURGIN, 1982[1]

This is not to suggest that there are no longer regional or national differences; there certainly are. Cigarette advertising in Great Britain or Norway, for instance, is directed by far different standards and regulations than in the United States or France. While American ads still depict cowboys, arm-wrestling adventurers, or loving couples with their cigarettes, governmental restrictions in other countries forbid any pictorial associations with cigarettes implying virility or potential sexuality.[4] What is suggested, however, is that a near global exchange of photographic styles, techniques, and personalities has taken place during the last twenty years that far exceeds the exchanges made between Europe and America in the mid-thirties.

The advent of this new internationalism was first identified in the annual publication *Photographis* in 1966. Published by Walter Herdeg in Zurich for twenty years (it now continues under another publisher), it came into being because its parent publication, *Graphis Annual*, which encompassed all commercial graphic arts, lacked adequate space to survey the sheer quantity of world advertising photography. Earlier annuals, such as *Publicité* in Paris and the *Annual of Advertising Art* in New York, had been devoted to the advertising arts, but, as in *Graphis Annual*, photography had been given only a cursory review. Similarly, there were earlier attempts to publish a purely photographic international annual, but photographs made for advertising were nearly lost amid other examples of progressive photography. *Photographis* was unique, and has maintained its standing as one of the finest sources of advertising camera art for nearly two generations, serving as a model for other annuals, indexes, and trade directories, from *Advertising Photography in Japan* to *The Creative Black Book*.

In *Photographis* Herdeg differentiated between important advertising photographs and those of lesser merit. "The works reproduced," he wrote, "are chosen for their exceptional photographic qualities, for the impact they achieve by their beauty, their creative or technical originality, their documentary immediacy and above all the unity of their pictorial and textual content." Those works "in which the accent is on design, however, and the photography is straightforward or of secondary importance, will still find [their] place in *Graphis Annual*."[5] A short text, written by various editors, art directors, photographers, critics, and historians, introduced each year's selection of hundreds of color and black-and-white images. These essays, by writers such as Steve Frankfurt, L. Fritz Gruber, George Lois, R. E. Martinez, Karl Steinorth, and Henry Wolf, outline some of the more vital concerns facing modern advertising photography.

PHOTOGRAPHER-DESIGNER AND ART DIRECTORS

Probably the single greatest impact on the field over the last twenty years has been the steady evolution of a new relationship between the photographer and the art director. Indications are clear that, while not an exact parity, at least a mutual understanding of the photographer's contribution to the advertising process has begun to surface within the advertising community. Greater artistic autonomy and responsibility, recognition of artists' rights, changes in copyright laws, younger and more visually literate art directors, and the establishment of professional societies have helped in elevating the photographer to a status once held only by the art director. Henry Wolf, from the position of both art director and photographer, has characterized the new tone: "I don't like the term art director because an art director is a guy who knows how to dial a telephone. Art directors who are not designers are pathetic."[6]

Beginning in the sixties artists like Onofrio Paccione and Wolf became equally comfortable—and successful—inventing an ad's "idea" at the drafting table or behind the camera (fig. 24). Wolf believed that "Designers, Art Directors, Illustrators and Photographers have a large hand in shaping our surroundings. By setting examples they give content to our dreams. They often show us how we ought to want to live; and sell us the artifacts necessary to do it."[7] At the same time that films like *Blow-Up* (1966) and novels like Peter Townend's Philip Quest series (1971–75) featured commercial photographers as popular heroes, real-life advertising photographers began to express artistic self-confidence. Since the sixties Wolf and others have promoted the personal creativity and individuality of the photographer as fundamental to great advertising. According to Wolf:

. . . FOR A PHOTOGRAPH TO BE GREAT, THE PHOTOGRAPHER HIMSELF HAS TO BE PART OF THE PICTURE. I MEAN BY THIS THAT THE MORE OF HIMSELF, HIS VIEWS, HIS PREJUDICES, HIS NOSTALGIA, HIS LOVE LIFE, HIS BACKGROUND SHOWS THROUGH, AND THE MORE THE PHOTOGRAPHER IS COMMITTED, THE MORE THE PICTURE WILL HAVE A CHANCE OF BEING UNIQUE AND BEAUTIFUL. AS ALL GOOD NOVELS, SO ALL GREAT PHOTOGRAPHS MUST BE PARTLY AUTOBIOGRAPHICAL; A PHOTOGRAPH FROM WHICH ONE GETS NO IMAGE OF THE PHOTOGRAPHER IS A FAILURE, EVEN IF IT IS A COMMERCIAL STILL-LIFE; EVEN IF THE BRIDGE BACK TO THE ARTIST IS ONLY THE QUALITY OF THE LIGHT AROUND THE GLASS OF SODA WATER HE WAS ASSIGNED TO PHOTOGRAPH.[8]

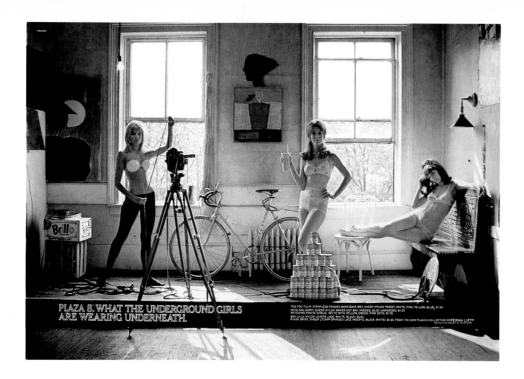

FIGURE 24. ONOFRIO PACCIONE. AD FOR
PERMA-LIFT LINGERIE. C. 1965. TEARSHEET.
COURTESY THE ARTIST

Wolf's own work—his image of a
woman's hand writing with a quill pen,
done for Carven perfumes in 1968
(plate 98), and his coolly textural
male back dressed in gray flannel
from 1980 (plate 103)—are already
modern classics of product advertis-
ing. Paccione's vision of a woman's
leg, bent at the knee and wearing a
jeweled necklace around her thigh,
done for Harry Winston in 1979, is a
timeless icon of beauty, as perfect a
study of graceful human form as was
ever made by the camera (plate 100).

While a growing number of art
directors are exceptionally open to
photography and some are even
photographers themselves, the norm is
still one in which the photographer is
apart from and subservient to the art
director. "Art directors think of us as
layouters' assistants," wrote a German
photographer in the seventies.[9] Most
of the resentment photographers feel
toward art directors stems, according
to sociologist Barbara Rosenblum,
from the photographers' relative lack
of control over what they create.[10] In
an attempt to restructure this relation-
ship on a more equal basis, the Ger-
man photographer Horst W. Staubach
and others established the Bund
Freischaffender Foto-Designer (Asso-
ciation of Freelance Photo Designers),
or the BFF, in 1969. The aims of the
BFF have been to assure commercial
designer-photographers a profes-
sional standing, to change the popular
notion that their work was mere hand-
icraft or simple technical labor, and to
pressure for legislation that would
protect the rights of these
professionals.

Dumont's *Lexikon der Fotografie*
defines "Photo-design" as "a term ap-
plied to the preparation of information
by photographic means for the pur-
poses of observation, learning and
communication. The work of the pho-
to-designer is necessarily and essen-
tially determined, quite apart from his
manual and technical skills, by his
mental and creative abilities in the
conception, planning and shaping of
the photographic picture."[11] Apart
from language sounding much like a
revolutionary design program from
the Bauhaus or a Constructivist man-
ifesto of the twenties, it is important to
note that in claiming the photogra-
pher's creative independence, there is
also a strong move toward eroding
the persistent claim by agencies and
clients that what is photographed for
them is "work-for-hire" and that all
rights to that work are theirs and not
the photographer's.

Several outstanding contemporary
photographers have got around this
rule by becoming creative directors
themselves. Richard Avedon con-
ceived, art directed, and photo-
graphed the legendary, episodic
series entitled *The Diors*, for the
clothing manufacturer, and engaged
the writer Doon Arbus to furnish the
advertisement's copy (plate 116). Like
an installment of one of Charles
Dickens's serial novels, or a weekly
broadcast of a soap opera, Avedon's
ads caused readers to look forward
to the next episode. Narrative has
never been taken to such a memor-
able extreme in advertising photogra-
phy. In similar fashion Serge Lutens is
currently "creative director" for Shi-
seido Company, and Dominique
Issermann art directs and photographs
for, among others, Maud Frizon's in-
ternational campaigns (plate 127).

In 1970 art director Steve Frankfurt
recognized the personal vision of
advertising photographers and, by ex-
tension, their share in the creation of
the ad:

"My partner, always, is the photographer," wrote art director and agency head George Lois in 1985. "The photographer, looking to fulfill *his* talent is at the mercy of the art director (in most cases an untalented one) and the client (in almost all cases unknowing)."[13]

Better art directors work with the photographer; they do not just hire him as an assistant. Their originating "idea" for the advertisement or campaign may still be the primary vehicle, but the creative input of the photographer, left to develop an image, can often change that idea in subtle and exciting ways. Few nonphotographers could have preconceived the haunting image of a woman's face in water as seen by Eric Meola (plate 101), or Reinhart Wolf's softly blurred still life for a coffee advertisement (plate 120), or the exquisite eroticism of Hiro's high-keyed vision of a Chanel lipstick with a woman's lips (plate 104). Someone had an idea, certainly, but the photographer brought it to life with often surprising results. In fact, the *idea* for the Chanel lipstick advertisement was utterly simplistic; it took the genius of the photographer to make it into an exceptional and moving photograph.

AN ERA OF ATTITUDES

The period from 1966 to 1986 was one of tremendous social, political, and economic extremes. It encompassed the Vietnam War, lunar landings, designer jeans, microchip technologies, and global terrorism. Faced with such complexities, advertising, whose prime purpose of course is still to sell products, did so "by using every artistic and expressive medium ever invented, and by playing on every hope and fear that make society responsive to its message."[14] The forms that advertising photography took during these years reflected a new approach. Corporate consultant and publicist Markus Kutter defined it in 1982 as

A MORE COMPLEX, INVOLVED APPROACH THAT DRAWS ITS FORMS AND MOODS FROM ALL SOURCES. MODERN PHOTOGRAPHY IS MORE INQUISITIVE, MORE SENSUOUS, AND TAKES SEX MORE FOR GRANTED. THE SET-UP IS NO LONGER CENTERED ON A POINT OR GAG, BUT THE AIM IS RATHER TO DEFINE AN ATTITUDE. THE TEAMWORK IS STILL THERE, BUT THE CONTRIBUTION OF EACH MEMBER, AND PARTICULARLY OF THE PHOTOGRAPHER, HAS BECOME MORE AUTONOMOUS, HIS WORK HAS GAINED IN CONTENT, IN MOOD VALUE AND IN IMPLICATIONS. APPLIED PHOTOGRAPHY IN 1982 IS MORE INDEPENDENT AND INDIVIDUAL, BUT IT IS ALSO RICHER, MORE MUSICAL, MORE SENSUOUS, AND THAT MEANS THAT IT IS ALSO LIVELIER.[15]

Innocent romantic icons remained popular, from the no-nonsense Western sheriff in a Marlboro ad to the chaste young bride in an ad for Estée Lauder's Beautiful fragrance (plate 123). So did visions of pastoral peacefulness, as in Deborah Turbeville's idyllic scene of symbolist damsels in a park, shot for Jessica McClintock (plate 122). An Ansel Adams landscape was applied to a three-pound coffee can (plate 96), and a dramatic moonlit landscape was the setting for a new French automobile (plate 118). But these were only one facet of visual advertising in print. The counterculture and avant-garde experiments of the late sixties expanded both pictorial vocabularies and alternative graphic styles. Psychedelic aesthetics were used to advertise everything from California politicians to radio stations (plate 92). In Japan advertising posters displayed a degree of photographic variety and innovation not seen since the late twenties and early thirties (plates 93, 99, 114).[16] In England the novelist J. G. Ballard purchased space on the back covers of magazines to photographically advertise his literary ideas (plate 94), much as John Heartfield had promoted his political propaganda during the early thirties. "Of course," Ballard wrote, "I was advertising my own conceptual ideas, but I wanted to do so within the formal circumstances of classic commercial advertising—I wanted ads that would look in place in *Vogue, Paris Match, Newsweek,* etc."[17]

The overwhelming tone of the seventies and early eighties, however, was one of exceptional emotional coolness and visual sophistication. This was heralded by Allan Porter in 1971, when he stated that "sensationalism is a thing of the past . . . visual perception is more astute than it has been in any other generation."[18] An instance of this change can be seen in the preliminary sketch and mechanical from the opening campaign for Estée Lauder's fragrance Beautiful. What was first styled as a rather active scene with the bridal party racing across the Brooklyn Bridge (figs. 25, 26) was ultimately dropped in favor of

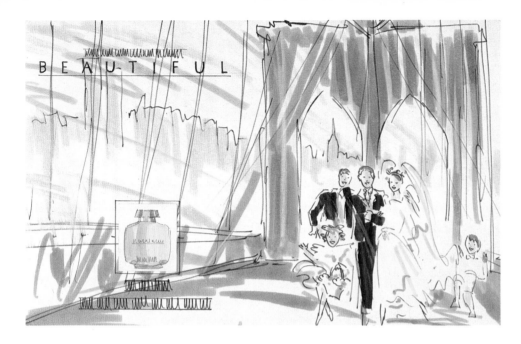

FIGURE 25. UNIDENTIFIED ARTIST. AD FOR BEAUTIFUL PERFUME [REJECTED DESIGN]. 1986. MARKER PEN DRAWING. COURTESY ESTÉE LAUDER, INC.

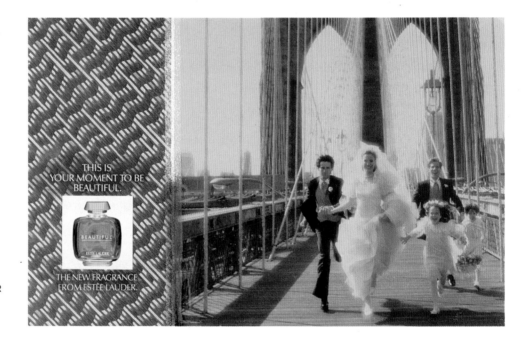

FIGURE 26. VICTOR SKREBNESKI AND UNIDENTIFIED ARTIST. AD FOR BEAUTIFUL PERFUME [REJECTED DESIGN]. 1986. GELATIN SILVER PRINT AND MECHANICAL. COURTESY ESTÉE LAUDER, INC.

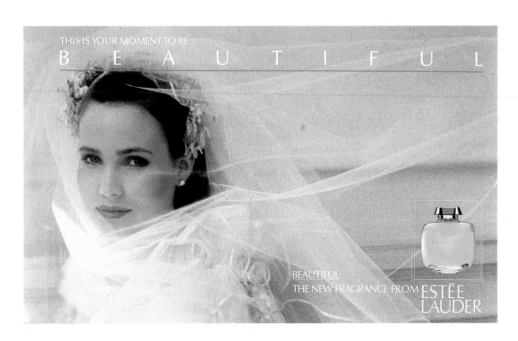

FIGURE 27. VICTOR SKREBNESKI. AD FOR BEAUTIFUL PERFUME. 1986. TEARSHEET. COURTESY ESTÉE LAUDER, INC.

a reflective close-up of the veiled model Willow Bay as the bride (plate 123, fig. 27). Initially active and complicated, the final ad is dominated by Victor Skrebneski's wistful photography. Compared to the hysterical high drama of thirties advertising photography, Avedon's series of pictorial farces for Dior come across as droll and urbane. Few fashionable couples were ever portrayed with as much detachment as Rebecca Blake's for Bollinger champagne (plate 121). The statuesque model in Marie Cosindas's print for a Helena Rubinstein ad is lost to her private thoughts (plate 97), just as Italian novelist Umberto Eco is engrossed in his private reading in a photograph made by Antonia Mulas for a chair manufacturer (plate 107). Two other images seem to summarize this element of pictorial removal: Henry Wolf's picture of a man's back and shoulder and Cosimo's portrait of a mummy. That both are predominantly gray in tonality only reinforces their chilly remoteness. Wolf's man in a gray flannel suit might well be an appropriate symbol of the corporate personality: upright, assertive, well groomed, and featureless. Cosimo's eternally exotic mummy, wearing only eye shadow and Aurea's "Cleopatra" necklace (plate 105), is a paradigm of the *noli me tangere* seductress of modern advertising.

The degree of visual sophistication that informs much of advertising photography in recent years may be measured in part by one of Kevin Summers's images for Benson & Hedges in Great Britain. Modern advertising places far more emphasis on the photographic image than ever before, and expects that image to carry most if not all of the ad's message; frequently, only the product's or manufacturer's name will appear beneath or to the side of the photograph.

MIDDLE TAR As defined by H.M. Government
DANGER: Government Health WARNING: CIGARETTES CAN SERIOUSLY DAMAGE YOUR HEALTH

Time Out

FIGURE 28. KEVIN SUMMERS. AD FOR BENSON & HEDGES SPECIAL FILTER CIGARETTES. 1986. TEARSHEET. COURTESY COLLETT, DICKENSON, PEARCE AND PARTNERS LTD., WITH PERMISSION OF GALLAHER LTD.

Working under severe governmental restrictions in England as to what can or cannot be said, portrayed, or implied in cigarette advertising, recent Benson & Hedges campaigns have reduced the message to a complicated, and nearly opaque, pictorial rebus. In the final advertisement the only real text is the government health warning, printed beneath a photographic still life (fig. 28). Summers's photograph is brilliant in the way it encodes everything the client desires. The sink-top arrangement of gold razor, plain gold package, and some shaving foam sprinkled with random bits of typography (a disarray of Benson & Hedge's logo form) is all there is to the picture. Yet, contained in the image are associations of luxury and success (the color gold), product recognition (the shape of the box and style of the letters), and more than a hint of privileged intelligence. About such ads Australian medical consultant Simon Chapman has written: "They interpellate and draw in viewers who feel they are clever or sophisticated enough to appreciate the puzzles involved. . . . Those who 'get' the ads, who are not intimidated by cultural forms that raise questions and fail to give answers, understand that they inhabit the same sophisticated, modernist world as where such images are commonplace. . . ."[19]

Without taking sides in the controversy surrounding cigarette advertising, this and other of Summers's photographs for this campaign verge on Conceptual Art, playing with and creating a new rhetoric with photography that communicates and entices without the explicitness of verbal language or literal imagery. David Wheeler, then chairman of the Institute of Practitioners in Advertising, in 1981 discussed this type of advertising photograph, and in so doing gave promise to the future: "The less you can actually say, the more you must fall back on sheer creativity. Which is why I believe that advertising will become increasingly creative over the next few years, and will tend to rely upon images of the sort most successfully conveyed by photography."[20] Photography's involvement with advertising copy over the past eight decades has become increasingly sophisticated. In the anonymous banking advertisement of 1922, the ad's hero knocks the letter "L" out of a word in the headline. In Henry Wolf's photograph done in 1968 for a Carven perfume ad, a backlighted woman's hand is seen holding a quill pen and using an open bottle of Ma Griffe perfume as an inkwell. In the finished ad the hand has written the ad's entire copy, "Ma Griffe is my signature," thereby utterly fusing the realms of text and image (fig. 29). In Summers's photograph for Benson & Hedges, the copy has all but disappeared; the photographic image carries the entire communication.

FIGURE 29. HENRY WOLF. AD FOR MA GRIFFE PERFUME. 1968. TEARSHEET. COURTESY THE ARTIST

1. Victor Burgin, "Looking at Photographs," in *Thinking Photography* (London, 1982), p. 144.

2. Bob Brooks, "Introduction," *Photographis* 4 (1969): 9.

3. Allan Porter, "Introduction," *Photographis* 6 (1971): 8.

4. E. Sue Atkinson, "Cigarette Advertising: A History," *The British Journal of Photography* 128, no. 6330 (20 November 1981): 1194–95, 1199.

5. Walter Herdeg, "A Note on This Annual," *Photographis* 1 (1966): 6.

6. Henry Wolf, *A Bold Look Backward* [Special Issue, *Idea*] (Tokyo, 1984), p. 41.

7. Ibid., p. 52.

8. Henry Wolf, "Introduction," *Photographis* 2 (1967): 9.

9. Unidentified photographer, cited in Horst W. Staubach, "Photo-Designer, a New Name for a Growing Profession," *Photographis* 14 (1979): 8.

10. Barbara Rosenblum, *Photographers at Work: A Sociology of Photographic Styles* (New York, 1978), pp. 77–80.

11. Horst W. Staubach, "Photo-Designer," p. 8.

12. Steve Frankfurt, "Introduction," *Photographis* 5 (1970): 8.

13. George Lois, "Preface," *Photographis* 20 (1985): 8.

14. Ada Louise Huxtable, "Advertising Art: Indelible Images and Cultural Commentary," *The New York Times* (1 March 1979), p. C10.

15. Markus Kutter, "Preface," *Photographis* 17 (1982): 8.

16. Ryuichi Yamashiro, "Foreword—What Happened This Year," in Art Directors Club of Tokyo, *Annual of Advertising Art in Japan* (Tokyo, 1975), unp.

17. J. G. Ballard, "Collages," *Re/Search*, nos. 8/9 (1984): 147.

18. Allan Porter, "Introduction," p. 9.

19. Simon Chapman, *Great Expectorations: Advertising and the Tobacco Industry* (London, 1986), p. 97.

20. Cited in "Advertising and Fashion Photography: A Short Survey," *The British Journal of Photography* 128, no. 6295 (20 March 1981): 313.

PLATE 92. ALTON KELLY AND RICHARD GRIFFIN.
KSAN. 1968. FOR KSAN RADIO, SAN FRANCISCO;
ART DIRECTORS ALTON KELLY AND RICHARD
GRIFFIN. PHOTOLITHOGRAPHIC POSTER,
73.2×51 CM. PRIVATE COLLECTION. REPRODUCED
WITH PERMISSION OF THE ARTISTS

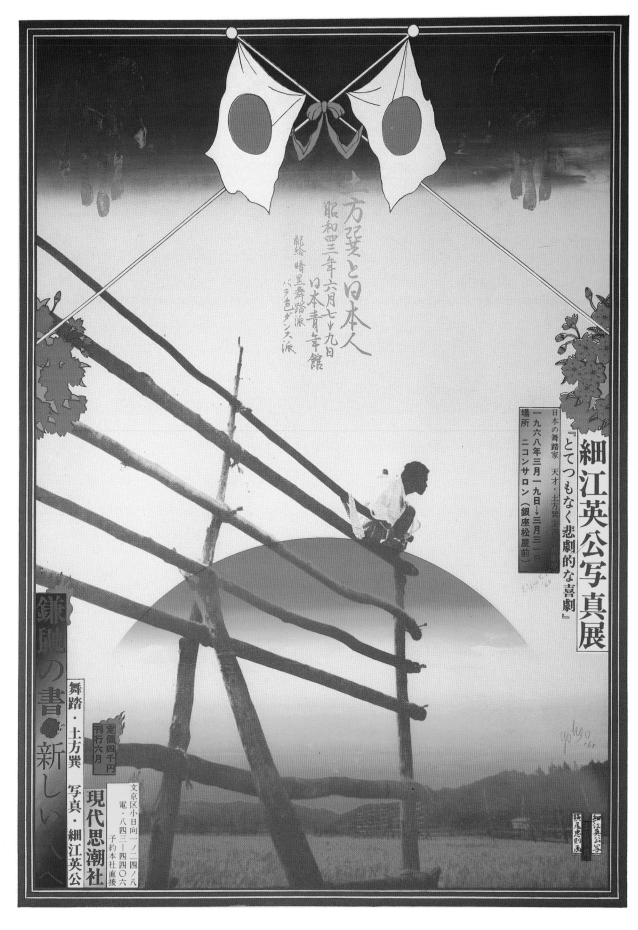

PLATE 93. EIKOH HOSOE. KAMAITACHI. 1969. FOR
TATSUMI HIJIKATA AND EIKOH HOSOE [PERFORMANCE,
EXHIBITION, AND PUBLICATION]; ART DIRECTOR
AND DESIGNER TADANORI YOKOO; PALM PRINT BY
TATSUMI HIJIKATA. PHOTOLITHOGRAPHIC POSTER,
100.5 × 71.4 CM. COURTESY EIKOH HOSOE

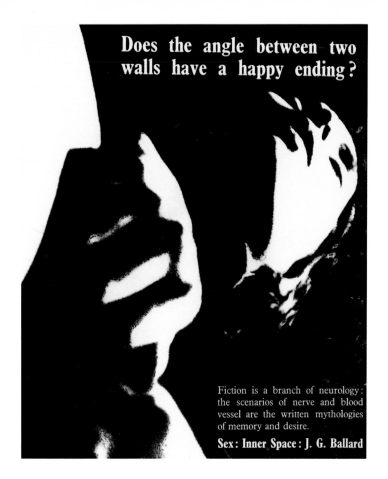

PLATE 94. J. G. BALLARD. MAGAZINE BACK COVER.
1967. FOR J. G. BALLARD. PHOTO-OFFSET
MAGAZINE PAGE, INCORPORATING STILL FROM
MOTION PICTURE ALONE BY STEPHEN DWOSKIN,
USED WITH PERMISSION; 24.7×18.5 CM. PRIVATE
COLLECTION. REPRODUCED WITH PERMISSION OF
THE ARTIST

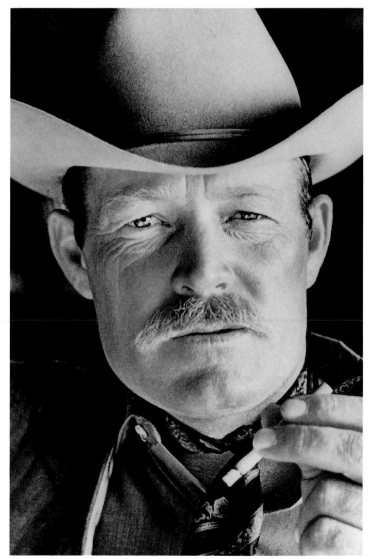

PLATE 95. JIM BRADDY. SHERIFF. 1969. LEO
BURNETT U.S.A. FOR PHILIP MORRIS [MARLBORO
CIGARETTES]; ART DIRECTOR KEN KROM.
TRANSPARENCY, [35 MM.]. COURTESY OF LEO
BURNETT U.S.A. AND PHILIP MORRIS

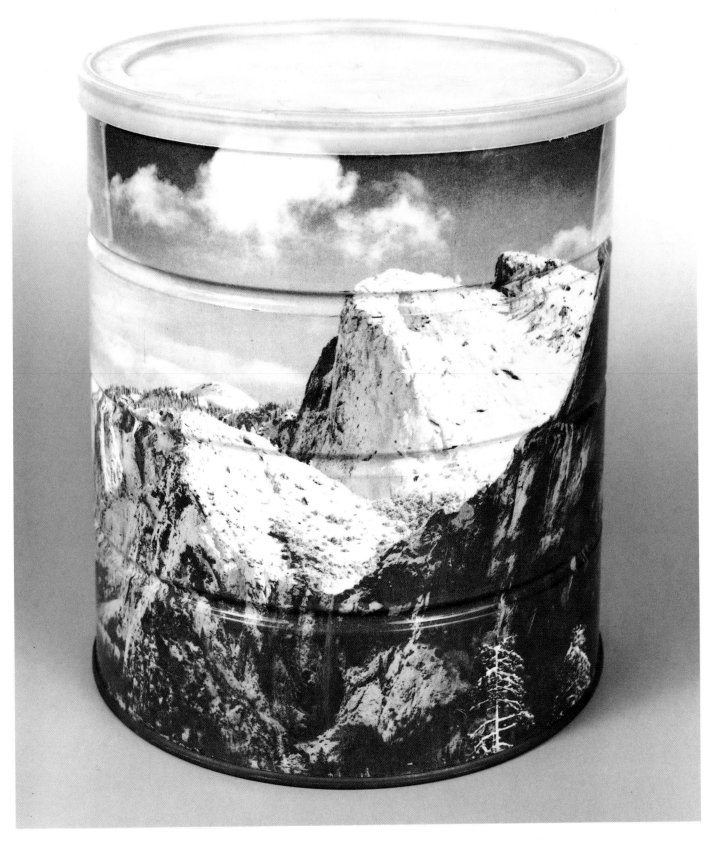

PLATE 96. ANSEL ADAMS. <u>WINTER MORNING,
YOSEMITE VALLEY</u>. 1969. IN-HOUSE AGENCY FOR
HILLS BROS. COFFEE, INC.; MERCHANDISING
MANAGER FRED S. VOIGT. PHOTO-OFFSET PRINT
ON METAL CONTAINER, 17.6 × 15.8 [DIA.] CM. (3-LB.
CAN). IMP/GEH. MUSEUM COLLECTION. COURTESY
HILLS BROS. COFFEE, INC.

PLATE 97. MARIE COSINDAS. <u>HERBESSENCE BEAUTY</u>
<u>PREPARATIONS</u>. 1968. KENYON & ECKHARDT, INC.
FOR HELENA RUBENSTEIN, INC.; CREATIVE
DIRECTOR GEORGE SOTER. TRANSPARENCY, [4 × 5"].
COURTESY THE ARTIST

PLATE 98. HENRY WOLF. FOR CARVEN PARFUMS
[MA GRIFFE]. 1968. TRAHEY ADVERTISING INC.;
ART DIRECTOR HENRY WOLF. TRANSPARENCY,
[35 MM.]. COURTESY THE ARTIST

PLATE 100. ONOFRIO PACCIONE. <u>NECKLACE ON
LEG</u>. 1979. FOR HARRY WINSTON, INC.; ART
DIRECTOR ONOFRIO PACCIONE. TRANSPARENCY,
[4 × 5″]. COURTESY THE ARTIST

PLATE 101. ERIC MEOLA. <u>FIRE EATER</u>. 1983. GEER
DUBOIS, INC. FOR ALMAY, INC. [COSMETICS];
ART DIRECTOR ROGER HINES. TRANSPARENCY,
[35 MM.]. COURTESY THE ARTIST

PLATE 102. NORIAKI YOKOSUKA. NAIL ENAMEL
[VARIANT]. 1978. IN-HOUSE AGENCY FOR SHISEIDO
CO., LTD.; ART DIRECTOR MAKOTO NAKAMURA.
TRANSPARENCY, [4×5"]. COURTESY THE ARTIST
AND SHISEIDO CO., LTD.

PLATE 104. HIRO. <u>EXTREME RED</u>. 1982. DOYLE
DANE BERNBACH, INC. FOR CHANEL, INC.;
ART DIRECTORS ALAN JACOBS AND BERNIE
CUMMINGS. TRANSPARENCY, [8 × 10"]. COPYRIGHT
© 1982 CHANEL, INC. PHOTOGRAPH COURTESY
THE ARTIST AND CHANEL, INC.

PLATE 103. HENRY WOLF. FOR GEOFFREY BEENE,
INC. [GREY FLANNEL COLOGNE]. 1980. PETER
ROGERS ASSOCIATES. TRANSPARENCY,
[35 MM.]. COURTESY THE ARTIST

PLATE 105. COSIMO. <u>MUMMY</u>. 1980. H.P.E. FOR
AUREA [JEWELRY]; ART DIRECTOR ARIC FRONS.
TRANSPARENCY, [8×10"]. COURTESY THE ARTIST

PLATE 106. GEORGE HOLZ. <u>GOLD</u>. 1985. DOYLE
DANE BERNBACH, INC. FOR INTERNATIONAL GOLD
CORPORATION, INC.; ART DIRECTOR RON LOUIE.
TRANSPARENCY, [35 MM.]. COURTESY THE ARTIST

PLATE 107. ANTONIA MULAS. <u>UMBERTO ECO</u>
[VARIANT]. 1983. FOR POLTRONA FRAU
[UPHOLSTERED FURNITURE]. TRANSPARENCY,
[2¼ × 2¼″]. COURTESY THE ARTIST

PLATE 108. JEFFREY K. SCHEWE. <u>WINDOWS IN
WALLS</u>. 1984. J. B. THOMAS & ASSOCIATES FOR
WOLVERINE TECHNOLOGIES, INC. [VINYL SIDING];
ART DIRECTOR KURT DIETCH. TRANSPARENCY,
[35 MM.]. COURTESY THE ARTIST

PLATE 109. IRVING PENN. <u>COMPOSITION WITH
TRIANGLE.</u> 1985. FOR FUJI PHOTO FILM [FUJINON
LENSES]. CIBACHROME PRINT, 58.7 × 48 CM. LENT
BY THE ARTIST

PLATE 110. ORIO RAFFO. <u>ARTISTS' INTERIORS
(EMILIO TADINI)</u>. 1985. B COMMUNICATIONS,
MILAN, FOR CASSINA [FURNITURE]; ART
DIRECTORS TITTI FABIANI AND FABIO LISCA.
TRANSPARENCY, [4 × 5"]. COURTESY
B COMMUNICATIONS

PLATE 111. BENDER AND BENDER STUDIO. <u>POTATO
AND FRIES</u>. 1984. LORD, SULLIVAN & YODER
ADVERTISING FOR NEVAMAR CORP. [PLASTIC
LAMINATE]; ART DIRECTORS DOUG FISHER AND
ROBERT BENDER. TRANSPARENCY, [4 × 5"].
COURTESY NEVAMAR CORP.

PLATE 112. KEVIN SUMMERS. <u>SHAVED PACK</u>. 1985.
COLLETT, DICKENSON, PEARCE AND PARTNERS LTD.
FOR GALLAHER LTD., BENSON & HEDGES SPECIAL
FILTER; ART DIRECTOR NIGEL ROSE. TRANSPARENCY,
[8×10"]. COURTESY COLLETT, DICKENSON,
PEARCE AND PARTNERS LTD. REPRODUCED
WITH PERMISSION OF GALLAHER LTD.

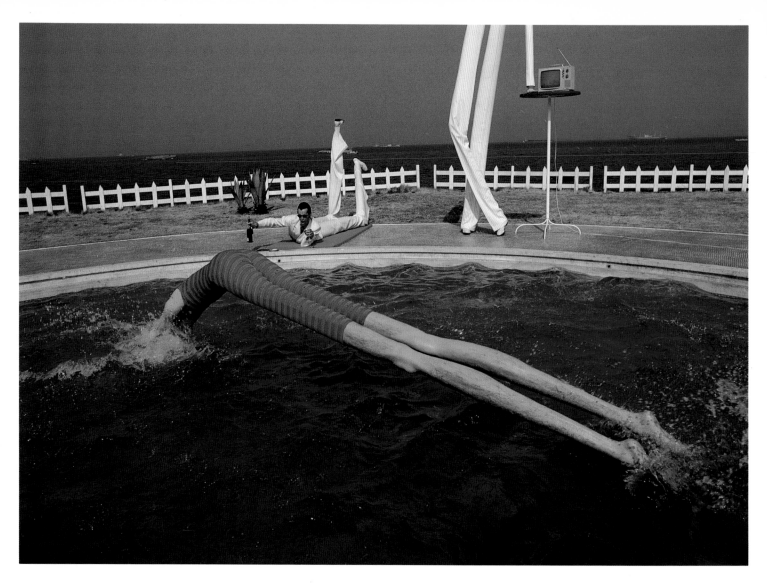

PLATE 113. BISHIN JUMONJI. FOR MATSUSHITA
ELECTRICAL CO. 1977. DAIKO CO., LTD.;
ART DIRECTOR MASAHARU HIGASHIZAWA.
TRANSPARENCY, [4 × 5"]. COURTESY THE ARTIST

PLATE 114. KAZUMI KURIGAMI. CAN WEST WEAR
EAST? 1979. IN-HOUSE AGENCY FOR PARCO CO.,
LTD. [FASHION]; ART DIRECTOR AND DESIGNER
EIKO ISHIOKA. PHOTO-OFFSET POSTER,
102.8 × 72.6 CM. COURTESY PARCO CO., LTD.

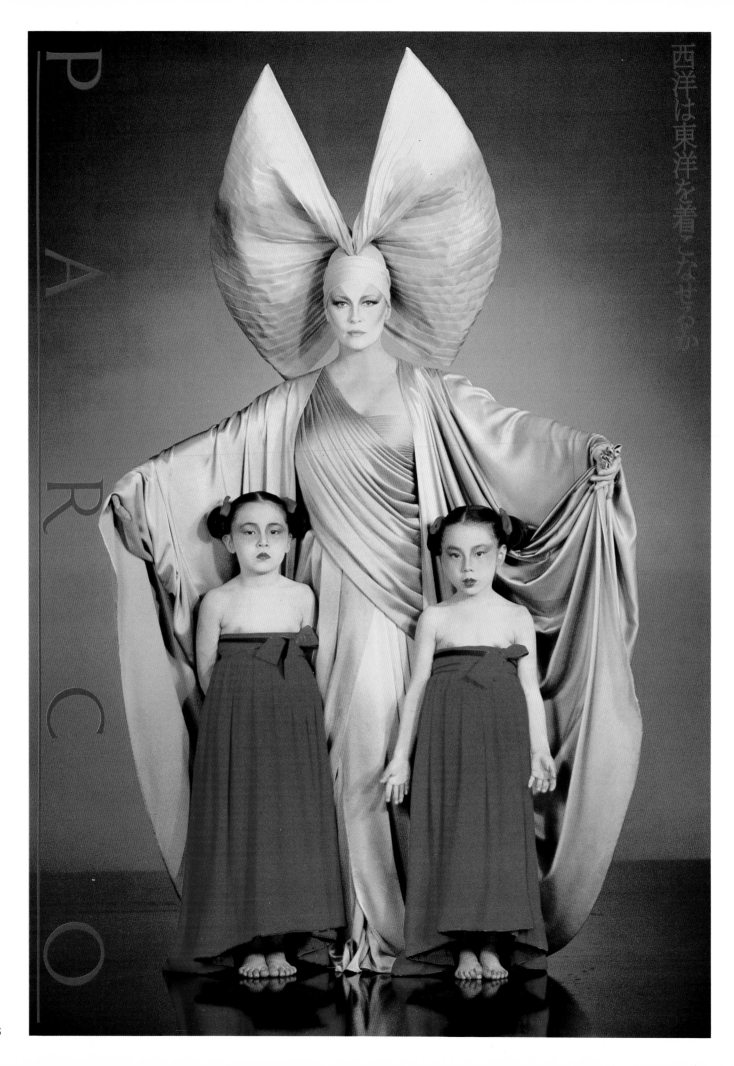

P
A
R
C
O

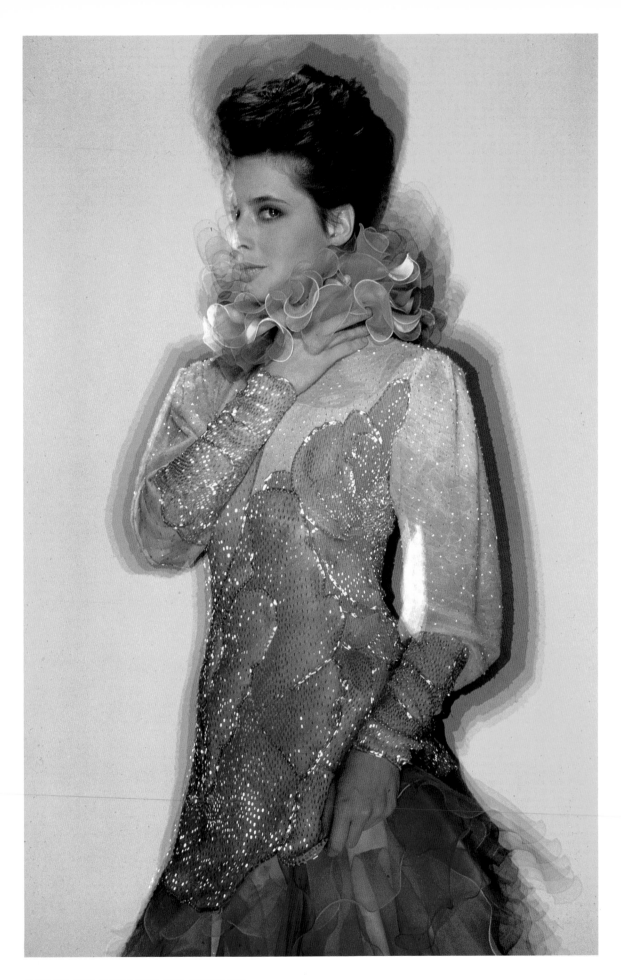

PLATE 115. HIRO. <u>HANAE MORI</u>. 1982. GREENGAGE
ASSOCIATES FOR HANAE MORI, INC. [FASHION];
ART DIRECTOR REGGIE TRONCONE. TRANSPARENCY,
[35 MM.]. COURTESY THE ARTIST

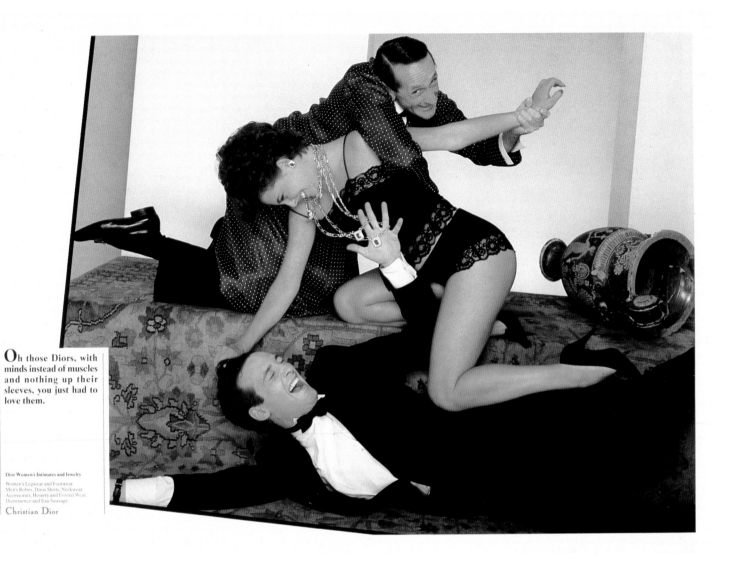

Oh those Diors, with minds instead of muscles and nothing up their sleeves, you just had to love them.

Dior Women's Intimates and Jewelry

Women's Legwear and Footwear,
Men's Robes, Dress Shirts, Neckwear,
Accessories, Hosiery and Formal Wear,
Dioressence and Eau Sauvage.

Christian Dior

PLATE 116. RICHARD AVEDON. <u>ADVERTISEMENT FOR CHRISTIAN DIOR</u>. 1982. RICHARD AVEDON INC. FOR CHRISTIAN DIOR; ART DIRECTOR RICHARD AVEDON. TEARSHEET, 28.2 × 40.8 CM. COURTESY THE ARTIST

PLATE 117. PAUL TORCELLO. <u>HOTEL</u>. 1985. DENTSU YOUNG & RUBICAM FOR ANSETT INTERNATIONAL HOTELS AND RESORTS; ART DIRECTOR PAUL MEEHAN, CREATIVE DIRECTOR TIM CROWTHER. TRANSPARENCY, [35 MM.]. COURTESY THE ARTIST

PLATE 118. JOHN CLARIDGE. <u>PEUGEOT 505 GTI</u>. 1980S. DDM ADVERTISING, LTD. FOR PEUGEOT LTD.; ART DIRECTOR KEN SCOTT. TRANSPARENCY, [8×10"]. COURTESY THE ARTIST

PLATE 119. NICOLAS MONKEWITZ. FOR KANEBO COSMETICS. 1986. BARLOGIS & JAGGI, ZURICH; ART DIRECTOR RICHARD RAU. TRANSPARENCY, [4×5"]. COURTESY THE ARTIST

PLATE 120. REINHART WOLF. FOR TCHIBO FRISCH-
ROST-KAFFEE AG [COFFEE]. 1982. SCHOLZ &
FRIENDS GMBH, HAMBURG; ART DIRECTOR ERIKA
MADEMANN. TRANSPARENCY, [8×10"]. COURTESY
THE ARTIST. TCHIBO ADVERTISEMENT

PLATE 121. REBECCA BLAKE. BOLLINGER
CHAMPAGNE. 1986. MCNAMARA, CLAPP & KLEIN
FOR BOLLINGER CHAMPAGNE; ART DIRECTOR
LINDA VOS. TRANSPARENCY, [8×5"]. COURTESY
THE ARTIST

PLATE 122. DEBORAH TURBEVILLE. <u>JESSICA</u>
<u>MCCLINTOCK</u>. 1986. IN-HOUSE AGENCY FOR
JESSICA MCCLINTOCK, INC. [FASHION]; ART
DIRECTOR KAT WALKER. TRANSPARENCY, [4 × 5"].
COURTESY JESSICA MCCLINTOCK, INC.

PLATE 123. VICTOR SKREBNESKI. <u>BEAUTIFUL</u>. 1986.
A. C. & R. FOR ESTÉE LAUDER, INC.; ART DIRECTORS
JUNE T. LEAMAN AND ALVIN CHERESKIN. TYPE-C
PRINT, 40.4 × 57.2 CM. COURTESY ESTÉE LAUDER, INC.

TRIUMPH OF THE IMAGE AND NEW TECHNIQUES 1980–87

... [ADVERTISING PHOTOGRAPHY] IS ENGAGED IN VISUALIZING THE THINGS THAT UNITE US: OUR NEEDS, OUR DREAMS AND OUR APPARENTLY IRRATIONAL MOTIVATIONS— AND OFTEN PRODUCES WORKS OF EXCEPTIONAL BEAUTY THAT EMERGE FROM THE SHARPEST COMPETITION THAT HAS EVER PREVAILED IN THE HISTORY OF ART.

—H. G. PUTTNIES, ART CRITIC, 1980[1]

IMAGES

"The purpose of advertising is to stimulate excess usage of anything," wrote Kenneth Yednock, vice-president of the N. W. Ayer advertising agency— undoubtedly the most succinct and unabashedly honest definition of the social role of advertising in modern culture.[2] The purpose of advertising has not changed in the least since its earliest days; nor, for that matter, has the function of the advertising photograph changed over the course of the last century or so. Advertising photography, like advertising itself, is a form of applied art designed to inform, persuade, and seduce. The bottom line, of course, is to sell a commodity—whether it is a product, brand name, corporate or other identity, public or private service, or an idea. Central to the image's purpose are communication and association. Before selling can occur, attention must be gained and a certain amount of understanding achieved. The next step is to create an association between what is sold and what is being pictured in the hope that the memory of the image will also include remembrance of the product or service. The simplest form of product advertising is to depict or describe the product as favorably or strikingly as possible, but as has been frequently pointed out, in a world where every competitor is marketing essentially the same product in equally attractive ways, there is really little chance of differentiating among them. Except one: with an unforgettable image.

In a culture suffused with claims, testimonials, counterclaims, comparative statistics, and warranties of quality, it may be only an image that makes the real difference in persuasion. Images may be vague abstractions, such as trademarks or corporate logotypes. Images may also be the hard contact points between advertiser and consumer. In print advertising these are now predominantly photographs designed to puncture the viewer's space, as it were, in order to reach, seduce, and affect him or her. It is no longer sufficient simply to picture what is being advertised, no matter how beautifully lighted or composed or how humorously presented. Direct documents have been replaced by indirect images whose responsibility it is to arrest the viewer's glance. In a way, the image in modern advertising has triumphed over the product. What we see is what we see, and what the German philosopher W. F. Haug has said about corporate trademarks and the expense of promoting them is essentially true for today's advertising in general. "Competition has widely shifted," he wrote in *Critique of Commodity Aesthetics*, "on to the level of images: now image fights image, incurring a drain on the national economy that runs into billions."[3]

FURTHER STATISTICS

Both Yednock and Haug are correct. Advertising is meant to increase sales, and the stakes are staggering. In American print advertising alone, more than $18 billion were expended in 1980, while the total amount spent on all forms of advertising that year exceeded $54.6 billion. Not only are these amounts staggering, so is the volume of advertising that affects us daily. Author Stephen Fox has outlined the extent of this volume, using the American Association of Advertising Agencies as a source:

AN ENTERPRISE THAT SPENT $54.6 BILLION A YEAR COULD REASONABLY EXPECT TO WIELD GREAT POWER. YET THE VOLUME AND UBIQUITY OF ADVERTISING ACTUALLY WORKED AGAINST ITS EFFECTIVENESS: A PARADOX THAT DENIED COMMON SENSE. AS COMMUNICATIONS RESEARCH HAS SHOWN, WHEN THE GROSS TOTAL OF ADS INCREASES PEOPLE SCREEN IT MORE FINELY. AT SOME POINT THE SCREAMING CACOPHONY SIMPLY BECOMES WHITE NOISE — BACKGROUND CLUTTER FROM WHICH FEW INDIVIDUAL MESSAGES STAND OUT. ACCORDING TO ONE STUDY BY THE AAAA, AN AVERAGE CONSUMER WAS EXPOSED TO 1,600 ADS A DAY; OF THESE 80 WERE CONSCIOUSLY NOTICED, AND ONLY 12 PROVOKED SOME REACTION. MOST RECENT POLLS OF PUBLIC OPINION ABOUT ADVERTISING HAVE FOUND NEITHER APPROVAL NOR DISAPPROVAL BUT JUST INDIFFERENCE, A LACK OF INTEREST.[4]

In a situation as saturated as this, the advertisement has to stand out; in order to become one of the twelve ads that provoke a response, the image has to be memorable, commanding, distinctively impressive.

A PALETTE

Late in 1986 Irving Penn took a number of shots of a fairly common subject, a close-up of a model's lips colored with lipstick. In itself, the image has been a stereotype in pictorial advertising for decades. Picturing glamorously colored lips was after all

the best way of showing what the lipstick looked like. What Penn did, however, was something uncommon. Working with art director George D'Amato of the McCann-Erickson ad agency, Penn had the model's lips aggressively smeared with various hues of lipstick, representing L'Oréal's color choices (plate 124). The smudges of color ignored the contours of the lips enough to suggest an artist's palette — presumably the core idea for the ad — but the overpowering effect was much more sculptural. In gentle yet solidly volumetric lighting, the smudges define the lips, articulate their fullness, follow their gesture; yet by a disregard of conventional physiognomic limits they also assume a biomorphic sensuousness of their own. Intended to run as a double-page spread in *Vogue* (fig. 30), with the essential copy beneath it, the photograph was a "drop-dead" image that stands for what advertising photography is all about: communicating an idea for a product through a singular image that holds our attention.

FIGURES 31–34. PETER ARNELL. SCRAPBOOK PAGES. 1986. VARIOUS MATERIALS. COURTESY ARNELL/ BICKFORD ASSOCIATES

RECENT TRENDS

Advertising photography of the eighties has provided us with an incredible array of powerful images, created by established names as well as by younger photographers. Hiro's photograph of extremely red lips hovering above an open lipstick container is, in its chilly classicism, just as forceful as Penn's more expressionistic version of the theme. One of the great colorists in any medium, Hiro is also a master of the most subtle harmonies of pure whites, as in his photograph

of a silver bracelet displayed on a bleached animal bone (plate 129). For Revlon, Richard Avedon gives us a high-relief frieze of monumentalized glamour from around the world, bathed in delicate golden tones (plate 133). Uwe Ommer's photograph for Charles Jourdan shoes depicts a pair of brilliantly red sandals deposited casually on charcoal gray industrial stairs (plate 125). Steve Wilkes orchestrates the warm colors of a Los Angeles sunset and a wall's graffiti as a backdrop to a young boy wearing Nikes (plate 130), and Kazuyoshi Miyoshi exaggerates the tropical colors of the Seychelles in a still life of fruit used in a Japanese shoe-store ad (plate 131).

In 1938 Victor Keppler had prophesied the obsolescence of black-and-white photography. In 1973 the German photographic historian L. Fritz Gruber said that black-and-white photography would "no doubt sink back more and more into the past."[5] Contrary to these expectations, monochromatic photography is again playing a prominent role in advertising—a surprising, and thus useful, exception to the general prevalence of color photography. Dominique Issermann's shots for Maud Frizon, Sonia Rykiel, and Christian Dior are exclusively and vividly black and white. Sarah Moon adopted the jarring immediacy of a bold, journalistic approach for a recent Cacharel

editorial and advertising campaign (plate 138). Duane Michals's double exposure for a Neiman-Marcus promotional brochure is a study in oneiric melancholy (plate 132). And Robert Mapplethorpe's print of a man's sinuous arm, outstretched in tension, is like a detail of some Olympian statue (plate 126).

Mapplethorpe's photograph—originally made for personal, artistic reasons but later used in an ad for Sportcraft, Inc.—is a good example of the growing use of found imagery by art directors. Increasingly, photographers are finding their stock images or those made strictly for artistic reasons incorporated into advertising. Miyoshi's tropical fruit was not made directly on assignment for a shoe ad, nor was Chris Collins's unparalleled still life of three colored liquids being propelled out of wine glasses (plate 139). Originally done for self-promotion, the latter image was picked up by several clients, including Royal Zenith.[6] Colombian photographer Johnny Rasmussen, wishing to comment on his country's fight against drug abuse, created an unsettling still life of a human skull surrounded by heavy smoke, its top removed and the cranium filled with marijuana buds (plate 128). After the picture was made it was used as a poster for a public campaign, reminding us that the photographic poster in most countries began by promoting social causes and only later turned to marketing consumer products. As photographic critic Willy Rotzler observed about the origins of the photographic poster: "It appeared first of all chiefly as a poster for social and humanitarian purposes in which the photographic 'document humain' made any caption superfluous."[7] Like Ballard before him and Heartfield in the thirties, Rasmussen used the techniques of advertising in order to "sell" an idea.

FIGURE 35. PETE TURNER. <u>OVERVIEW</u> [FOR BELL ATLANTIC TELEPHONE CO.]. 1986. TYPE-C PRINT. COURTESY THE ARTIST

The German photographer Gerhard Vormwald portrayed the idea-hungry art director of today in a shot for the French commercial photography index *Le Book* (plate 137). Surrounded by reams of papers, an architect's lamp, and various idea photos, he frantically searches the index for the right photographer while suspended in midair with a calculator in one hand and telephone in another. Real-life art director Peter Arnell similarly strives for appropriate photographers, and has worked with such international artists as Duane Michals, Denis Piel, and Torkil Gudnason. More importantly, Arnell, a trained architect and former book designer, has given traditional photomontage a new look in contemporary advertising. He develops his ideas by compiling voluminous notebooks of his own sketches—drawn, annotated, and montaged (figs. 31–34). When pioneering designers and photographers of the twenties turned to montage, they felt it necessary to invent a new kind of pictorial language. Those who followed them either aped the earlier lessons of modernism or used the technique to get around technical limits. In today's Post-Modernist era, Arnell feels perfectly at ease in drawing his ideas from the entire history of pictorial art.

Arnell assembled fashion photographer Denis Piel's images of a model wearing the latest Albert Nipon fashions and surrounded it with childhood snapshots of the same model in a diaristic structure, as though it were a page from a family album (plate 142). For a kaleidoscopic montage of Donna Karan's new line, the art director constructed a nearly Dadaistic vision of contemporary urban life using Torkil Gudnason's fashion shots (plate 146), similar in structure to one of Arnell's own scrapbook pages (figs. 33–34). "The ability to play with perspective," Arnell has said, "is a wonderful

thing. All this stuff created by Picasso and Braque at the turn of the century . . . it was considered Abstraction, but it's not. It's a better depiction of reality. Nothing ever stands still."[8] For a later Karan campaign, Piel photographed more than six hundred black-and-white shots in a single day (fig. 36). "This was the first time," Arnell recalls, "anybody had ever asked him to start at 4:30 in the morning on a rainy day and shoot blurred, surreal images. . . .That's how you get the twist, when you take somebody and have them do something new. That's how you get invention, which is always so much more rewarding than derivation."[9]

AN ELECTRONIC LANDSCAPE

Speaking about his own photography, Jay Maisel has said: "My interest is provoked by beauty (whatever that is). The photograph I take is then, hopefully, an image which transmits its inherent beauty as I perceived it. My contribution to the image is in its selection and the ability to render precisely what I've chosen."[10] In his highly macroscopic photograph of a microchip circuit, made for a series of corporate-identity ads run by United Technologies, that is exactly what Maisel has done: he has transmitted the inherent beauty of something abstract and technologically esoteric (plate 144). As its name implies, United Technologies is not only concerned with computers; it includes major holdings in communications and transportation as well as data systems. What the company is advertising is, thus, not an individual product, but the complex identification of the corporation's role in society. "Institutional advertising," wrote a critic in 1924, "is the making known to the public the fact that the institution employing such advertising is also employed in rendering a highly organized and economic service of direct and expressible results of benefit to the public. . . . It is the clear expression of why an institution exists."[11] This sort of advertising grew out of the twenties, when corporations began to publicize what they were about in hopes of forestalling large-scale public mistrust and animosity. The specific concerns of that era principally differ in terms of language from those of today. "Socialists loll in railway coaches," wrote the same critic, "anarchists smack their lips over beef dressed by packers, communists ride in motor cars built of steel and fueled by corporations against which they vituperate—and the average, casual citizen accepts all the favors of big business while envy makes him critical of every industry which rises above the level of little business."[12] In today's world mega-corporations face similar fears—misunderstanding, indifference, and mistrust.

Maisel's photograph is ultimately a record of our new computerized world, delineating an unseen part of a cultural landscape made up of electronics, fiber optics, satellites, and global networking. As these products and systems have become more integrated with our lives, photographers have sought various and novel ways of depicting this landscape. In Japan Kazuo Kawai portrayed the elemental beauty of reflected bubbles (plate 147), expressing the ineffable wonder of it all. To advertise a word-processing system, Barbara Kasten constructed an idealized environment of pure Platonic forms symbolic of the mathematical basis of our operational environment (plate 143). For Toshiba's line of VCRs and color televisions, Ryszard Horowitz fabricated a wonderous new metropolis of towering video images, floating monitors, and disengaged eyes (plate 145)—the shape of things to come or a spotless reprise of the future pictured in director Ridley Scott's film *Blade Runner*.

The shape of things to come very well may not resemble what we have learned to expect from advertising photography. With constant advances in electronic imaging and still-video cameras, the production and consumption of images will undoubtedly change. Not only their form, but how they are distributed will challenge our capacity to assimilate them. A recently developed digitalized system, for example, will "enable the direct transmission of colour and monochrome (35mm) originals via regular telephone lines to remote computers, colour scanners or printing systems."[13] Pete Turner, well known for his perfectly honed color photography, has already turned away from conventional photographic processes and traditional techniques to portray another version of our brave new world in completely new ways (plate 148).

Availing himself of the latest in digital imaging systems, Turner chooses multiple photographic transparencies, projects them in combination, maneuvers them into matrices, turns these combinations into digitalized binary impulses called pixels (as many as four million per 35-millimeter image), runs them through a computer, such as a Scitex or Hell Chromacon, has them laser scanned and separated, and ultimately printed either as color photographs or offset photomechanical illustrations.[14] Using a single system he is able to achieve "generation of transparent image effects, positioning by separations, cropping, retinting, transparent retouching, generation of color vignettes and lines, image reversal, [and] softening of contours."[15] Electronically redacted, the final, exceptionally high-quality image is entirely first generational, since it really never existed, except in its components, prior to printing. Turner's photographs, made for Bell Atlantic, may appear to be futuristic landscapes or science fiction fantasies, but they are created from today's science fact (fig. 35). They just might be a glimpse into what lies in store for us in terms of photography, showing us, as Bert Stern said, "something in a way not seen before" and suggesting limitless possibilities to the challenge of creating the perfect advertising photograph.

1. H. G. Puttnies, art critic for the *Frankfurter Allgemeine Zeitung*, cited in Karl Steinorth, "The Arrested Glance," *Photographis* 15 (1980): 8.

2. Cited in Johnnie L. Roberts, "Telephone Ads Create 'Brands' of Local Calls," *The Wall Street Journal* (12 January 1987), p. 27.

3. W. F. Haug, *Critique of Commodity Aesthetics: Appearance, Sexuality and Advertising in Capitalist Society*, trans. by Robert Bock (Minneapolis, 1986), p. 31.

4. Stephen Fox, *The Mirror Makers: A History of American Advertising and Its Creators* (New York, 1984): 327.

5. L. Fritz Gruber, cited in Karl Steinorth, "Preface," *Photographis* 8 (1973): 8.

6. "Liquid Assets," *American Photographer* 14, no. 5 (May 1985): 102.

7. Willy Rotzler, "Evolution of the Photographic Poster," *Camera* 10 (October 1959): 30.

8. Peter Arnell, cited in Randi Hoffman, "Cube Root," *Advertising and Graphic Arts Techniques* (March 1986): 14.

9. Peter Arnell, cited in Martin Gardlin, "The Selling of Donna Karan," *Photo District News* 6, no. 13 (December 1986): 40–42.

10. Cited in "Jay Maisel," *Camera 35* 23, no. 9 (October 1978): 78.

11. Amos Stote, "Beware of the Business Muckraker!," *Printers' Ink* 127 (24 April 1924): 10.

12. Ibid., p. 10.

13. Adam Woolfit, "Items and Pixels," *Image: The Magazine of the Association of Fashion Advertising and Editorial Photographers* 137 (January 1987): 25.

14. Cf. Allan Ripp, "Whose Picture Is It Anyway?," *American Photographer* 18, no. 6 (June 1987): 76.

15. Promotional brochure for Hell Graphic Systems and Chromacom CPR 403, n.d.

PLATE 124. IRVING PENN. <u>PALETTE</u> [VARIANT]. 1986.
MCCANN-ERICKSON, INC. FOR L'ORÉAL, COSMAIR,
INC.; ART DIRECTOR GEORGE D'AMATO.
TRANSPARENCY, [2¼ × 2¼"]. COURTESY THE ARTIST
AND L'ORÉAL, COSMAIR, INC.

PLATE 125. UWE OMMER. CHARLES JOURDAN.
1985. FOR CHARLES JOURDAN, INC. [SHOES];
ART DIRECTOR MICHEL PAHIN. TRANSPARENCY,
[35 MM.]. COURTESY THE ARTIST AND
MICHELE S. SAUNDERS

PLATE 126. ROBERT MAPPLETHORPE. <u>DERRICK CROSS</u>. 1982. CRAWFORD HALLS PARTNERSHIP FOR SPORTCRAFT, INC.; ART DIRECTOR HUGH MOSLEY. GELATIN SILVER PRINT, 19.1 × 48.3 CM. COURTESY THE ARTIST

PLATE 127. DOMINIQUE ISSERMANN. <u>MAUD FRIZON</u>. 1986. IN-HOUSE AGENCY FOR MAUD FRIZON [SHOES]; ART DIRECTOR DOMINIQUE ISSERMANN. GELATIN SILVER PRINT, 26.9 × 49.5 CM. COURTESY THE ARTIST

PLATE 128. JOHNNY RASMUSSEN. <u>HOMO</u>
<u>CANNABIS</u>. 1984. FOR ANTIDRUG CAMPAIGN;
ART DIRECTOR JOHNNY RASMUSSEN. TYPE-C
PRINT, 38.5 × 43.5 CM. IMP/GEH. GIFT OF THE
ARTIST

PLATE 129. HIRO. ETERNAL. 1984. FOR ELSA PERETTI
[JEWELRY] AND TIFFANY & CO.; ART DIRECTORS
HIRO AND ELSA PERETTI. TRANSPARENCY, [8×10"].
COURTESY THE ARTIST

PLATE 130. STEPHEN WILKES. <u>GRAFFITI</u>. 1984.
WIEDEN & KENNEDY FOR NIKE, INC.;
ART DIRECTOR RICK MCQUISTON. TRANSPARENCY,
[35 MM.]. COPYRIGHT © STEPHEN WILKES, 1984.
COURTESY THE ARTIST

PLATE 131. KAZUYOSHI MIYOSHI. <u>RAKUEN</u>. 1986.
ORIKOMI ADVERTISING CO., LTD., TOKYO, FOR
AMERICAYA LTD. [SHOE COMPANY]; ART DIRECTOR
KATSU ASANO. TRANSPARENCY, [35 MM.].
COURTESY THE ARTIST

PLATE 132. DUANE MICHALS. <u>NEIMAN-MARCUS</u>.
1985. ARNELL/BICKFORD ASSOCIATES FOR NEIMAN-
MARCUS; ART DIRECTOR PETER ARNELL. GELATIN
SILVER PRINT, 32 × 48 CM. COURTESY ARNELL/
BICKFORD ASSOCIATES

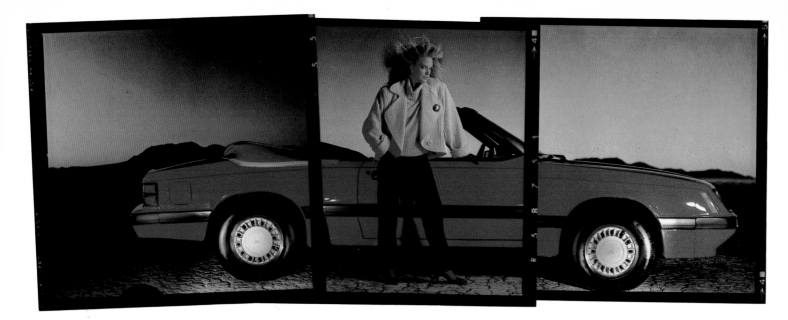

PLATE 134. ANNIE LEIBOVITZ. MUSTANG SALLY.
1985. WUNDERMANN, RICOTTA & KLINE FOR FORD
MOTOR CO.; ART DIRECTOR STEVE NOXON.
PHOTOMONTAGE OF THREE TRANSPARENCIES,
[EACH 2¼ × 2¼"]. COURTESY WUNDERMANN,
RICOTTA & KLINE

PLATE 135. TIM SIMMONS. CHECK IN. 1985. FOR
VIRGIN ATLANTIC AIRLINES; ART DIRECTOR JOHN
HENRY. TRANSPARENCY, [8 × 10"]. COURTESY THE
ARTIST

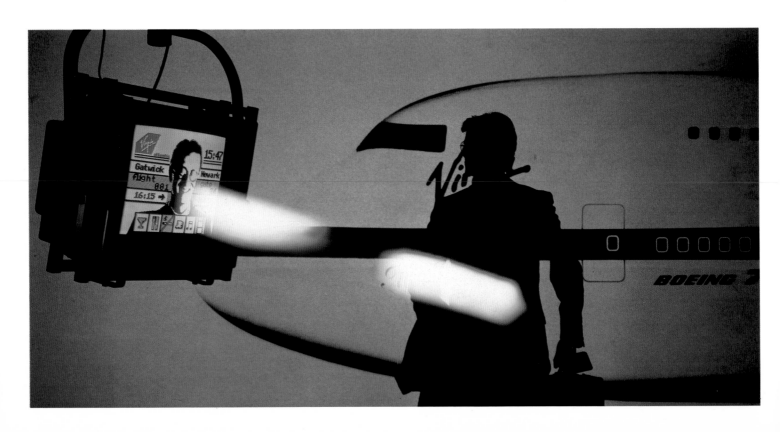

PLATE 136. RYSZARD HOROWITZ. <u>WALL STREET</u>
<u>JOURNAL</u>. C. 1985. JIM JOHNSTON ADVERTISING,
INC. FOR <u>WALL STREET JOURNAL</u>; ART DIRECTOR
BO ZAUNDERS. TRANSPARENCY, [8×10"].
COURTESY THE ARTIST

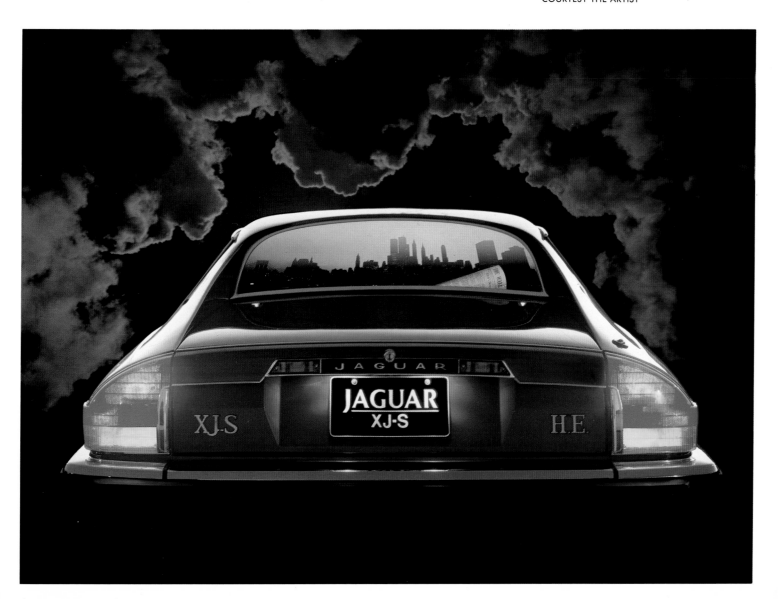

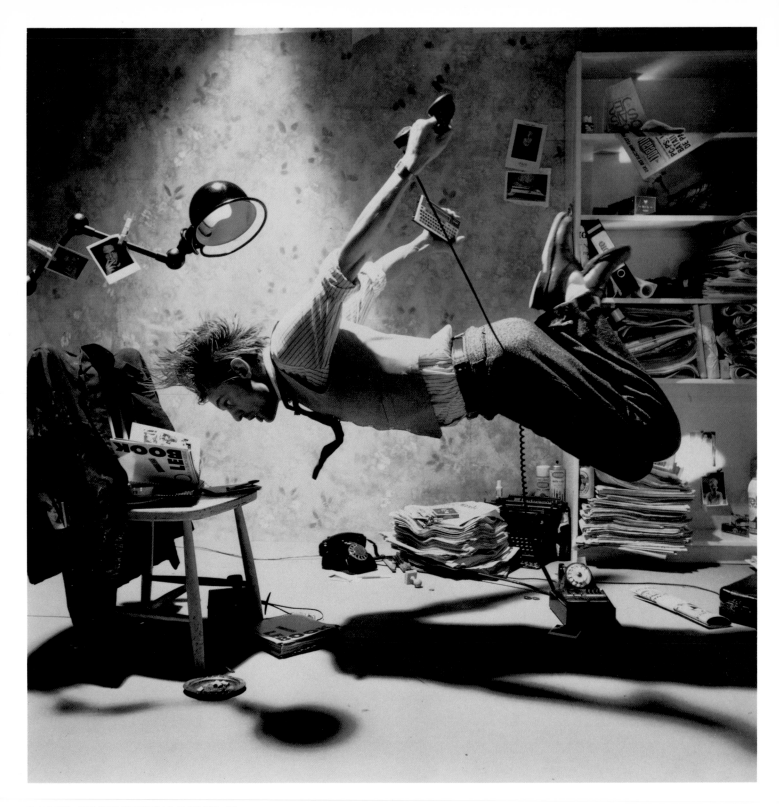

PLATE 137. GERHARD VORMWALD. <u>THOMAS — LE
BOOK</u>. 1985. FOR <u>LE BOOK</u>, PARIS; ART DIRECTORS
GERHARD VORMWALD AND BILL BUTT.
CIBACHROME PRINT, 29 × 29 CM. COURTESY THE
ARTIST

PLATE 138. SARAH MOON. <u>CACHAREL</u>. 1987. FOR
CACHAREL [FASHION]. GELATIN SILVER PRINT,
11 × 16.5 CM. COURTESY THE ARTIST

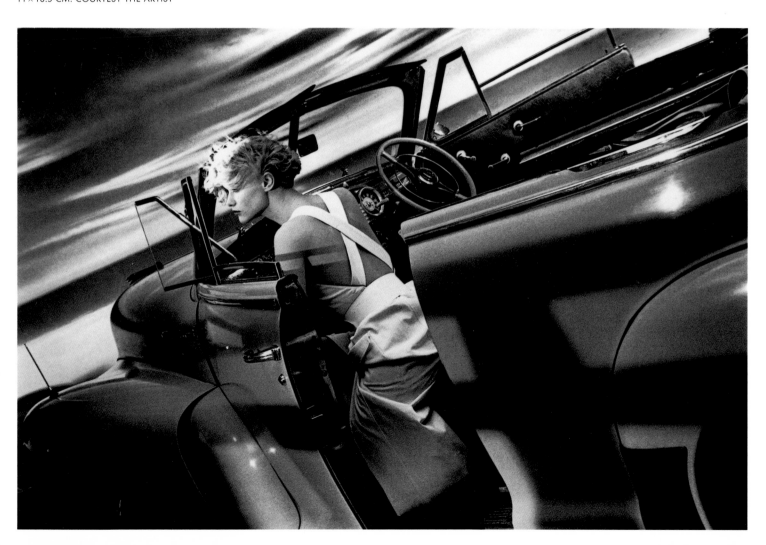

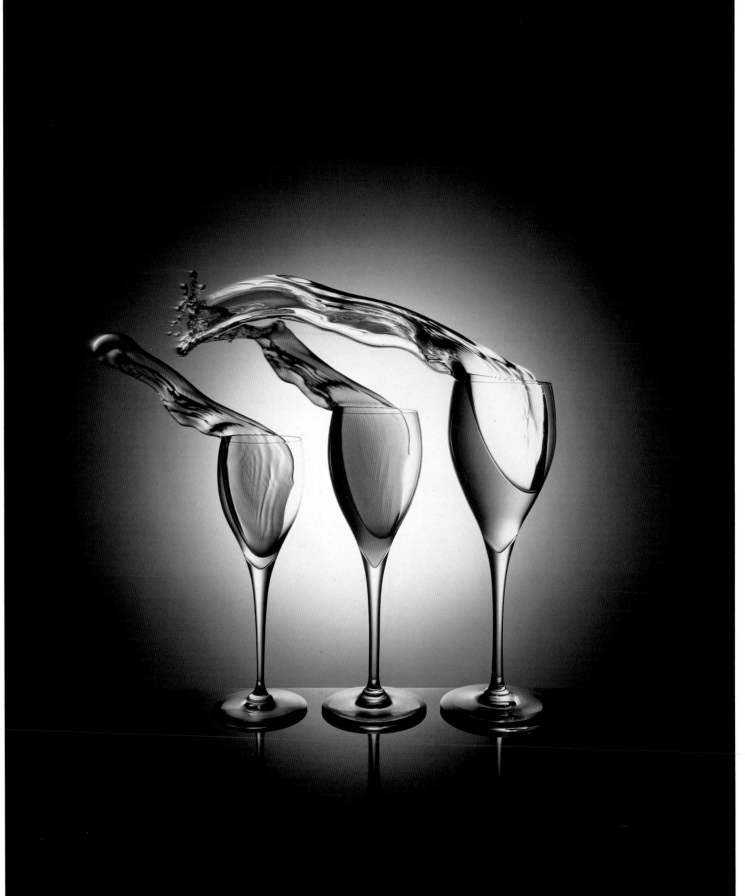

PLATE 139. CHRIS COLLINS. <u>UNTITLED</u>. 1984.
FIORENTINO REINITZ LEIBE FOR ROYAL ZENITH
[PRINTING COMPANY]; ART DIRECTORS CHRIS
COLLINS AND LOU FIORENTINO. TRANSPARENCY,
[8×10"]. COURTESY THE ARTIST

PLATE 140. IRVING PENN. <u>TWICE A DAY</u>. 1986.
IN-HOUSE AGENCY FOR CLINIQUE LABORATORIES,
INC. [COSMETICS]. TRANSPARENCY, [8×10"].
COURTESY THE ARTIST AND CLINIQUE
LABORATORIES, INC.

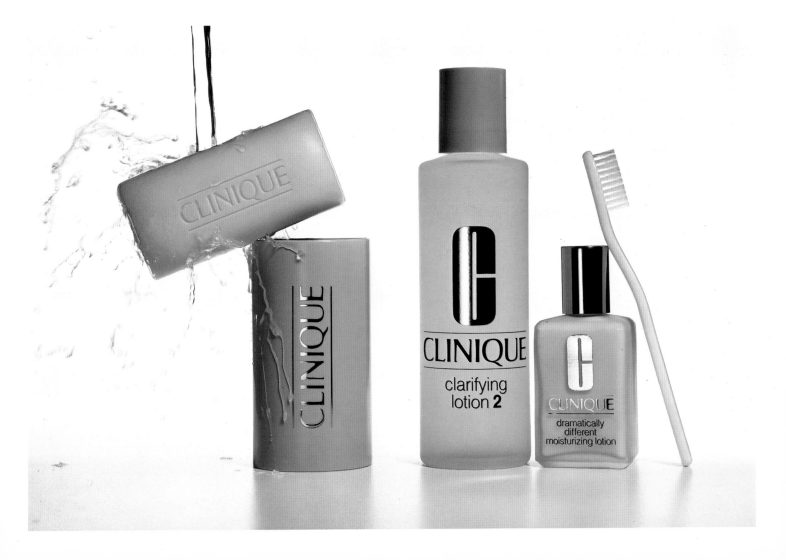

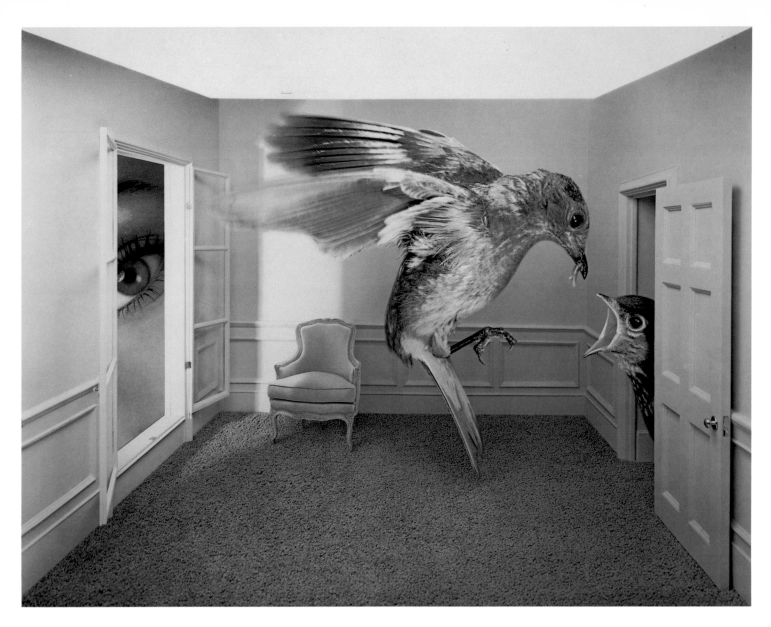

PLATE 141. HENRY WOLF. <u>NESTING INSTINCT</u>. 1986.
ALLY GARGANO/MCA ADVERTISING, LTD. FOR
FIELDCREST MILLS, INC., KARASTAN RUG MILLS
DIVISION; ART DIRECTOR TOM WOLSEY. TYPE-C
PRINT WITH ARTWORK, 40.5 × 54.5 CM. COURTESY
ALLY GARGANO/MCA ADVERTISING, LTD.

PLATE 142. DENIS PIEL. <u>ALBERT NIPON</u>. 1986.
ARNELL/BICKFORD ASSOCIATES FOR ALBERT
NIPON, INC. [FASHION]; CREATIVE DIRECTORS
PETER ARNELL AND TED BICKFORD, ART DIRECTOR
LISA STEVENS. TEARSHEET, 33.7 × 50.2 CM.
COURTESY ARNELL/BICKFORD ASSOCIATES

Show me the child and I'll give you the woman.

ALBERT NIPON

PLATE 143. BARBARA KASTEN. <u>QUARK WORD JUGGLER</u>. 1985. FOR QUARK, INC. [WORD PROCESSOR PROGRAM]; ART DIRECTOR SUZANNE MORIN. TRANSPARENCY, [4 × 5″]. COURTESY THE ARTIST AND THE JOHN WEBER GALLERY

PLATE 144. JAY MAISEL. <u>MICRO MAZE</u>. 1983. IN-HOUSE AGENCY FOR UNITED TECHNOLOGIES CORP.; ART DIRECTOR GORDON BOWMAN. TRANSPARENCY, [35 MM.]. COPYRIGHT © JAY MAISEL, 1983. COURTESY THE ARTIST

PLATE 145. RYSZARD HOROWITZ. <u>TOSHIBA</u>. 1985.
SUCCESS, PARIS, FOR TOSHIBA; ART DIRECTOR
STAN LEVY. TRANSPARENCY, [8 × 10"]. COURTESY
THE ARTIST

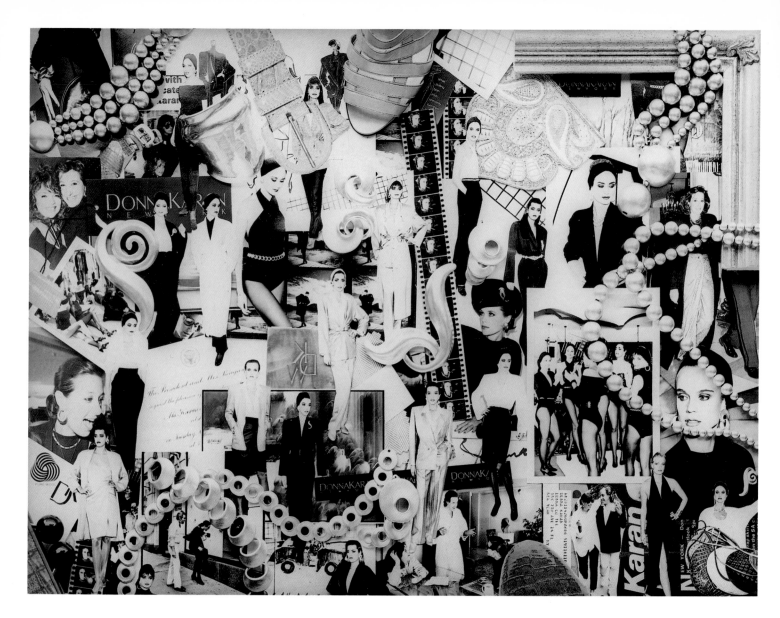

PLATE 146. TORKIL GUDNASON. <u>DONNA KARAN</u>.
1986. ARNELL/BICKFORD ASSOCIATES FOR DONNA
KARAN [FASHION]; CREATIVE DIRECTORS PETER
ARNELL AND TED BICKFORD, ART DIRECTOR CATHY
HENSZEY. PHOTO-OFFSET POSTER, 44.6 × 60.6 CM.
COURTESY ARNELL/BICKFORD ASSOCIATES

PLATE 147. KAZUO KAWAI. <u>WATER BEADS</u>. 1984.
HAKUHODO INC. FOR TOYO ROSHI KAISHA, LTD.,
ADVANTEC, LTD.; ART DIRECTOR KOJI KOJIMA.
TRANSPARENCY, [4 × 5"]. COURTESY THE ARTIST

PLATE 149. SERGE LUTENS. <u>COLOR REFLECTS</u>. 1986.
IN-HOUSE AGENCY FOR SHISEIDO CO., LTD.; ART
DIRECTOR SERGE LUTENS. PHOTO-OFFSET POSTER,
102.9×72.7 CM. COURTESY SHISEIDO CO., LTD.

PLATE 148. PETE TURNER. <u>FUTURE CITY</u>. 1986.
KETCHUM ADVERTISING FOR BELL ATLANTIC
TELEPHONE CO.; ART DIRECTOR JOE CASERTA.
TYPE-C PRINT, 28.6×43.5 CM. IMP/GEH. GIFT OF
THE ARTIST

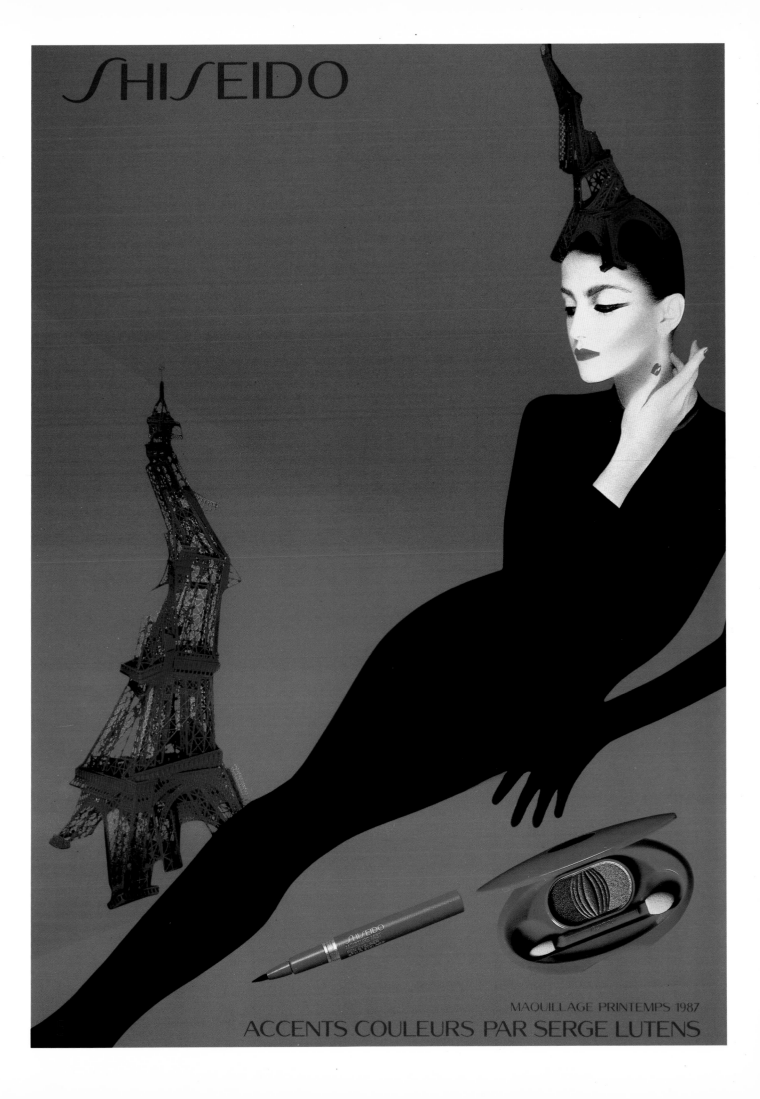

BIOGRAPHIES OF THE ARTISTS

ANSEL ADAMS Born February 20, 1902, San Francisco; died Carmel, California, April 22, 1984. Studied piano privately and at the San Francisco Conservatoire; studied photography under Frank Dittman. Best known for his landscape photography of the West. Commercial work included industrial, federal, and state documentation, and environmental photography. Clients have included Paul Masson and Hills Bros. Coffee. Taught extensively and wrote many books and articles on photography. Received numerous awards, including the United States Presidential Medal of Freedom, 1980.

RICHARD AVEDON Born May 15, 1923, New York. Educated in public schools; studied philosophy at Columbia University, 1941–42; U.S. Merchant Marine, Photo Section, 1942–44. Studied with Alexey Brodovitch at the New School for Social Research, New York, 1944–50. Staff photographer for *Junior Bazaar*, 1945–47, and for *Harper's Bazaar*, 1945–65. Opened studio in New York, 1946. Photographed for leading magazines, including *Harper's Bazaar*, American and French *Vogue, Life, Graphis,* and *Look.* Photographed Civil Rights Movement, 1963.

SID AVERY Born 1918, Los Angeles. Studied at the Art Center, Los Angeles. Established his own studio in the 1940s. Served five years in the U.S. Army Pictorial Service Laboratory in London. Reestablished his studio in Los Angeles; produced photographic essays of film stars for *Look, Saturday Evening Post,* and others. In the 1960s expanded into advertising photography, later also into directing television commercials. Clients have included United States Steel Corp., Sunkist, Inc., Chevrolet Motor Car Division, Max Factor, The Coca-Cola Co., and General Mills. Currently involved with the Hollywood Photographers Archives.

ROBERT BAGBY Born October 14, 1896, St. Joseph, Missouri; died August 4, 1972, Santa Fe, New Mexico. Completed photography program at Illinois College of Photography, c. 1915. Photographer for the International Film Service, Chicago, 1917–18. Managed the studio of Stadler Photo Company, New York, 1918–33. Opened studio in New York, 1933; worked in fashion, advertising, and travel photography. Taught photography at the Rochester Institute of Photography, Rochester, New York, 1953–72. Elected as Fellow to the Royal Photographic Society, 1948.

J. G. BALLARD Born November 15, 1930, International Settlement, Shanghai, China, of English parents. Lived in Shanghai until the end of World War II, when his family returned to England. Attended Leys School for two years; studied medicine at King's College, Cambridge, until 1951. Became a writer of fiction. Best known of his works are *The Drowned World, Vermillion Sands, Crash, The Atrocity Exhibition*, and *Empire of the Sun.* Lives in Middlesex, England.

RALPH BARTHOLOMEW, JR. Born January 26, 1907, New York [?]; died March 8, 1985, Scarsdale, New York. Graduated from the Clarence White School of Photography, 1932. Joined Underwood and Underwood Commercial as an art director under Lejaren à Hiller. Established own studio in New York in 1936; retired in 1972. Clients included Whitman Candies, General Electric Co., Du Pont, Eastman Kodak Co., and Texaco, Inc. Was director of the Photo-Illustrators Society, Philadelphia.

BENDER AND BENDER STUDIO Waldo, Ohio Formed by Ross Hickson, Fred Bender, and Sue Bender. Began in 1968 with part-time photographic projects done while working in research labs; became a full-time studio, Hickson and Bender, in 1971; studio became Bender and Bender in 1985. Both Benders work in the creative executions of ad campaigns. Won awards for the Nevamar series (1982–86) and Harter series (1986). Other clients have included Dow Chemical Co., Wolverine Technologies, and Roppe.

RUTH BERNHARD Born October 14, 1905, Berlin. Studied typography at Royal Academy, Berlin, 1926–27, and photography in a Berlin studio. Emigrated to New York, 1928; naturalized American citizen, 1935. With the help of Ralph Steiner, began career as assistant photographer at *Delineator* magazine. Free-lance portrait and advertising photographer, 1928–36. Moved to Los Angeles, 1936; continued to work in commercial and advertising photography until 1953. Since 1953 has lived in San Francisco; continues to teach and photograph.

REBECCA BLAKE American, born 1949, Antwerp. Came to the United States at age five. Studied to be a concert pianist at New York High School of Music and Art; graduated from New York University, studied music, art history, and English literature. Pursued career in painting, then turned to photography. Established Rebecca Blake Studio in New York, 1972. Known for her beauty, fashion, and portrait photography. In 1977 became a photographic consultant for the film *Eyes of Laura Mars.* Photographs have appeared in *Vogue, Harper's Bazaar,* and *Gentleman's Quarterly.* Advertising clients have included Halston, Revlon, Inc., Du Pont, Nikon, Inc., Bollinger Champagne, Warner Brothers, and Bali Co. Currently heads Rebecca Blake Films in association with Richard Marlis and Norman Seeff.

JIM BRADDY Born 1925, Pontiac, Illinois. Self-taught in photography. Worked in photographic laboratory for National Advisory Committee on Aeronautics (now NASA). Began as a professional photographer following World War II. Established commercial studio in Chicago, 1956; specialized in still-life photography until 1967, when he began to include location photography. For nineteen years was principal photographer for Philip Morris's Marlboro Man series; other clients have included Jack Daniels, Miller Beer, and Kellogg. Lives and works in Chicago.

ANTON BRUEHL Born March 11, 1900, Hawker, Australia; died Florida, 1982. Studied electrical engineering at Christian Brother's School; received degree in electrical engineering from Melbourne College of Engineering. Emigrated to United States, 1919; naturalized American citizen, 1940. Worked as assistant to Jessie Tarbox Beals and studied photography at the Clarence White School of Photography, New York, 1924–25. From 1928 to 1966 worked commercially in fashion and advertising photography for *Vogue, Vanity Fair, House and Garden,* Dole, Four Roses, Chrysler Corp., Bonwit Teller, and others. Was among the first commercial photographers to work in color, 1928.

JOHN CLARIDGE Born August 15, 1944, London. Educated West Ham Technical School, London, 1955–60; self-taught in photography. Assistant photographer for McCann-Erickson Advertising Agency, London, 1959–61, and for David Montgomery in the United States, 1961–63. Also worked for *American Photographer,* London. Free-lance photographer in London since 1964.

CHRIS COLLINS Born September 14, 1949, Southampton, New York. Self-taught in photography. Assistant to Pete Turner for two years. Established studio in New York, 1978; free-lance still-life and location photographer; published widely. Major clients include Oneida Silverware, AT&T, American Express, and General Foods Corp.

JOHN F. COLLINS Born Marietta, Ohio, 1888. First worked in photography at St. Louis World's Fair developing solar prints for William Rau. Worked as photojournalist, cinematographer, and commercial photographer in Ohio, Florida, and New York, 1910–18. First worked in color (Autochromes), 1917. While in the Army, 1918–19, made movies for war college records. Opened studio in Syracuse, New York, as advertising photographer, 1919–30. Worked for Eastman Kodak Co. as in-house catalogue and special assignment photographer from 1934 until retirement in 1954. Continued on special assignments until 1974. Lives in Rochester, New York.

COSIMO Born Cosimo Scianna, January 13, 1941, New York. Graduated from School of Art and Design, Pratt Institute, New York, 1958. Art director for Miller Advertising, 1960; art director and illustrator, Ace Books, 1962. Established Cosimo Studio, Inc. in 1968. Clients have included Minolta, Du Pont, AT&T, GTE, Goodyear, and Eastern Airlines. Recently has directed and produced television commercials in partnership with Michael Daniels. Has taught and lectured on photography.

MARIE COSINDAS Born Boston. Studied painting at Modern School of Fashion Design and Boston Museum School. Illustrator and designer, 1945–60. After attending workshops with Ansel Adams, 1961, and later with Minor White, she turned to photography. Since 1960s has been a free-lance portrait and fashion photographer. Known for her use of Polaroid color film and her color portraiture. Clients have included Helena Rubenstein, Inc. Lives in Boston.

GORDON COSTER Born 1906, Baltimore. Began working in the 1920s in Chicago as photojournalist and commercial photographer. Worked for Underwood and Underwood Commercial in New York under Lejaren à Hiller, late 1920s. Taught at the Chicago Institute of Design under László Moholy-Nagy; advocate of avant-garde photography. Lives in the Chicago area.

CESAR DOMELA-NIEUWENHUIS Born January 15, 1900, Amsterdam. Began drawing, 1918; moved to Switzerland, 1919, painted landscapes. Became member of De Stijl group, 1925; moved to Berlin, 1927. Began working in relief, which eventually led to separation from De Stijl group, 1930. In 1929 joined "der ring neuer werbegestalter," a group of advertising artists founded by Kurt Schwitters. Worked in Berlin in advertising until 1933, then moved to Paris. Founded silk-screen studio with Frederick Kann; began *Plastique* magazine with Jean Arp and Sophie Taeuber-Arp. By 1941 was also working in jewelry. Was living in Paris in 1975.

WILLIAM SHEWELL ELLIS Born 1876, Philadelphia [?]; died April 3, 1931, Philadelphia. Nationally known photo illustrator; by 1913 established another studio in Wilmington, Delaware. Produced many of the "Kodak Girl" pictures prior to 1917. Worked with Autochrome and Agfa color plates for magazines including *Country Gentlemen* and *Ladies' Home Journal*.

HERBERT LYMAN EMERSON Born August 2, 1908, San Diego; died September 14, 1983, Mill Valley, California. Attended California Institute of Technology; studied with photographer Will Connell at the Art Center School of Los Angeles, which Emerson helped found. In 1929 began working as an advertising photographer in Los Angeles and later in San Francisco, until retiring in 1978. Clients included Dole, Hunts, Sunkist, Inc., Pacific Gas and Electric, Dana Perfumes, and Walt Disney.

HANS FINSLER Born December 7, 1891, Zurich; died 1972, Zurich. Studied architecture at the Technische Hochschule, Munich, 1909–14; studied art history, 1914–18; self-taught in photography. Established studio in Zurich; worked as free-lance photographer in Halle and Zurich, 1922–72. Was librarian and taught art history at Kunstgewerbeschule, Halle, Germany, 1922–32; founded class on "Object Photography." Became head of department of photography at Kunstgewerbeschule in 1932 until retirement in 1958.

GRANCEL FITZ Born William Grancel Fitz, August 17, 1894, Philadelphia; died May 12, 1963, New York. Began photographing as a hobby in 1914; won many awards in pictorial photography salons, 1916–20. Began career as an illustrator in Philadelphia, 1920. In 1929 established photography studio in New York; major clients included Chrysler Corp., Chevrolet Motor Car Division, Westinghouse Electric Corp., and AT&T.

EDWARD P. FITZGERALD American. Commercial photographer, active 1940s and 1950s in Philadelphia. Clients included Tennessee Eastman Co.

LESLIE GILL Born 1908, Cumberland, Rhode Island; died 1958, New York. Graduated with honors in fine arts from Rhode Island School of Design, 1930. Painted in Greenwich Village, 1930–32. Became art director of *House Beautiful*, 1932. Abandoned painting for photography in 1936 when he opened a commercial studio in New York. Worked for *Harper's Bazaar* and other magazines as fashion, portrait, and still-life photographer. Worked with Alexey Brodovitch at *Harper's Bazaar*; photographed for *Life*, *McCall's*, *Town & Country*, *Flair*, and *Holiday*.

GEORGE GREB STUDIOS American firm, active 1940s–50s. Collaborated with Underwood and Underwood Commercial.

RUZZIE GREEN Born Kneeland l'Amoureux Green, October 28, 1892, New York [?]; died 1956. Studied at the Art Students League, New York, c. 1913. Commercial layout designer, 1920s. Shared studio with Nickolas Muray, 1930s. Art director for *Harper's Bazaar* and Stehli Silks Corp., 1930s. Clients included *Redbook*, *Ladies' Home Journal*, Cadillac Motor Car Division, Lucky Strike Cigarettes, Palmolive-Peet Company, Camel Cigarettes, and Personal Products Corporation.

RICHARD GRIFFIN See Alton Kelly and Richard Griffin.

TORKIL GUDNASON Born November 18, 1947, Denmark. Educated in Denmark; studied photographic theory. Assistant photographer in Paris, 1972–74. Free-lance photographer in Denmark; emigrated to New York, 1979. Primarily an editorial photographer; clients include German, Italian, and American *Vogue*, Donna Karan, and Bill Blass. Has taught fashion photography at the School of Visual Arts, New York. Lives and works in New York.

JOHN HAVINDEN Born 1909, London; died July 15, 1987, London. Known as a modernist photographer. Began his commercial career in London, 1929. Opened studio as product photographer, 1932. Clients included General Electric Co. and Standard Car. Abandoned photography at the onset of World War II.

JOHN HEARTFIELD Born Helmut Herzfeld, June 19, 1891, Berlin; died April 26, 1968, East Berlin. Studied painting and drawing with Hermann Bouffier and at the Volksschule in Wiesbaden, 1905–6. Studied art at the Kunstgewerbeschule, Munich, 1907–11, and Kunst- und Handwerkschule, Berlin-Charlottenberg, 1912–14. Began working in photomontage with painter Georg Grosz, c. 1916. Helped found the Dada group in Berlin, 1918. Lived in Prague five years; resumed work in London, 1938–39, 1941–50. Worked as graphic artist and theater designer in East Berlin, 1951–61. Taught at the Deutsche Akademie der Künste, East Berlin, from 1960 until his death.

PAUL HESSE Born 1896, Brooklyn, New York; died 1973, California. Graduated from Pratt Institute of General Art, New York, 1913. Worked as illustrator in the studios of International Art Service, c. 1918. Began to experiment with and study photography. Opened studio for advertising photography in New York, mid-1920s. Was among the first photographers to use color photography in national ad campaigns. In 1940 moved studio to Hollywood, California, where he photographed movie stars for *Photoplay*; worked on Reingold Beer campaign for twenty-five years. Other clients included Lux Soap, Studebaker, Chesterfield, Andrew Jergens Co., the Pennsylvania Railroad, and Trans World Airlines. Retired in 1963.

LEJAREN À HILLER Born 1880, Milwaukee, Wisconsin; died 1969. At fifteen was apprenticed as lithographer. Studied at the Chicago Art Institute, 1896–1902. Moved to New York, worked as a free-lance illustrator and painter of magazine covers; promoted use of photographs for illustrations as early as 1908. Hiller's photographs were the first to be used—by *Cosmopolitan*—to illustrate a story. Studied in Paris, then returned to New York to work as a cover illustrator for *Life* and *Munsey's*. Worked for Underwood and Underwood Commercial, 1929. Became well known for his dramatic sets and use of theatrical lighting.

LEWIS WICKES HINE Born September 26, 1874, Oshkosh, Wisconsin; died November 4, 1940, Hastings-on-the-Hudson, New York. In Oshkosh worked manual jobs while studying at night, 1892–1900; studied education at University of Chicago, 1900–1902, and New York University, 1901–5; studied sociology,

Columbia University, 1907. Self-taught in photography. Photographer for the Ethical Culture School, New York, under Frank Manny, 1901–8. Free-lance documentary photographer for numerous social agencies, including the National Child Labor Committee, 1906–18, 1921–22; Red Cross, 1931; National Research Project, 1936–37.

HIRO Japanese, born Yasuhiro Wakabayashi, November 3, 1930, Shanghai, China. Public education in China and Tokyo, 1937–49. Assistant to Rouben Sanberg, New York, 1954–55. Studied with Alexey Brodovitch at the New School for Social Research, New York, 1956–58. Assistant to Richard Avedon, 1956–57; partner in Avedon Studio until 1971. Assistant to Alexey Brodovitch, 1958–60. Established own studio in New York in 1958 as free-lance magazine and fashion photographer. Staff photographer for *Harper's Bazaar*, 1966–74. Numerous clients have included Chanel, Inc., Revlon, Inc., Hanae Mori, Inc., and Tiffany & Co.

M. LUTHER HOFFMANN Born July 12, 1913, Philadelphia. Apprentice photographer in W. H. Hoedt Studio, Philadelphia, under Fred Goodwin and Francis Feist, 1927. Continued as photographer in Hoedt Studio, becoming a partner in 1956. Numerous clients included Wallace Silver, RCA, Philco, Du Pont, Abbotts Laboratories, Hamilton Watch Company, and *Ladies' Home Journal*. Retired in 1972 and lives in New Jersey.

GEORGE HOLZ Born 1956, Oak Ridge, Tennessee. Educated University of Tennessee and Art Center College of Design, Pasadena, California. Assisted Helmut Newton. Worked in Milan for Italian *Vogue, Lei,* and *Linea Italiana*. Currently works as advertising and editorial photographer in New York. Clients have included International Gold Corporation, Inc., Elizabeth Arden, Inc., DeBeers Consolidated Mines, Ltd., Revlon, Inc., and Kohler Co.

RYSZARD HOROWITZ Born May 5, 1939, in Krakow, Poland. Survived internment in Auschwitz, 1945. Attended Fine Arts Academy in Krakow. Moved to New York in 1959 to study design at the Pratt Institute with Alexey Brodovitch. Became art director for Grey Advertising. In 1967 opened studio in New York; works in fashion, editorial, and

advertising photography. Clients have included Calvin Klein, Toshiba, Lincoln-Mercury, Saks Fifth Avenue, and *Wall Street Journal*.

EIKOH HOSOE Born Toshihiro Hosoe, March 18, 1933, Yonezawa, Yamagata Prefecture, Japan. Studied photography at the Tokyo College of Photography, 1951–54. Since 1954 has worked as free-lance photographer in Tokyo. Has taught photography at the Tokyo Institute of Polytechnics since 1975. Among other awards, was Photographer of the Year, Japan Photo Critics Association, 1963. His extended photographic portrait of Japanese novelist Yukio Mishima was published in 1963 as *Killed by Roses*, reissued as *Ba-ra-kei*, 1971, 1985.

EUGENE HUTCHINSON American. Studied literature at Keenly Institute in Chicago. Apprenticed under New York society photographer known as "Histead." Opened a portrait studio in Chicago and in Lake Forest, Illinois, around 1912. By 1918 was working in advertising photography. Clients included Vanity Fair Mills, Inc., *Town and Country, Harper's Bazaar,* and *House Beautiful*. Moved studio to New York City in 1930. Was associated with Underwood and Underwood Commercial.

DOMINIQUE ISSERMANN Born April 11, 1947, Paris. Studied French and English at the École Normal Superior of the Sorbonne; self-taught in photography. Began as free-lance editorial portrait photographer for Gamma/Sigma agency. Began fashion photography in 1979 for designer San Miguel. Commercial work includes both still photography and television. Clients have included Sonia Rykiel, Dior, American and French *Vogue, Elle, The New York Times Magazine, Esquire*, Maud Frizon, and Parco Co., Ltd., Japan. Lives and works in Paris.

LOTTE JOHANNA JACOBI Born August 17, 1896, Thorn, West Prussia. Educated at the Königliche Louisenschule, Posen, 1902–12; studied art history and literature at the Academy of Posen, 1912–16. Attended Bavarian State Academy of Photography, Munich, and the University of Munich, 1925–27. Directed family photography studio, Berlin, 1927–35. Emigrated to the United States, 1935; naturalized American citizen, 1940. Opened studio in New York as free-lance photographer, 1935–55; experimented with "photogenics," 1950. In 1955 moved to Deering, New Hampshire, where she now lives and works. Founded Department of Photography, Currier Gallery of Art, Manchester, New Hampshire, 1970.

ALFRED CHENEY JOHNSTON Born 1884, New York (?); died 1971. Active as a fashion and portrait photographer, c. 1915–28. Worked for *Vanity Fair* and *Vogue*; early proponent of Autochrome and color carbro processes. Contract photographer for Ziegfeld Follies, 1917–27. After 1928 he moved from the city and photographed only occasionally. By the late 1930s he had become a virtual recluse.

BISHIN JUMONJI Born 1947, Yokohama. Attended Technological Institute, Institute for Industrial Design, and Kanagawa Prefectural Industrial Science School. Was an assistant to Kishin Shinoyama in Tokyo, 1969–71. Since 1971 has worked as a free-lance photographer in Tokyo. His clients have included Shiseido Co., Ltd., Matsushita Electric Co., Parco Co., Ltd., Seibu, and Sony Corp.

BARBARA KASTEN Born 1936, Chicago, Illinois. Graduated from University of Arizona, 1959, and from California College of Arts and Crafts, 1970. Studied weaving in Poland, 1971–72; National Endowment of the Arts Photography Fellowship, 1977; John Simon Guggenheim Fellowship, 1982. Since 1984 work has been used in advertising by Minolta Camera Co., Quark, Inc., and others; has photographed for *Esquire, Digital Review,* and *Ornament* magazines. Lives and works in New York.

KAZUO KAWAI Born 1944, Japan. Commercial photographer with studio in Tokyo. Clients have included Toyo Roshi Kaisha, Ltd.

TOM KELLEY Born December 11, 1911, Brooklyn, New York; died January 7, 1983, Malibu, California. Self-taught in photography. At age sixteen worked as a photographer in the studio of Arnold Genthe. By 1931 was free-lance editorial photographer and staff photographer for Associated Press; photographed political, social, and business leaders for *Town & Country* magazine. Moved studio to California, late 1940s; continued to photograph the famous. Photographed a nude Marilyn Monroe for *Playboy* magazine, 1953. Later expanded into advertising; clients included Du Pont, Ford Motor Co., Max Factor, Studebaker, Weber Bread, BMW, and The Coca-Cola Co.

ALTON KELLY AND RICHARD GRIFFIN Americans. Graphic artists active in California in the 1960s. Most noted for their design of posters for San Francisco rock concerts at the Avalon Ballroom and Fillmore West Auditorium.

VICTOR KEPPLER Born September 30, 1904, New York; died December 1, 1987, New York. Graduated from Stuyvesant High School, New York, 1922. Self-taught in photography. Worked as photographer in the Fingerprint Bureau, New York, 1926–28. Began working in advertising and magazine photography, 1927. During World War II worked for the U.S. Treasury Department producing ads and posters for war bonds. Numerous clients included Corning Glass, Eastman Kodak Co., United States Steel Corp., and General Electric Co. Founded and directed Famous Photographers' School, Westport, Connecticut, 1961–72. In 1981 was director of the Center of Continuing Education International, a program for teaching art, writing, sculpture, and photography to amateurs.

GUSTAV GUSTAVOVICH KLUTSIS Born January 4, 1895, near Volmar, Latvia; died 1944. Attended seminary in Volmar; studied art in Riga and Petrograd, 1913–15. Took part in the February and October Revolutions. Studied art with Konstantin Korovin in Moscow, 1918; then transferred to the studio of Kasimir Malevich, 1919–20. By the 1920s was working in photomontage and graphics; produced art for the masses in the form of posters, graphics, and book covers. Helped found the artist group "October" in 1928. Was arrested during Stalinist purges, 1938; died in a Kazakhstan labor camp.

FRANÇOIS KOLLAR Born October 8, 1904, Szenc, Hungary; died July 3, 1979, Créteil, France. Practiced photography as a teenager. Head of Draeger printing studio in 1928. Worked for Chevojon and Lecram agency beginning in 1930. By 1932 work appeared in *Harper's Bazaar, Vendre, Plaisir de France, Vu,* and *Voilà.* Decorated French Pavilion at New York World's Fair, 1939. Worked for *Harper's Bazaar* until 1949. After World War II traveled to Africa; continued as free-lance photographer.

KAZUMI KURIGAMI Born 1936, Japan. Fashion photographer; active in the United States; lives in Tokyo. Clients have included Parco Co., Ltd., Tokyo.

ANNIE LEIBOVITZ Born October 2, 1949, Connecticut. Studied art, then photography at San Francisco Art Institute, 1967–70. Studied photography with Ralph Gibson. Worked for *Rolling Stone* magazine, 1970–83. Well known for portraiture. Currently does editorial photography for *Vanity Fair* magazine and free-lance advertising photography.

SERGE LUTENS Born 1942, Lille, France. Designed theater sets and costumes, sculpture, and jewelry, 1956–67. In 1970 turned to photography; work has appeared in *Vogue* and *Elle.* Clients have included Shiseido Co., Ltd. Lives and works in Paris.

JAY MAISEL Born January 18, 1931, Brooklyn, New York. Studied painting with Joseph Hirsch, 1949, and at Cooper Union, New York, 1952. Graduated from Yale University, 1953. Studied with Herbert Matter, 1954, and Alexey Brodovitch, 1956. Free-lance photographer for advertising, annual reports, and magazines since 1954. Lives and works in New York.

ROBERT MAPPLETHORPE Born November 4, 1946, New York. Studied at Pratt Institute, Brooklyn, New York, 1963–70; produced underground films, 1965–70. Since 1973 has been free-lance photographer in New York. Best known for his portraits and still lifes in black and white; also works with Polaroid and in color. His work has been used in advertising and has appeared in Italian and American *Vogue, GEO* (U.S.A.), and others.

HERBERT MATTER Born 1901, Switzerland; died 1984, New York. Studied painting at École des Beaux-Arts in Geneva, 1925–27, and at the Académie Moderne in Paris, 1928–29. Worked in Paris, then returned to Switzerland in 1932 to work for the Swiss National Tourist Office. Emigrated to New York, 1936; worked as free-lance commercial photographer for *Vogue* and *Harper's Bazaar.* Designed Swiss Pavilion and Corning Glass Pavilion at New York World's Fair, 1939; staff photographer for Editions Condé Nast, 1946–57. Taught photography at Yale University, 1952–76.

SOL MEDNICK Born October 30, 1916, Philadelphia; died April 12, 1970. Learned photography in father's studio. Studied art at the Philadelphia College of Art and the Philadelphia Museum School of Industrial Art under Alexey Brodovitch. Began career as a free-lance illustrator and designer, 1939; turned to photography. Moved studio to New York in 1949 while continuing to live in Philadelphia. Clients included Carrier Corporation, Chrysler Corporation, and Maltine Corporation. Developed the Photography Department at the Philadelphia College of Art and taught there from 1951 until his death.

ERIC MEOLA Born 1946, Syracuse, New York. Received B.A. in English Literature at Syracuse University, 1968; self-taught in photography. Assistant to Pete Turner, 1969–70.

Editorial photographer for *Life, Travel and Leisure, Esquire,* and *Time,* 1970–75. Since 1975 has been corporate photographer with studio in New York. Clients have included Nikon, Inc., Porche, R. J. Reynolds Tobacco Co., Seagram Distillers Co., IBM, General Electric Co., and Polaroid Corp.

HOLMES I. METTEE Born May 1881, Philadelphia; died September 1947, Baltimore. Self-taught in photography; exhibited at salons in the United States, Canada, and Europe. Moved to Baltimore, 1918; photographed dance artists such as Ruth St. Denis and Ted Shawn. Opened professional studio, 1924. Worked in advertising and commercial photography; noted for early use of color. Covered local assignments for *Fortune* and *Life* magazines. Other clients included Armstrong Cork Co., Western Electric, Amoco, and Black and Decker. The Mettee Studio continues under his son, N. Boyd Mettee.

DUANE MICHALS Born February 18, 1932, McKeesport, Pennsylvania. Graduated from University of Denver, 1953. Studied at Parsons School of Design, New York, 1956–57. Assistant art director, *Dance Magazine,* New York, 1957. Worked in design studio; began to photograph while in the USSR, 1958. Has worked as free-lance commercial and advertising photographer for *Esquire, Mademoiselle, Vogue,* and *Horizon,* since 1958. Has taught at the New York School of Visual Arts. Studio is in New York.

KAZUYOSHI MIYOSHI Born 1958, Japan. Studied literature; self-taught in photography. Clients have included Eastman Kodak Co., Americaya Ltd., Toyota, and Polydor Records.

LÁSZLÓ MOHOLY-NAGY Born July 20, 1895, Bacsborsod, Hungary; died November 24, 1946, Chicago, Illinois. Studied law at the University of Budapest, 1913–14, 1918–19, serving with army in Odessa in between. Began painting in Odessa, 1918; continued to paint and write in Vienna and Berlin; associated with the Constructivists and Dada group. In 1922 began experimenting with photograms. Founded and directed department of photography at the Bauhaus in 1923. Established commercial design studio in Berlin, 1928–34. Emigrated to United States, 1937; founded and directed the New Bauhaus School (became School of Design, then Institute of Design), Chicago, 1937–46. Naturalized American citizen, 1944.

NICOLAS MONKEWITZ Born 1948, Zurich, Switzerland. Early education in Zurich; self-taught in photography. Worked as a photographer in Turkey. Returned to Zurich after traveling in England and Ireland. Attended photography classes at the Kunstgewerbeschule, Zurich, late 1960s. Currently free-lance advertising photographer with studio in Zurich.

SARAH MOON French, born Marielle Hadengue, 1940 in England. Studied drawing. Fashion model in Paris during 1960s. Self-taught in photography; free-lance fashion and product photographer since 1968. Clients have included Cacharel, Woolmark, *Harper's Bazaar, Vogue, Elle,* and *Marie-Clair.*

ANTONIA MULAS Italian, born 1939. Free-lance photographer in Milan. Has produced several books from personal work: *Eros dell'antichita classica* (1974–75), *La Scala a Mosca* (1974), *Il muro di Berlino* (1976), *San Pietro* (1979), *Eros in Grecia* (1985). Commercial clients have included Frau Furniture.

NICKOLAS MURAY Born February 15, 1892, Szeged, Hungary; died November 2, 1965, New York. Studied lithography, photography, and photogravure at Graphic Arts School, Budapest, 1904–8, and color photogravure at National Technical School, Berlin, 1909–11. Emigrated to United States, 1913; naturalized American citizen. Worked as color-separation printer, 1913–16, and color print processor for Condé Nast, 1916–21. Known for his portraiture; also worked in advertising and fashion photography for *Vogue, Vanity Fair, Harper's Bazaar, McCall's, Ladies' Home Journal,* and others from 1921 until his death.

UWE OMMER Born September 15, 1943, Cologne, Germany. By age eighteen had won the Grand Prize in Photography for German youth. Went to Paris, mid-1960s. A commercial free-lance photographer, now lives and works in Paris. Clients have included Charles Jourdan, Inc.

PAUL EVERAD OUTERBRIDGE, JR. Born August 15, 1896, New York; died October 17, 1958, Laguna Beach, California. Studied anatomy and aesthetics at Art Students League, New York, 1915–17; studied photography at the Clarence White School, New York, 1921–22, and sculpture with Alexander Archipenko,

New York, 1923–24. Began as free-lance photographer in New York, 1922; worked for *Vogue, Harper's Bazaar,* and *Vanity Fair.* Established studio in Paris, 1927–28, then in Monsey, New York, 1929–43; worked in color carbro process for advertising and magazines.

ONOFRIO PACCIONE Born 1927, Bensonhurst, New York. Graduated from Brooklyn Community College, 1949, with degree in advertising. Assistant to Paul Rand at the William H. Weintraub agency, 1949–54. Assistant art director, then art director and co–creative director, Grey Advertising, 1954–59. Became partner with Leber, Katz agency, 1960–69. Opened photographic studio in New York, 1969.

IRVING PENN Born June 16, 1917, Plainfield, New Jersey. Attended Philadelphia Museum School of Industrial Art, 1934–38; studied design with Alexey Brodovitch. Worked as commercial artist for Brodovitch at *Harper's Bazaar,* 1938–41. Began to use photography for design of *Vogue* covers, 1943–44. From 1946 worked with Alexander Lieberman, Condé Nast Publications, New York. Established studio, 1952, for free-lance advertising, editorial, fashion, and portrait photography. Clients have included Clinique Laboratories, Inc., Chanel, Inc., DeBeers Consolidated Mines, Inc., General Foods (Jell-O), Fuji Photo Film, L'Oréal, and Plymouth.

JOHN PAUL PENNEBAKER American, active 1930s. Studied painting at Corcoran Art School, Washington, D.C., and Academy of Fine Arts, Chicago. Portrait photographer for Underwood and Underwood Commercial in Washington, D.C. Transferred to the Underwood studios in New York to work as an advertising, fashion, and still-life photographer. Applied technique of photomontage to fashion photography.

DENIS PIEL Australian, born 1944, France. Worked as commercial photographer in Australia until 1969. Moved to Europe; worked as editorial fashion photographer in France and England until 1979, when he relocated to New York. Photographs have appeared in *Elle, Marie-Claire, Votre Beauté,* and American *Vogue.* Clients have included Albert Nipon, Inc., Donna Karan, Max Factor, Revlon, Inc., L'Oréal, Harvé Bernard, Anne Klein II, and Benson & Hedges. In 1986 with Mason Boyd formed Jupiter Films, Inc., a production company for television commercials. Lives and works in New York.

PAUL LÁSZLÓ RADKAI Born Paul László Ratkai, August 2, 1915, Budapest, Hungary. Emigrated to the United States in 1934 (later became naturalized American citizen) with hopes of becoming an actor. Studied news photography under Martin Munkacsi, then turned to advertising photography. Opened studio in New York, mid-1940s. Clients included Max Factor, Palmolive-Peet Co., Chevrolet Motor Car Division, Imperial Whiskey; also worked under Alexey Brodovitch at *Harper's Bazaar.* Moved studio to Paris, 1962, then to London until retiring. Now lives in France.

ORIO RAFFO Born 1936, Milan. Began career as photojournalist. Studied black-and-white photography with Ugo Mulas. Worked in several studios, including Photolight and Centrokappa. Since 1979 has worked in advertising photography with B Communications studio in Milan. Clients have included Estée Lauder, Inc., Duracell, Lazzaroni, Belfe, Citroën, Coin, Kartell, and Cassina.

JOHNNY RASMUSSEN Born 1946, Cali, Colombia. Attended University of Barcelona, Spain; studied chemistry. In 1972 was head of Department of Photography of Carton, Colombia. Attended workshop in silkscreen with Pablo Obelar at the Museo Rayo. Work has been used in antidrug campaigns and has been exhibited in Europe, the United States, and Colombia. Lives and works in Cali, Colombia.

EARL CARLETON ROPER Born 1888; died September 13, 1967, Philadelphia. Commercial, portrait, and illustration photographer. Operated a studio in Philadelphia until 1941. From 1941 to 1948 was technical representative for Eastman Kodak Co. in Ohio, transferring to Philadelphia from 1948 until his retirement from Kodak in 1957. Was member of Society of Commercial Photographers and Guild of Professional Photographers since the late 1920s.

JAROSLAV ROSSLER Born May 25, 1902, in Smilov, Czechoslovakia. Apprenticed in portrait studio of František Drtikol in Prague, 1921–26. Studied bromoil printing technique in studio of Manuel Brothers, Paris, 1926–27. Photographed for the weekly *Pestrý týden* and for the Prague theater, 1927–28. Photographed for Studio Lorelle and Studio Piaz in Paris, 1928–35. Established portrait studio in Prague, 1935–51. From 1951 until retirement in 1964, was associated with Studio Fotographia, Prague.

AUGUST SANDER Born November 17, 1876, Herdorf, Germany; died 1964, Cologne. Studied at Academy of Painting, Dresden, 1901–2; self-taught in photography. Assistant in studios in Magdeburg, Chemnitz, Berlin, Dresden, and Linz, Austria, 1898–1904; opened studio in Linz, 1904–9. Moved studio to Cologne-Lindenthal; worked in portrait, advertising, and industrial photography, 1910–44. In 1920 began work on book *Men of the 20th Century*. Retired to Kuchhausen in the Westerwald where he pursued landscape photography from 1944 until shortly before his death. Recipient of the Federal Order of Merit, West Germany, 1961.

XANTI SCHAWINSKY Born Alexander Schawinsky, March 25, 1904, Basel; died September 11, 1979, New York. Studied art and architecture in Basel and Zurich, 1915–22; architecture and graphic design at the University of Cologne and Akademie der Künste, Berlin, 1922–23. Worked as designer in Germany and Italy, 1929–36. Emigrated to United States, 1936; naturalized American citizen, 1939. Taught art at Black Mountain College, Beria, North Carolina, 1936–38, and at City College of New York and New York University, 1943–54. Free-lance photographer and artist in New York and Oggebbio, Italy, from 1954 until his death.

JEFFREY K. SCHEWE Born February 22, 1954, Chicago, Illinois. Graduated from Rochester Institute of Technology, Rochester, New York, 1978. Free-lance commercial photographer in Chicago. Clients have included McDonald's, Burger King, Hyatt Corporation, Anheuser-Busch, and Wolverine Technologies.

PAUL SCHUITEMA Born 1897, Rotterdam; died 1973, Wassenaar, the Netherlands. Educated as a painter at Rotterdam Academy, 1915–20. Began as graphic designer. Member of Opbouw, a group of architects and designers, 1920s; met El Lissitzky and J. J. P. Oud. In 1927 joined "der ring neuer werbegestalter"; became aware of the international avant-garde; began to photograph. His work was included in the exhibition *Film und Foto*, 1929. Became professor of graphic design at academy in The Hague, 1930. Began designing furniture, 1939. With Piet Zwart was one of the leaders of Dutch modernist photography.

TIM SIMMONS Born 1955, Wood Green, England. Developed interest in photography, 1979. Began as free-lance assistant; established studio, 1982. Recognized for strong lighting style and photographs of people. Clients have included Virgin Atlantic Airlines.

LOUIS WALTON SIPLEY Born April 10, 1897, Maywood, New Jersey; died October 18, 1965, Philadelphia. Educated at Bucknell University, Lewisburg, Pennsylvania; degrees in science, mechanical engineering, and electrical engineering in 1918, 1920, and 1923. Founded American Museum of Photography, Philadelphia, 1940. Author of *Paintings by Later American Artists* (1939); *A Half Century of Color* (1951); *Frederick Ives* (1956); *A Collector's Guide to American Photography* (1957); and *The Photomechanical Halftone* (1958).

VICTOR SKREBNESKI Born 1930, Chicago, Illinois. Studied art at Institute of Design, Illinois Institute of Technology, painting and sculpture at Roosevelt and Northwestern universities; self-taught in photography. Opened studio in early 1950s; produced photo essays on movie stars; well known as portrait photographer; also worked in fashion, editorial, and advertising photography. Major accounts have included Marshall Field, Montgomery Ward, Estée Lauder, Inc., I. Magnin, and *Town & Country* and *Interview* magazines.

EDWARD STEICHEN Born Eduard Steichen, March 27, 1879, Luxembourg; died March 25, 1973, West Redding, Connecticut. Emigrated to the United States, 1881, naturalized American citizen, 1900. Interest in photography began while apprenticed as lithographer. Studied art in Paris and New York, 1900–1914; cofounded the Photo-Secession, 1902. Gave up painting in the early 1920s to become fashion and portrait photographer; worked for Condé Nast, J. Walter Thompson Co., and others until 1938. Became first director of Department of Photography at The Museum of Modern Art, New York, 1947–62. Produced exhibition *Family of Man*, 1955. Among many awards, received Presidential Medal of Freedom, 1962.

BERT STERN Born October 3, 1929, Brooklyn, New York. Self-taught in photography. Began career as assistant to art director Hershel Bramson at *Look* magazine, 1946–48; art director at *Mayfair* magazine, 1949–51. Rejoined Bramson at L. C. Gumbiner advertising agency; Smirnoff vodka campaign was one of his earliest photographic efforts. Opened first of four studios, 1954. Major

accounts included United States Steel Corp., Revlon, Inc., I.B.M., *Vogue, Glamour,* and *Life.* Closed studio, 1971; lived in Spain, 1971–75. Currently works in New York.

GRETE STERN Born May 9, 1904, Elberfeld, Germany. Studied graphic design at Kunstgewerbeschule Weisenhof, Stuttgart, 1923–25; studied photography with Walter Peterhans, 1927–28. With Ellen Rosenberg (later Ellen Auerbach), cofounded Studio Ringl & Pit, which produced avant-garde advertising photography, 1930–33. Worked in London, 1933–36. Emigrated to Buenos Aires, 1937; naturalized Argentinian citizen, 1958. Director and photographer, Department of Correspondence of the Museo Nacional de Bellas Artes, 1956–70. Taught photography at Resistencia University, Chaco, 1959–60.

KEVIN SUMMERS Born March 9, 1956, Ipswich, England. Studied photography at Medway College, Kent; graduated 1977. Influenced by the work of Irving Penn and Guy Bourdin. Assistant photographer in several studios in London, 1977–81. Established studio, 1981; specialized in still-life, advertising, and editorial photography. Clients have included Benson & Hedges, BMW, Bell's Whiskey, Hague Whiskey, and *World of Interiors* magazine.

MAURICE TABARD Born July 12, 1897, Lyons, France; died February 1984, France. Studied violin, 1903–13. Moved to New York, 1918; studied photography at the New York Institute of Photography until 1922. Assistant photographer with Bachrach Studio, New York; worked in Cincinnati, Baltimore, and Washington, D.C., 1922–28. Returned to Paris as free-lance advertising, editorial, fashion, and portrait photographer, 1928–38. Established advertising studio for Deberny-Peignot publishers, 1930–31. Worked in Paris for Pathé Films, 1932, and Gaumont Films, 1936. Photographed for Alexey Brodovitch and Carmel Snow at *Harper's Bazaar*, 1946–50. Resumed free-lance work in Paris until 1965.

ISAIAH WEST TABER Born 1830, New Bedford, Massachusetts; died 1912, San Francisco. Moved from East Coast to San Francisco, 1849. Principal manager and possibly chief photographer for Bradley and Rulofson Studios, 1864–70. Opened studio, 1871; active until the 1880s.

SALOMON BENEDIKTOVITCH TELINGATER Born 1903, Tbilisi (Georgia); died 1969, Moscow. Finished his studies at the Azerbaydzhan Art Academy in 1920 and entered the Vhutemas in Moscow. From 1921 to 1925 worked in Baku (Azerbaydzhan) for the magazines *Molodoi rabotchi (The Young Worker)* and *Troud (Strength)*. Directed the art studio at the Communist Education House. Worked in publishing and typography in Moscow and collaborated in the journal *Poligrafitchyeskoe proizvodstvo (Polygraphic Production)*, 1925–27. Member of the group *Oktiabr (October)*, in the polygraphic section. Exhibited widely in 1927 and 1928. Continued in graphic arts, book design, and photomontage until his death.

PAUL TORCELLO Born 1954, Trieste, Italy. Emigrated to Australia, 1957. Studied painting and sculpture, Caulfield Institute of Technology, Prahran College of Advanced Education, Melbourne, 1974–75. Traveled throughout Europe, the Middle East, and Scandinavia, 1976–79. Studied at Photography Studies College, Melbourne, 1979–81. From 1983 to the present, has worked as a free-lance photographer in still-life, advertising, and fashion photography in Melbourne. Clients have included Ansett International Hotels and Resorts, Nike, Inc., Eastman Kodak Co., American Express International, Nylex, and Kraft.

DEBORAH TURBEVILLE Born July 6, 1937, Medford, Massachusetts. Attended Parsons School of Design, New York, 1955–57. Attended photography seminars conducted by Richard Avedon and Marvin Israel, 1958; design assistant to Claire McCardell, New York. Editorial assistant at *Ladies' Home Journal*, then fashion editor for *Harper's Bazaar* and *Mademoiselle*, 1960–71. Began career as free-lance fashion photographer, 1972; clients have included Jessica McClintock, Inc. and *Vogue* magazine.

DONALD P. (PETE) TURNER Born May 30, 1934, Albany, New York. Graduated from Rochester Institute of Technology, 1956; studied under Ralph Hattersley. Operated photographic lab during military service. Worked in New York as editorial photographer for magazines such as *Look, National Geographic, Horizon*, and *Esquire*, beginning 1958. Began working in advertising photography, 1962; established studio in New York, 1965. Included among many clients are Atlantic Bell, Vantage, and Kohler.

UNDERWOOD AND UNDERWOOD COMMERCIAL Begun by Elmer J. Underwood and his brother, Bert E. Underwood, in Ottawa, Kansas, 1882. Established to produce stereoscopic photographs, firm's activities extended to the West Coast by 1884. After 1886 offices opened in Baltimore, Toronto, New York, Chicago, and overseas. By 1896 were also producing news photographs for periodicals. Added portrait and commercial departments, 1914. Stereographic business sold to Keystone View Company, 1921. Company was reorganized into four separate corporations, 1931, with portrait and commercial portions continuing into the 1950s. Commercial division featured photographers such as Lejaren à Hiller, Eugene Hutchinson, Edward Scherck, Leon de Vos, Valentino Sarra, John Paul Pennebaker, and Walter Stork.

GERHARD VORMWALD Born 1948, Heidelberg. Studied painting and drawing, 1954–62; offset printing and photography, 1962–66. Studied commercial art, painting, and sculpture at Freien Akademie, Mannheim, 1966–70. Established studio, 1971. Photographer for National Theater, Mannheim, 1969–72, 1978–81. Moved studio to Paris, 1983. Resumed painting and drawing, free-lance photography and video, 1984.

F. W. WESTLEY British, active 1930s. Worked with Vivex color process at Color Photograph, Ltd., London.

STEPHEN WILKES Born October 28, 1957, New York. Graduated from Syracuse University, 1980; degrees in marketing and photography. Assistant, then associate, to Jay Maisel, 1981–83. Established studio in New York, 1983. Has created ad campaigns for Nike, Inc., The Coca-Cola Co., Equitable Life Assurance, Eastman Kodak Co., and Manufacturer's Hanover Trust.

H. I. WILLIAMS Born Harney Isham Williams, 1886, Ladoga, Indiana; died March 15, 1965. Graduated from Cincinnati Art Academy, 1910; commercial artist until 1919. Opened photographic studio in New York, 1926. Work included fashion, portraiture, and advertising photography; worked in the carbro process. Was fellow of the British Royal Photographic Society.

HENRY WOLF Born 1925, Vienna, Austria. Early education in France. Emigrated to the United States, 1941; studied design and photography in New York at School of Industrial Arts; studied painting with Stuart Davis. Worked as designer, 1945–47. Art director for Geer DuBois Advertising, 1947. Art director for Voice of America, U.S. Information Agency, 1950; *Esquire*, 1952–58; *Harper's Bazaar*, 1958; *Show* magazine, 1958–61; and Center for Advanced Practice, McCann Erickson, 1961–65; also continued as free-lance designer and photographer. Executive V.P. and creative director for Trahey/Wolf Advertising, 1966–71. Since 1971, president of Henry Wolf Productions, Inc. Clients have included Carven Parfums, Geoffrey Beene, Inc., and Karastan Rug Mills Division.

REINHART WOLF Born 1930, Berlin. Studied art history, literature, and psychology in the United States; continued studies in Paris and at Hamburg University. Earned Master Photographer degree from Bavarian State College of Photography, Munich, 1956. Established commercial photography studio in Hamburg. Founded production company for television commercials, 1969. Well known for editorial photography, including detailed images of food and dramatically lighted architectural subjects. Photographed for *Stern, GEO*, and other magazines.

NORIAKI YOKOSUKA Born 1937, Yokohama, Japan. Educated at Nihon University School of Art. A free-lance advertising photographer, has photographed extensively for Shiseido Co. Lives and works in Tokyo.

PIET ZWART Born May 28, 1885, Zaandijk, The Netherlands; died September 24, 1977, Wassenaar, The Netherlands. Educated at Rijksschool voor Kunstnijverheid, Amsterdam, 1902–7. Taught art history and drawing at Industrie-en-Huishoudschool voor Meisjes, Leeuwarden, 1909–19. Furniture and interior designer, from 1911; architect, graphic, and industrial designer, from 1919. Self-taught in photography, from 1924; combined photograms and photography in his designs. Taught design and decoration, Academie van Beeldende Kunsten en Technische Wetenschappen, Rotterdam, 1919–33, and at the Bauhaus, Berlin, 1931. Free-lance graphic designer using photography, from 1945.

Compiled by Jeanne W. Verhulst

SELECTED BIBLIOGRAPHY

ADVERTISING, GENERAL

Abbott, David; Marcantonio, Alfredo; and O'Driscoll, John. *Is the Bug Dead?* New York, 1983.

Advertising Age. How It Was in Advertising: 1776–1976. Chicago, 1976.

Baudrillard, Jean. *La société de consommation: ses mythes, ses structures.* Paris, 1970.

Brown, Bruce W. *Images of Family Life in Magazine Advertising: 1920–1978.* New York, 1981.

Chapman, Simon. *Great Expectorations: Advertising and the Tobacco Industry.* London, 1986.

Dobrow, Larry. *When Advertising Tried Harder. The Sixties: The Golden Age of American Advertising.* New York, 1984.

Draper, Roger. "The Faithless Shepherd." *The New York Review of Books,* 26 June 1986, pp. 14–18.

Ewen, Stuart. *Captains of Consciousness: Advertising and the Social Roots of the Consumer Culture.* New York, 1976.

————, and Ewen, Elizabeth. *Channels of Desire: Mass Images and the Shaping of American Consciousness.* New York, 1982.

Forty, Adrian. *Objects of Desire: Design and Society from Wedgwood to IBM.* New York, 1986.

Fox, Stephen. *The Mirror Makers: A History of American Advertising and Its Creators.* New York, 1984.

French, George. *Advertising: The Social and Economic Problem.* New York, 1915.

Goode, Kenneth M. *Modern Advertising.* New York, 1932.

H., E. "Portraits in Advertising." *Photo Technique International* 2 (May, June, July 1987): 48–55.

Haug, W. F. *Critique of Commodity Aesthetics: Appearance, Sexuality and Advertising in Capitalist Society.* Translated by Robert Bock. Minneapolis, 1986.

Holme, Bryan. *Advertising: Reflections of a Century.* New York, 1982.

Hower, Ralph M. *The History of an Advertising Agency.* Cambridge, MA, 1939.

Huxley, Aldous. "Advertisement." In *Essays: New and Old,* pp. 126–31. New York, 1927.

Key, Wilson Bryan. *The Clam-Plate Orgy and Other Subliminal Techniques for Manipulating Your Behavior.* Englewood Cliffs, NJ, 1980.

———. *Media Sexploitation.* Englewood Cliffs, NJ, 1976.

———. *Subliminal Seduction.* Englewood Cliffs, NJ, 1972.

Leiss, William; Kline, Stephen; and Jhally, Sut. *Social Communication in Advertising: Persons, Products, and Images of Well-Being.* London, 1986.

Levenson, Bob. *Bill Bernbach's Book: A History of the Advertising That Changed the History of Advertising.* New York, 1987.

Lois, George. *The Art of Advertising.* New York, 1977.

Marchand, Roland. *Advertising the American Dream: Making Way for Modernity, 1920–1940.* Berkeley and Los Angeles, 1985.

McLuhan, Marshall. "Ads: Keeping Up With the Joneses." In *Understanding Media: The Extensions of Man.* New York, 1971. Reprinted in *Advertising's Role in Society,* edited by J. S. Wright and J. E. Mertes, pp. 5–9. New York, 1974.

Naether, Carl A. *Advertising to Women.* New York, 1928.

Ogilvy, David. *Confessions of an Advertising Man.* New York, 1980.

Pollay, Richard W., ed. *Information Sources in Advertising History.* Westport, CT, and London, 1979.

Schudson, Michael. *Advertising, the Uneasy Persuasion: Its Dubious Impact on American Society.* New York, 1984.

Scudiero, Maurizio, and Leiber, David. *Depero Futurista and New York: Futurism and the Art of Advertising.* Rovereto, 1986.

Vestergaard, Torben, and Schroder, Kim. *The Language of Advertising.* Oxford and New York, 1985.

ADVERTISING, PHOTOGRAPHY IN

Ades, Dawn, et al. *The 20th-Century Poster: Design of the Avant-Garde.* New York, 1984.

"Advertising and Fashion Photography: A Short Survey." *The British Journal of Photography* 128, no. 6295 (20 March 1981): 300–305, 313.

Association of Fashion, Advertising and Editorial Photographers. *AFAEP Awards.* London, 1986.

Atkinson, E. Sue. "Cigarette Advertising: A History." *The British Journal of Photography* 128, no. 6330 (20 November 1981): 1190–95, 1199.

———. "Photography in Advertising [Part 1]." *The British Journal of Photography* 132, no. 6518 (5 July 1985): 749–51, 754.

———. "Photography in Advertising [Part 2]." *The British Journal of Photography* 132, no. 6528 (13 September 1985): 1024–27, 1031.

Baker, Stephen. *Visual Persuasion: The Effect of Pictures on the Subconscious.* New York, 1961.

Barthes, Roland. "The Photographic Message." (1961) Reprinted in *Image, Music, Text,* pp. 15–31. Translated by Stephen Heath. New York, 1977.

———. "Rhetoric of the Image." (1964) Reprinted in *Image, Music, Text,* pp. 32–51.

———. "Depth Advertised." In *The Eiffel Tower and Other Mythologies,* translated by Richard Howard, pp. 47–49. New York, 1979.

Bertonati, Emilio. *Das experimental Photo in Deutschland.* Munich, 1978.

Bojko, Szymon. *New Graphic Design in Revolutionary Russia.* Translated by Robert Strybel and Lech Zembrzuski. New York, 1972.

Bouqueret, Christian, and Chavanne, Blandine. *La nouvelle photographie en France 1919–1939.* Poitiers, 1986.

Briggs, W. G. *The Camera in Advertising and Industry.* New York and Chicago, 1939.

Burgin, Victor. *Between.* London, 1986.

———. "Photographic Practice and Art Theory." In *Thinking Photography,* edited by Victor Burgin, pp. 39–83. London, 1982.

Dentsu Incorporated. *30 Years of Dentsu Advertising Awards.* Tokyo, 1978.

Durand, Jacques. "Rhétorique et image publicitaire." *Communications* 5 (1970): 70–91.

Goldberg, Vicki. "The Art of Salesmanship." *American Photographer* 18, no. 2 (February 1987): 28, 30.

Gottschall, Edward M., ed. *Advertising Directions Three: Photography.* Trends in Visual Advertising. New York, 1962.

Graeff, Werner. *es kommt der neue fotograf!* Berlin, 1929.

Guillot, Laure Albin. *Photographie Publicitaire.* Paris, 1933.

Hine, Thomas. *Populuxe.* New York, 1986.

Huxtable, Ada Louise. "Advertising Art: Indelible Images and Cultural Commentary." *The New York Times,* 1 March 1979, p. C10.

International Center of Photography. *Art & Advertising: Commercial Photography by Artists.* New York, 1986.

Ishioka, Eiko. *Eiko by Eiko.* Tokyo and New York, 1983.

Kepes, Gyorgy. *Language of Vision.* Chicago, 1959.

Khan-Magomedor, Selim O. *Rodchenko: The Complete Work.* Translated by Hirn Evans. Cambridge, MA, 1986.

Kruger, Barbara. *We won't play nature to your culture.* London and Basel, 1983.

Lavin, Maud. "Advertising Utopia: Schwitters as Commercial Designer." *Art in America* 73, no. 10 (October 1985): 135–39, 169.

Lears, Jackson. "The Artist and the Adman." *Boston Review,* April 1986, pp. 5–6, 22–26.

Lewis, Harvey S. "Commercial Photography and Its Adaptation to Modern Advertising." *Western Camera Notes,* serialized, beginning 5, no. 10 (October 1904) to 6, no. 7 (July 1905).

Lodder, Christina. *Russian Constructivism.* New Haven, 1983.

Musée de la Publicité (UCAD). *30 Ans de photographie publicitaire au japon.* Paris, 1984.

Nagai, Kazumasa, and Kaji, Yusuke. *Creative Works of Shiseido.* Tokyo, 1985.

Nurnberg, Walter. *The Science and Technique of Advertising Photography.* London and New York, 1940.

Nye, David E. *Image Worlds: Corporate Identities at General Electric.* Cambridge, MA, 1985.

Paccione, Onofrio. "Advertising Photography." In *Advertising Directions Two: Trends in Visual Advertising,* edited by Arthur Hawkins and Edward Gottschall, pp. 25–32. New York, 1961.

Pagano, Inc. *Photographs for Advertising.* New York, n.d. [c. 1932].

Parco Co., Ltd. *Parco Advertisement Art: 1980–1986.* Tokyo, 1986.

———. *Parco Ad Work: 1969–1979.* Tokyo, 1979.

Péninou, Georges. "Physique et métaphysique de l'image publicitaire." *Communications* 5 (1970): 96–109.

Rose, L. G. *The Commercial Photographer.* Philadelphia, 1920.

Rosenblum, Barbara. *Photographers at Work: A Sociology of Photographic Styles*. New York, 1978.

Sanna, Gavino. *Pubblicità senza parole*. Turin, 1987.

Schott, John. "Photo Texts/Media Context." In Society for Photographic Education, *New Order/No Order*, pp. 17–22. New York, 1986.

Shogakukan, Ltd. *Advertising Photography. The Complete History of Japanese Photography*. Vol. 11. Tokyo, 1986.

Spielmann, Heinz. *Die japanische Photographie: Geschichte, Themen, Strukturen*. Dumont Foto 5. Cologne, 1984.

Stapely, Gordon, and Sharpe, Leonard. *Photography in the Modern Advertisement*. Pelham, NY, 1937.

Steinorth, Dr. Karl, and Gundlach, F. C., eds. *Foto-Design als Auftrag: Eine Ausstellung des Bundes Freischaffender Foto-Designer Deutschland*. Stuttgart, 1982.

————, and Wagner, Franz-Erwin, eds. *Foto-Design 1986: Eine Ausstellung des Bundes Freischaffender Foto-Designer Deutschland*. Stuttgart, 1986.

Takeyama, Hirohiko, ed. *The Poster*. Tokyo, 1985.

Taylor, G. Herbert, ed. *My Best Photograph and Why*. New York, 1937.

Tono, Yoshiaki. "Tadanori Yokoo: Between Painting and Graphic Art." *Artforum* 22, no. 1 (September 1983): 38–43.

Williamson, Judith. *Decoding Advertisements*. London, 1985.

ADVERTISING, ANNUALS AND INDEXES

Accent. *Le Livre des Photographes de Mode et de Publicité*. Paris, 1984–present.

Advertising Photographers' Association of Japan. *Advertising Photography in Japan*. Tokyo, 1982–present.

Adweek. *Adweek Portfolio: Photography*. New York, 1986–present.

Adweek/Rotovision SA. *Art Directors' Index*. New York and Geneva, 1974–present.

American Showcase, Inc. *American Showcase*. New York, 1978–present.

————. *Corporate Showcase*. New York, 1982–present.

American Society of Magazine Photographers, Inc. *ASMP Book*. New York, 1981–present.

Art and Industry. *Art and Industry* [slight title changes]. London and New York, 1922–58.

Art Directors Club of New York. *Annual of Advertising Art* [title changes]. New York, 1921–present.

Art et Métiers Graphiques. *Arts et métiers graphiques*. Paris 1927–39.

————. *Photographie*. Paris, 1930–40, 1947.

————. *Publicité*. Paris, 1934–39.

Chapman, Morris, Williams, Ltd. *Art Directors' Index to Photographers*. London, 1970–72.

Chapman, Morris, Williams, Ltd./Rotovision SA. *Art Directors' Index to Photographers*. London and Geneva, 1972–77.

Clibborn, Edward Booth. *American Photography*. New York, 1985–present.

Friendly Publications, Inc. *The Creative Black Book*. New York, 1970–present.

Graphic-sha Publishing Co., Ltd. *Photographers Index*. Tokyo, 1985–present.

Herdeg, Walter, ed. *Photographis*. Zurich, 1966–86.

Japan Creators' Association. *Commercial Photography Exposed*. Tokyo, 1983–present.

Moser, Wilhelm, and Colby, David, eds. *Select Magazine*. Dusseldorf, 1984–present.

Pederson, B. Martin, ed. *Photographis*. Zurich, 1987–present.

Phoenix Illustrationsdruck und Verlag. *Gebrauchsgraphik-International Advertising Art*. Berlin, 1925–present.

Rotovision SA. *Art Directors' Index to Photographers*. Geneva, 1978–present.

INDIVIDUAL PHOTOGRAPHERS

ADAMS, ANSEL

Adams, Ansel. *Ansel Adams: Images 1923–1974*. Boston, 1974.

————. with Mary Street Alinder. *Ansel Adams: An Autobiography*. Boston, 1985.

AVEDON, RICHARD

Avedon, Richard. *Photographs, 1947–1977*. New York, 1978.

————. *Portraits*. New York, 1976.

Enrico, Dottie. "Revlon Breaks Ads Featuring Unknown Beauties." *Adweek* 27, no. 55 (8 December 1986): 6.

Schiffman, Amy. "Requiem for Some Lightweights." *American Photographer* 12, no. 2 (February 1984): 12.

AVERY, SID

Markus, David. "Spots of Fun." *American Photographer* 11, no. 2 (August 1983): 116–18.

BALLARD, J. G.

Vale, and Juno, Andrea, eds. *J. G. Ballard. Re/Search* [entire issue] 8/9 (1984).

BENDER & BENDER

"Merit Photography." *Studio Magazine* [Studio Awards], December 1986, pp. 84–85.

BERNHARD, RUTH

Mitchell, Margaretta. *Recollections: 10 Women of Photography*. New York, 1979.

Sabine, Lillian. "Ruth Bernhard of New York City." *Abel's Photographic Weekly* 48, no. 1248–1250 (21 November–5 December 1931): 591, 623, 647.

BLAKE, REBECCA

Blake, Rebecca. *Forbidden Dreams*. New York, 1984.

Leddick, David. "Rebecca Blake: rêves d'une fille dans les grandes villes américaines." *Zoom* 63 (1979): 66–73.

BRUEHL, ANTON

Allen, Casey. "Bruehl." *Camera 35* 23, no. 9 (October 1978): 20–26, 75–77.

Deal, Joe. "Anton Bruehl." *Image* 19, no. 2 (June 1976): 1–9.

CLARIDGE, JOHN

Girling, Mari. "Interview." *The British Journal of Photography* 128, no. 6303 (15 May 1981): 497–99.

Seaman, Debbie. "Ilford Films Get Snappy Image in London." *Adweek* 27, no. 35 (21 July 1986): 24.

COLLINS, CHRIS

"Liquid Assets." *American Photographer* 14, no. 5 (May 1985): 102.

COLLINS, JOHN F.

"Where to Put the Lights and Camera." *Printed Salesmanship* 57, no. 5 (July 1931): 404–5, 440.

COSIMO

"Mummy's the Word." *American Photographer* 6, no. 2 (February 1981): 24.

COSINDAS, MARIE

Cosindas, Marie. *Faces and Facades*. Cambridge, MA, 1977.

————. *Marie Cosindas: Color Photographs*. Boston, 1978.

Weiss, Margaret R. "A Show of Color." *Saturday Review* 24 (September 1966): 45–52.

DOMELA-NIEUWENHUIS, CESAR

Domela-Nieuwenhuis, Cesar. "Fotomontage." In Staatliche Museen, *Fotomontage*. Berlin, 1931.

FINSLER, HANS

Finsler, Hans. *Mein Weg zur Fotografie—My Way to Photography*. Zurich, 1971.

FITZ, GRANCEL

Edwards, Owen. "Having Fitz About Advertising and Art." *American Photographer* 16, no. 6 (June 1986): 26, 28.

Fondiller, Harvey V. "Grancel Fitz: World Class Pioneer in Advertising Photography." *Popular Photography* 23, no. 7 (July 1986): 106.

GILL, LESLIE

Cato, Robert. "With an Eye for Clarity: Leslie Gill, 1908–1958." *Infinity* 8, no. 8 (October 1958): 3–25.

"Leslie Gill: His Work and His Influence." *Modern Photography* 23 (January 1959): 80–89.

New Orleans Museum of Art. *Leslie Gill: A Classical Approach to Photography, 1935–1958*. New Orleans, 1983.

GRIFFIN, RICHARD

Walker, Cummings G. *The Great Poster Trip: Art Eureka*. Palo Alto, CA, 1968.

GUDNASON, TORKIL

"What's New Portfolio." *Adweek* 27, no. 9 (24 February 1986): 48.

HEARTFIELD, JOHN

Arbeitsgruppe Heartfield, ed. *John Heartfield: Dokumentation*. Berlin, 1969.

Berger, John. "The Political Uses of Photo-Montage." In *The Look of Things*, pp. 183–89. New York, 1974.

Herzfelde, Wieland. *John Heartfield: Leben und Werk*. Dresden, 1962.

Kahn, Douglas. *John Heartfield: Art and Mass Media*. New York, 1985.

HESSE, PAUL

Paul Hesse: Hollywood's Photographic Ziegfeld. Los Angeles, n.d. [1950s].

HILLER, LEJAREN À

"Camera Studies in Medical History." *Printing Art* 60 (January 1933): 364–65, 401.

Hiller, Lejaren à. *Surgery Through the Ages, A Pictorial Chronical [sic]*. New York, 1944.

Katz, Joseph. "Lejaren à Hiller." *The Commercial Photographer* 10, no. 10 (July 1935): 319–20, 322.

HINE, LEWIS WICKES

Hine, Lewis W. *Men at Work: Photographic Studies of Modern Man and Machines*. New York, 1932; rev. ed., 1977.

Rosenblum, Walter; Rosenblum, Naomi; and Trachtenberg, Alan. *America & Lewis Hine: Photographs, 1904–1940*. Millerton, NY, 1977.

HIRO

Edwards, Owen, with Callahan, Sean, et al. "The Great American Photographer." *American Photographer* [special issue] 8, no. 1 (January 1982): 28, 34–73.

"Hiro." *Photo World* 2, no. 5 (May 1974): 28–41, 94, 96.

Meyer, Pucci. "Hiro." Translated by Robert Y. Pledge. *Zoom* 13 (1972): 46–85.

Zwingle, Erla. "Sweet Smell of Success." *American Photographer* 8, no. 3 (March 1982): 125–27.

HOLZ, GEORGE

Russell, Anne M. "Golden Glow." *American Photographer* 14, no. 6 (June 1985): 100–102.

HOROWITZ, RYSZARD

Pozner, André. "Ryszard Horowitz: Délit de publicité pour l'imaginaire." *Zoom* 16 (1972): 60–73.

Thorsen, Karen. "Ryszard Horowitz." *Zoom* 82 (1981): 56–63.

HOSOE, EIKOH

Hosoe, Eikoh, and Hijikata, Tatsumi. *Kamaitachi*. Tokyo, 1969.

Szarkowski, John, and Yamagishi, Shoji, eds. *New Japanese Photography*. New York, 1974.

HUTCHINSON, EUGENE

Taylor, G. Herbert, ed. *My Best Photograph and Why*. New York, 1937.

ISSERMANN, DOMINIQUE

Hinstin, J. "Dominique Issermann: Traduire un look." *Zoom* 83 (1981): 18–25.

"Issermann: Un chateau en été." *Photo* 235 (April 1987): 54–61.

JACOBI, LOTTE JOHANNA

Beck, Tom. *Lotte Jacobi: Portraits and Photogenics*. Baltimore, 1978.

White, Stephen. *Lotte Jacobi*. Beverly Hills, 1986.

Wise, Kelley, ed. *Lotte Jacobi*. New York, 1978.

JOHNSTON, ALFRED CHENEY

"Ziegfeld Follies: Alfred Cheney Johnston." *Collectors Photography* (March–April 1987): 88–97.

JUMONJI, BISHIN

Terayama, Shuji. "Bishin Jumonji, l'Homme suspendu entre le cauchemar et la réalité." *Zoom* 42 (1976): 52–71.

KASTEN, BARBARA

Kasten, Barbara, and Jussim, Estelle. *Constructs*. Boston, 1985.

KELLY, ALTON

Walker, Cummings G. *The Great Poster Trip: Art Eureka*. Palo Alto, CA, 1968.

KEPPLER, VICTOR

Keppler, Victor. *The Eighth Art: A Life of Color Photography*. New York, 1938.

———. "Legend in Our Times." *Infinity* 20, no. 8 (August 1971): 4–11.

———. *Man + Camera: A Photographic Autobiography*. New York, 1970.

———. "The Problem of Types." *Printer's Ink* 172 (26 September 1935): 80–81.

KLUTSIS, GUSTAVE GUSTAVOVICH

Rowell, Margit, and Rudenstine, Angelica Zander. *Art of the Avant-Garde in Russia: Selections from the George Costakis Collection*. New York, 1981, pp. 274–75.

KOLLAR, FRANÇOIS

Kollar, François, and Photiadès, V. *25 photos de Kollar*. Paris, 1934.

Lelieur, Anne-Claude, and Bachollet, Raymond. *François Kollar. La France travaille. Regard sur les années trente*. Paris, 1985.

KURIGAMI, KAZUMI

L., I. "Kurigami." *Zoom* 62 (1979): 42–49.

LEIBOVITZ, ANNIE

Leibovitz, Annie. *Photographs/Annie Leibovitz*. New York, 1983.

MAISEL, JAY

"Jay Maisel." *Camera 35* 23, no. 9 (October 1978): 32–49, 78.

Zwingle, Erla. "United Technologies." *American Photographer* 5, no. 2 (August 1980): 86–87.

MAPPLETHORPE, ROBERT

Institute of Contemporary Art. *Robert Mapplethorpe, 1970–1983*. London, 1983.

Mapplethorpe, Robert. *Certain People: A Book of Portraits*. Los Angeles, 1985.

——. *Black Book*. New York, 1986.

MATTER, HERBERT

A+A Gallery, Yale University. *Herbert Matter: A Retrospective*. New Haven, 1978.

American Institute of Graphic Arts. *Herbert Matter*. New York, 1961.

Dufner, Georg. *Herbert Matter*. Engelberg, 1985.

MEDNICK, SOL

Philadelphia College of Art. *The Sol Mednick Memorial Exhibition*. Philadelphia, 1971.

"We Knew Sol." *Camera* 1 (January 1971): 6–13, 21.

MEOLA, ERIC

Masucci, Myrna. "Eric Meola." *The Pro Review* 2, no. 3 (July–August 1986): 14–21.

Roth, Evelyn. "Upstairs, Downstairs." *American Photographer* 14, no. 6 (June 1985): 68–73.

MICHALS, DUANE

Michals, Duane. *Homage to Cavafy*. Danbury, CT, 1978.

——. *Journey of the Spirit After Death*. New York, 1972.

——. *Real Dreams*. Danbury, CT, 1976.

Roth, Evelyn. "Moving the Merchandise." *American Photographer* 13, no. 3 (March 1985): 92–94.

MIYOSHI, KAZUYOSHI

Miyoshi, Kazuyoshi. *Rakuen*. Tokyo, 1986.

MOHOLY-NAGY, LÁSZLÓ

Haus, Andreas. *Moholy-Nagy: Photographs and Photograms*. Translated by Frederic Samson. New York, 1980.

Hight, Eleanor M., et al. *Moholy-Nagy: Photography and Film in Weimar, Germany*. Wellesley, MA, 1985.

Kostelanetz, Richard, ed. *Moholy-Nagy*. Documentary Monographs in Modern Art. New York, 1970.

Moholy-Nagy, László. *Painting Photography Film*. Translated by Janet Seligman. Cambridge, MA, 1969.

——. *Vision and Motion*. Chicago, 1947.

MOON, SARAH

Pacific Press Service. *Sarah Moon*. Tokyo, 1984.

MURAY, NICKOLAS

International Museum of Photography. *Nickolas Muray*. Rochester, NY, 1974.

Muray, Nickolas, and Gallico, Paul. *The Revealing Eye*. New York, 1967.

OMMER, UWE

Markus, David. "Uwe Ommer." *American Photographer* 12, no. 9 (September 1984): 50–56.

Ommer, Uwe. *Uwe Ommer Photoédition*. Schaffhausen, 1980.

——. *Exotic*. Munich, 1983.

Roth, Evelyn. "On Set with Uwe Ommer." *American Photographer* 12, no. 9 (September 1984): 96–97.

OUTERBRIDGE, PAUL EVERAD, JR.

Dines, Elaine, ed. *Paul Outerbridge, A Singular Aesthetic*. Laguna Beach, CA, 1981.

Howe, Graham, and Hawkins, G. Ray, eds. *Paul Outerbridge, Jr.: Photographs*. New York, 1980.

Outerbridge, Paul, Jr. *Photographing in Color*. New York, 1940.

PACCIONE, ONOFRIO

Paccione, Onofrio, and Solow, Martin. *Paccione*. New York, n.d.

Russell, Anne M. "Paccione." *American Photographer* 14, no. 5 (May 1985): 38–49.

Zwingle, Erla. "The Ageless Diamond." *American Photographer* 2, no. 2 (February 1979): 90–91.

PENN, IRVING

Clark, Willard. "A Look at Irving Penn." *Camera 35* 2, no. 2 (1958): 120–25, 154.

Marlborough Gallery. *Irving Penn: Recent Still Life*. New York, 1982.

Penn, Irving. *Moments Preserved: Eight Essays in Photographs and Words*. New York, 1960.

Szarkowski, John. *Irving Penn*. New York, 1984.

PENNEBAKER, JOHN PAUL

Barkley, Allan. "A Bagful of Photographic Tricks-of-the-Trade." *Printed Salesmanship* 62 (February 1934): 336–39, 357.

PIEL, DENIS

Cullerton, Brenda. *Donna Karan: New York*. New York, 1986.

"What's New Portfolio." *Adweek* 27, no. 31 (23 June 1986): 42.

SANDER, AUGUST

Keller, Ulrich. *August Sander: Menschen des 20. Jahrhunderts: Portraitphotographien, 1892–1952*. Munich, 1980.

Sander, August. *Menschen ohne Maske*. Luzern and Frankfurt am Main, 1971.

SCHAWINSKY, XANTI

Schawinsky, Xanti. *What Photography Taught Me*. Beria, NC, 1936.

SCHUITEMA, PAUL

Steinorth, Karl. *Photographen der 20er Jahre*. Munich, n.d., pp. 90–91.

SIPLEY, LOUIS WALTON

Sipley, Louis Walton. *A Half Century of Color*. New York, 1951.

SKREBNESKI, VICTOR

Butler, Jean. "He Lives in Ads He Photographs." *The New York Times Biographical Service* 9, no. 10 (February 1978): 264–66.

Fraser, Kennedy. "As Gorgeous As It Gets." *New Yorker*, 15 September 1986, pp. 42–81.

STEICHEN, EDWARD

Museum of Modern Art. *Steichen the Photographer*. New York, 1961.

Steichen, Edward. *A Life in Photography*. New York, 1963.

STERN, BERT

Cornfield, Jim. *The Photo Illustration: Bert Stern*. Los Angeles, 1974.

Halebian, Carol. "The Bert Stern Story." *Camera 35* 24, no. 3 (March 1979): 26–53, 70–71, 76.

Stern, Bert, and Vallarino, Vincent. "Bert Stern." *Interview*, February 1987, pp. 53–60.

STERN, GRETE

Coke, Van Deren. *Avant-Garde Photography in Germany, 1919–1939*. New York, 1982.

Wingler, H. M. *Begegnungen mit Menschen: Das fotografische Werk von Grete Stern*. Berlin, 1975.

TABARD, MAURICE

Fleig, Alain. "Maurice Tabard, Gentleman photographe." In *Clichés* 6 (1984): 53.

Fondation nationale de la photographie. *Maurice Tabard, l'Alchimiste des formes.* Lyon, 1985.

TABER, ISAIAH WEST

Hales, Peter Bacon. *Silver Cities: The Photography of American Urbanization, 1839–1915.* Philadelphia, 1984.

Taber, Isaiah W. *View Album and Business Guide, of San Francisco, Photographically Illustrated.* San Francisco, n.d. [1884].

TELINGATER, SALOMON BENEDIKTOVITCH

Telingater, Salomon. *Iskousstvo knigui.* Moscow, 1960.

————, and Kaplan, L. E. *Iskousstvo aktsidentnovo nabora.* Moscow, 1965.

Association France-URSS. *Salomon Benediktovitch Telingater, L'oeuvre graphique, 1903–1969.* Paris, 1978.

TURBEVILLE, DEBORAH

Turbeville, Deborah. *Les amoureuses du temps passé.* Tokyo, 1985

————. *Unseen Versailles.* New York, 1981.

TURNER, PETE

Kaplan, Michael. "Perfect Match." *American Photographer* 7, no. 4 (October 1986): 100–102.

Russell, Anne M. "Whiskey Sours." *American Photographer* 15, no. 4 (October 1985): 108–10.

Turner, Pete. *Pete Turner Photographs.* New York, 1987.

Zwingle, Erla. "Kohler's Chromium Oasis." *American Photographer* 3, no. 5 (November 1980): 92–95.

UNDERWOOD AND UNDERWOOD COMMERCIAL

Underwood and Underwood. *Reserve Illustrations: Advertising Photography for the $10 Budget.* New York, 1937.

VORMWALD, GERHARD

Mannheimer Kunstverein. *Gerhard Vormwald: Photos!* Mannheim, 1987.

WILLIAMS, H. I.

Sabine, Lillian. "H. I. Williams, New York City." *The Commercial Photographer* 7, no. 1 (October 1931): 10–17.

WOLF, HENRY

Livingston, Kathryn. "Winging It." *American Photographer* 13, no. 5 (November 1984): 114–18.

Wolf, Henry. "Funny Pictures." *American Photographer* 15, no. 5 (November 1985): 60–67.

————. "A Bold Look Backward." *Idea* [special issue]. Tokyo, 1984.

WOLF, REINHART

Die grösse Küche und ihre kleinen Geheimnisse. Munich, 1986.

Wolf, Reinhart. *China's Food, A Photographic Journey.* New York, 1985.

————. *New York.* New York, 1980.

YOKOSUKA, NORIAKI

"Yokosuka." *Zoom* 129 (1987): 26–31.

ZWART, PIET

Haags Gemeentemuseum. *Piet Zwart.* The Hague, n.d.

Steinorth, Karl. *Photographen der 20er Jahre.* Munich, n.d., pp. 112–13.

Illustration references in italics

Abbotts Laboratories, 119
Absorbine Jr. (Pagano & Co.), *54*
A. C. & R., 163
Adams, Ansel, 129, 192; *137*
Adams Briefs (Avery), 102; *125*
Advantec, Ltd., 189
Advertisement for Christian Dior (Avedon), 128, 131; *157*
Advertisement for Revlon (Avedon), 166; *177*
Advertising: effectiveness of, 165; expenditures on, 165; image in, 164–65; institutional, 168; origins of, 16; purpose of, 164
Advertising agencies: in mass market period, 102–3; postwar growth in, 96–97
Advertising photography
 annual publications of, 127
 appropriated into art imagery, 13–15
 artistry of, 11
 black-and-white, 166–67
 color, 67–71
 in computerized world, 168–69
 and creative independence, 97–98, 127–29
 crossovers from editorial imagery in, 99
 early twentieth century, 20–23
 in England, 129, 131
 era of visual sophistication in, 129–32
 fear appeal in, 66–67, 88
 first published treatment of, 19–20
 found imagery in, 167
 in Germany, 33–35, 36, 49, 160
 histrionics in, 65–66
 iconic, 100–101, 129
 internationalism of, 126–27
 in Japan, 30–31, 100, 126, 129, 135, 140, 143, 154, 155, 169, 175, 189, 191
 life-styles in, 100
 male stereotypes in, 100
 modernism in: 30–63, 64–65; appearance in 1922, 30–32; early, 32–33; European, 33–36; features of, 30; international impact of, 64; reaction against, 65
 naturalism in, 65
 in nineteenth century, 16–19
 vs. painted illustration, 12
 recent trends in, 166–68
 scarcity of original prints, 13
 sex appeal in, 30–31, 36
 sexist, 66
 sixties experiments in, 129
 sociological studies of, 12
 standards for, 20
 with strobe lighting, 102
 three-dimensional, 101–2
 usage of older forms in, 101, 167
Agfacolor, 70
Agha, Mehemed F., 36
Akadama Port Wine (Kawaguchi Photo Studio), 30–31; *38*
Akravue, 101
Albert Nipon (Piel), 167; *185*
All Union Spartakiada, 46
Ally Gargano/MCA Advertising, Ltd., 184
Almay, Inc., 142
Aluminum (Roper), 101; *115*
American Meat Institute, 86
American Red Cross, 94
American Tobacco Co., 82
Americaya Ltd., 175
Annual of Advertising Art, 127
Ansett International Hotels and Resorts, 158
Antidrug campaign, 173
Arbeiter-Illustrierte-Zeitung (A-I-Z), 34
Arbus, Doon, 128
Armstrong Cork, 87
Arnell, Peter, 167–68; *166*
Arnell/Bickford Associates, 36, 166, 168, 176, 185, 188
Art directors, 97–98, 99, 127–29
Art Directors Club of New York exhibition, 30
Artists' Interiors (Emilio Tadini) (Raffo), 151
Aspasia (Hiller), 66; *85*
Association of Freelance Photo Designers, 128
Aurea, 131, 146
Avedon, Richard, 101, 128, 131, 166, 192; *157, 177*

Avedon (Richard), Inc., 157, 177
Avery, Sid, 102, 192; *124, 125*
Ayer (N. W.) & Son, 96, 111, 121

Bagby, Robert, 100, 192; *108*
Baldus, Edouard-Denis, 11
Ballard, J. G., 34, 129, 193; *136*
Barlogis & Jaggi, 159
Bartholomew, Ralph, Jr., 67, 99, 100, 102, 193; *88, 114, 124*
Bass, Saul, 103
Batten, Barton, Durstine & Osborn, Inc., 124
Bauhaus, 33, 34, 64
Baumeister, Willi, 36; *37*
Bayer, Herbert, 34, 36, 64; *34*
B Communications, 151
Beautiful (Skrebneski), 11, 129, 131; *130, 163*
Beene (Geoffrey), Inc., 144
Bell Atlantic Telephone, 167, 169, 190
Bender and Bender Studio, 193; *152*
Benglis, Lynda, 13, 34
Benson & Hedges, 131–32, 153
Bernbach, William, 97
Bernhard, Ruth, 99, 193; *110*
Better Shape (Keppler), 65; *76*
Beverwijksche Conservenfabriek, 53
Blake, Rebecca, 131, 193; *161*
Bollinger Champagne (Blake), 131; *161*
Book, Le, 167, 180
Booth, John Wilkes, 17, 24
Bosch Radio, 67, 77
Bourke-White, Margaret, 68
Braddy, Jim, 193; *136*
Brady, Stanley, 35, 36
Bramson, Hershel, 97, 99
Brooks, Bob, 126
Bruehl, Anton, 33, 65, 193; *81*
Bullocks, Los Angeles (Bernhard), 99; *110*
Bullocks-Wilshire Department Store, 110
Bund Freischaffender Foto-Designer (BFF), 128
Burchartz, Max, 14
Burgin, Victor, 13, 126; *14*
Burnett (Leo) Co., Inc. [now Leo Burnett U.S.A.], 86, 101, 136
Business directories, 17–18

Cacharel (Moon), 167; *181*
Cadillac (Bruehl), 65; *81*
Camel Cigarettes (Steichen), 32; *44*
Camera Work, 20
Campbell-Ewald Co., 80
Can West Wear East? (Kurigami), 155
Carbro printing, 69
Carrier Air Conditioning, 111
Carven Parfums, 132, 139
Cashmere Bouquet soap, 67
Cassina, 151
Chanel, Inc., 129, 145
Chapman, Simon, 131
Charles Jourdan (Ommer), 166; *171*
Check In (Simmons), 178
Chemical Apparatus, 18; *25*
Chermayeff, Serge, 103
Chevrolet (Fitz), 65; *80*
Chevrolet (Sipley), *106*
Children's Clothing Appeal (Hiller), 94
Christofle Silver, 57
Chromatone, 70
Chromspun (Fitzgerald), *109*
Chrysler Corp., 78
Cigarette advertising, 44, 69, 70, 82, 127, 131–32
Claridge, John, 193; *158*
Clinique Laboratories, Inc., 183
Coca-Cola Company, The, 69, 101
Coffee Drinkers, The (Outerbridge), *100*
Colgate-Palmolive-Peet Co. [now Colgate-Palmolive Co.], 67, 68, 90
Collar (Outerbridge), 32, 33; *44*
Collett, Dickenson, Pearce and Partners Ltd., 131, 153
Collins, Chris, 167; *182*
Collins, John F., 32, 33, 193; *60*
Cologne Cathedral (Sander), 35
Cologne 4711 (Sander), 55

INDEX

Color photography, 67–71
Color Reflects (Lutens), *191*
Color-separation camera, 69
Columbia Slide Co., 27
Come In!, 41; *41*
Compass Camera (Havinden), *72*
Composition with Triangle (Penn), *150*
Connors, Elizabeth, *102*
Corning Glass Works, 67, 88
Cosimo, 131, 193; *146*
Cosindas, Marie, 131, 193; *138*
Costain, Harold Haliday, 71
Coster, Gordon, 33, 193; *61*
Cox, Edward Machell, 33
Crawford Halls Partnership, 172
Critique of Commodity Aesthetics (Haug), 165
Crowd Scene (Sander), *35*
Crowninshield, Frank, 36

Daiku Co., Ltd., 154
Daniel & Charles, 96
Davis & Geck, Inc., 66, 85
DDM Advertising, Ltd., 158
DeBeers Consolidated Mines, Ltd., 120, 129
Defender Photo Supply Company, 70
De Meyer, Baron, 36
Dentsu Young & Rubicam, 158
Depth-O-Graphs, 102
Derrick Cross (Mapplethorpe), *167*; *172*
Deutscher Werkbund, 50
Dior, Christian, 157, 166
Diors, The (Avedon), 128, 131; *157*
Dodge (Muray), 65, 100; *78*
Dole, 99, 117
Domela-Nieuwenhuis, Cesar, 35, 194; *48*
Donna Karan (Gudnason), *167*; *188*
Don't Get Hurt (Keppler), *95*
Dorfsman, Lou, 97
Douglas Lighters (Steichen), *56*
Doyle Dane Bernbach [now DDB Needham World-
 wide], 96, 97, 98, 145, 147
Draper, Ernest, *102*
Duchamp, Marcel, 32
Duplex Razors (Collins), 32; *60*
Dye Transfer process, 70

Eastman Kodak Co., 22–23, 29, 32, 60, 70, 99, 112,
 114
Eco, Umberto, 131, 148
Edgerton, Harold, *102*
Editorial photography, 12, 99
8 O'Clock Coffee, 100
1847 Rogers Bros. (Muray), *91*
Eighth Art, The (Keppler), 70
Ellis, William Shewell, 23, 33, 194; *43*
Emerson, Herbert Lyman, 194; *105*
es kommt der neue fotograf! (Graff), 36, 37
Eternal (Hiro), *166*; *174*
Etienne Gourmelen (Hiller), 66; *66*
Extreme Red (Hiro), *145*

Fenton, Roger, 11
Ferry-Hanly Advertising Co., 76
Fieldcrest Mills, Inc., 184
Film und Foto, 50
Finsler, Hans, 194; *59*
Fiorentino Reinitz Leibe, 182
Fire Eater (Meola), 129; *142*
Fitz, Grancel, 11, 65, 194; *80, 81, 92*
Fitzgerald, Edward P., 101, 194; *109*
Ford (Greb Studios), *106*
Ford Motor Co., 92, 106, 178
Foreign Advertising Photography (exhibition), 36
Fox, Stephen, 165
Fox Talbot, William Henry, 18
Frankfurt, Steve, 97, 127, 128
Fresh! (Bartholomew), 99; *114*
Fresh deodorant, 99, 114
Frizon, Maud, 166, 172
Fruit Cocktail (Muray), 99; *117*
Fuji Photo Film, 150
Future City (Turner), 169; *190*

Gallaher Ltd., 153
Galloway, Ewing, 66
Geer Dubois, Inc., 142
General Electric Co., 67, 88, 116, 123
General Mills, Inc., 104
General Motors Corp., 80, 81, 106
Gill, Leslie, 99, 194; *112*
Goerz (Moholy-Nagy), *45*
Gold (Holz), *147*
Goldschmidt, Charles, 96
Grace, Roy, 97
Grace Cruise Lines, 100, 108
Graff, Werner, 36, 37
Graffiti (Wilkes), *166*; *175*
Graflex Cameras, 41
Graphis Annual, 127
Greb (George) Studios, 100, 194; *106*
Green, Ruzzie, 99, 194; *90, 107*
Greengage Associates, 156
Griffin, Richard, 195; *134*
Griffith, D. W., 36
Grosz, George, 36
Gruber, L. Fritz, 127, 166
Gudnason, Torkil, 36, 167, 194; *188*
Guerlain, 61
Gumbiner (L. C.) agency, 99, 121

Hakuhodo Inc., 189
Hamburg Importplatz (Domela-Nieuwenhuis), *48*
Hanae Mori (Hiro), 101; *156*
Harper's Bazaar, 36
Hartmann, Sadakichi, 20
Hats (Telingater), *47*
Haug, W. F., 17, 165
Havinden, John, 64, 194; *72*
Heartfield, John (Helmut Herzfeld), 33–34, 129, 194;
 49
Henri, Florence, 36
Herbessence Beauty Preparations (Cosindas), 131;
 138
Herbigs Hellster, 52
Herdeg, Walter, 127
Hesse, Paul, 194; *118*
Hiller, Lejaren à, 66, 67, 68, 99, 194; *66, 77, 85, 94,*
 104
Hills Bros. Coffee, Inc., 137
Hine, Lewis Wickes, 32, 194–95; *40*
Hine, Thomas, *102*
Hiro, 101, 129, 166, 195; *145, 156, 174*
Hoedt (W. H.) Studios, 119
Hoffman, M. Luther, 99, 195; *119*
Hoffmann-La Roche & Cie, 58
Holz, George, 195; *147*
Homeless Women—The Depression (Steichen), 65;
 84
Homo Cannabis (Rasmussen), *167*; *173*
Hoover Vacuum Cleaners, 27
*Hopkins' Advertising Album and Business Directory
 for the City of Baltimore*, 18
Horowitz, Ryszard, 36, 169, 195; *179, 187*
Horst, Horst P., 11
Hosoe, Eikoh, 195; *135*
Hotchkiss Arms, 17; *25*
Hotel (Torcello), 158
Houbigant Cosmetics (Ellis), 33; *43*
Howard, Kathleen, 36
Hoyningen-Huene, George, 11, 36
H.P.E., *146*
Huebner, William C., 68
Hurray, Butter Is Everything (Heartfield), 34; *49*
Hutchinson, Eugene, 195; *93, 104*
Huxley, Aldous, 11–12
H. W. & D., Inc., 79

Ide (Geo. P.) & Co., Inc., 44
Illustration, L', 68
In the Cab—P.R.R. (Hine), 32; *40*
Intaglio printing, 68
International Gold Corp., 147
International Silver Co., 91
Iribe, Paul, 36
Issermann, Dominique, 128, 166, 195; *172*
Ives, Frederic E., 102

Jacobi, Lotti Johanna, 195; *58*
Jell-O pudding, 102, 103
Jergens (Andrew) Co., 32, 41
Jessica McClintock (Turbeville), 129; *162*
Johnson & Johnson, 65, 76
Johnston, Alfred Cheney, 33, 195; *63*
Johnston (Jim) Advertising, Inc., 179
Jones, Lewis B., 22–23
Jourdan (Charles), Inc., 166, 171
Jumonji, Bishin, 195; *154*

Kamaitachi (Hosoe), *135*
Kanebo Cosmetics, 159
Karan, Donna, 167, 168, 188
Kasten, Barbara, 169, 195; *186*
Kastor (H. W.) & Sons Advertising Co., 43
Kawaguchi Photo Studio, 30, 100; *38*
Kawai, Kazuo, 169, 195; *189*
Kelley, Tom, 195; *117*
Kelly, Alton, 195; *134*
Kempinski Coffee (Jacobi), *58*
Kenyon & Eckhardt, 94, 138
Keppler, Victor, 65, 66, 67, 70, 71, 166, 196; *67, 70,*
 76, 82, 88, 95
Ketchum Advertising, 190
Kimball, Abbott, 36
Kitchen Interior (Mettee), *87*
Klein, Calvin, 101
Klietsch, Karl, 68
Klutsis, Gustav, 34, 196; *46*
Kodachrome, 70
Kodak Ciné Camera (Bartholomew), 99; *114*
Kodak Girl, 22, 23; *22*
Kohler Chocolate (Finsler), *59*
Kollar, François, 64, 100, 196; *73*
Kölnisch Wasser 4711, 55
Kotobukiya Ltd., 30, 38
Krone, Helmut, 97
Kruger, Barbara, 14; *15*
KSAN (Kelly and Griffin), *134*
KSAN Radio, 134
Kurigami, Kazumi, 196; *155*
Kurtz, William, 68
Kutter, Markus, 129

Ladies' Home Journal, 69, 99
Lafon, L., 17; *25*
Lauder (Estée), Inc., 11, 129–31, 163
Lazarnick, Nathan, 66
Lecoultre Watch Co., 72
Le Gray, Gustave, 11
Leibovitz, Annie, 196; *178*
Lewis, Harvey S., 19–20, 21
Lincoln, Abraham, 17, 24
Lincoln Zephyr (Fitz), *92*
Lois, George, 97, 127, 129
Lord, Sullivan & Yoder Advertising, 152
Lord & Thomas, 82
Lucky Strike (Keppler), 70; *70, 82*
Lucky Strike cigarettes, 69, 70, 82
Luna International Photography Competition, poster
 of, 27
Luna Papiers et Tissus Artistiques, 27
Lune Macaroni, La (Kollar), *73*
Lutens, Serge, 126, 128, 196; *191*
Lyon, David, 100

Mabel Allen Ackermann, 29
McCann-Erickson, 96, 165, 170
McClintock (Jessica), Inc., 129, 162
McKinney, J. R., 33
McNamara, Clapp & Klein, 161
Ma Griffe perfume, 132, 139
Maisel, Jay, 168, 169, 196; *186*
Make-up Tokyo (Yokosuka), *140*
Mapplethorpe, Robert, 167, 196; *172*
Marlboro cigarettes, 100, 129, 136
Martinez, R. E., 127
Martini and Pyramid (Stern), 99, 101; *101, 121*
Matsushita Electrical Co., 154
Matter, Herbert, 64, 196; *75*
Maud Frizon (Issermann), *166*; *172*

Mayakovsky, Vladimir, 33
Mednick, Sol, 101, 196; *111*
Meola, Eric, 129, 196; *142*
Mercurochrome, 79
Mettee, Holmes I., 71, 196; *87*
Metz's Mincemeat, For (Spencer), 21; *21*
Michals, Duane, 167, 196; *176*
Micro Maze (Maisel), 168; *186*
Mili, Gjon, 102
Miyoshi, Kazuyoshi, 166, 167, 196; *175*
Modern Publicity, 71
Moholy-Nagy, Lázló, 34, 36, 101, 196; *45*
Molteni, William J., Jr., 102
Monkewitz, Nicolas, 197; *159*
Moon, Sarah, 166–67, 197; *181*
Morris, Robert, 13, 34
Mulas, Antonia, 131, 197; *148*
Mummy (Cosimo), 131; *146*
Munsingware, 125
Muray, Nickolas, 65, 69, 71, 99, 100, 101, 197; *69,
 91, 117, 123*
Murger, Henry, 10
Mustang Sally (Leibovitz), *178*

Nadar, 11
Nail Enamel (Yokosuka), *143*
National Needlecraft Bureau, 94
Necklace on Leg (Paccione), *141*
Neiman-Marcus (Michals), 167; *176*
Nesting Instinct (Wolf), *184*
Nevamar Corp., 152
Newell Emmet Agency, 88
Nike, Inc., 166, 175
Northwestern Knitting Co., 28
Nurnberg, Walter, 97–98, 103

Offset lithography, 68–69
Ogilvy, Benson & Mather, 96, 98, 122
Ogilvy, David, 97, 98
Oldsmobile (Fitz), 65; *81*
Olivetti (Schawinsky), 74
Olivetti typewriters, 74
Ommer, Uwe, 166, 197; *171*
$100,000 Reward!, 17; *24*
Oréal, L', Cosmair, Inc., 165, 170
Orikomi Advertising Co., 175
O'Sullivan, Timothy H., 11
Outerbridge, Paul, Jr., 11, 32, 33, 99, 197; *44, 100*
Overview (Turner), 167

Paccione, Onofrio, 98, 99, 127, 128, 197; *128, 141*
Padbury and Dickins, 18
Pagano & Co., 54
Paine, Wingate, 97
Palette (Penn), 165; *165, 170*
Papert, Koenig, Lois, 96
Parachutes (Hutchinson), 93
Parallax Stereogram, 102
Parco Co., Ltd., 31, 155
Peeling Potatoes (Steichen), 32; *41*
Pencil of Nature, The (Fox Talbot), 18
Penn, Irving, 99, 102, 129, 165, 197; *103, 120, 150,
 165, 170, 183*
Pennebaker, John Paul, 67, 197; *89*
Pennsylvania Railroad, 32, 40
Peretti, Elsa, 174
Perma-Lift lingerie, 128
Personal Products Corp., 107
Pétrole Hahn (Stern), 54
Peugeot, Ltd., 158
Peugeot 505 GTI (Claridge), *158*
Philips Electrical, 51
Philips ½ Watt Lightbulbs (Schuitema), *51*
Photo designers, 128
Photoengraving, 68
Photo Era, 21
Photogram, 33, 34, 36
Photographis, 127
Photography: editorial *vs.* advertising, 99; repro-
 duction techniques, 16; separation of commer-
 cial and art, 10–11, 20; *see also* Advertising
 photography
Photomontage, 33, 34, 35, 64, 101, 167

Piel, Dennis, 167, 168, 197; *168, 185*
Polaroid Corp., 102
Poltrona Frau, 148
Port Authority of Hamburg, 48
Porter, Allan, 126, 129
Portrait of a Young Girl (Sander), 35
Possession (Burgin), 14
Posters: in Japan, 129, 135; nineteenth century, 17,
 24; for social causes, 167, 173; travel, 64, 75;
 for war effort, 67, 95
Potato and Fries (Bender and Bender), *152*
Pousette-Dart, Nathaniel, 65
Pream (Hoffmann), 99; *119*
Prescher's Homemade Candies, 42
Printers' Ink Monthly, 36
Product photography, 18–19
Publicité, 127
Puttnies, H. G., 164

Quark, Inc., 186
Quark Word Juggler (Kasten), 169; *186*

Radkai, Paul László, 99, 197; *98, 122*
Raffo, Orio, 197; *151*
Rakuen (Miyoshi), 166; *175*
Ramos, Mel, 13
Rand, Paul, 103
Rapid Fire Hotchkiss Cannon (Lafon), 25
Rasmussen, Johnny, 34, 167, 197; *173*
Ray, Man, 36, 101
Reality photograph, 34, 36
Reed & Reed (distributors), 27
Revlon, Inc., 166, 177
Reynolds (R. J.) Tobacco Co., 44
Rodchenko, Alexander, 33
Rogers (Peter) Associates, 144
Rogers Bros. Silverplate, 69, 91
Roh, Franz, 34–35, 36
Roper, Earl C., 101, 197; *115*
Rose, L. G., 16
Rosenblum, Barbara, 128
Rössler, Jaroslav, 33, 197; *58*
Rotzler, Willy, 167
Royal Zenith, 167, 182
Rozon-Verduraz, 73
Rubinstein (Helena), Inc., 131, 138
Russell, Thomas, 22

Sander, August, 35, 198; *35, 52, 55*
Schawinsky, Xanti, 64, 198; *74*
Schewe, Jeffrey K., 198; *149*
Schmidt Label and Lithographic Co., 26
Scholz & Friends, GmbH, 160
Schudson, Michael, 65
Schuitema, Paul, 51, 198
Schweppe's quinine water, 98
Scott, John, 66
Separation negatives, 69
Shaved Pack (Summers), 131–32; *131, 153*
Sheriff (Braddy), 129; *136*
Shiseido Company, Ltd., 31, 126, 128, 140, 143, 191
Simmons, Tim, 198; *178*
Sipley, Louis Walton, 101, 198; *106*
Skrebneski, Victor, 11, 131, 198; *130, 163*
Smirnoff vodka, 99, 101, 121
Smith, P. R., 36
Smith's Bile Beans, 28
Somnifène (Rössler), 58
Sophia Loren (Hesse), 118
Spencer, Emma, 21; *21*
Sportcraft, Inc., 167, 172
Standard Oil, 67, 89
Staubach, Horst W., 128
Steichen, Edward, 32, 33, 67–68, 99, 198; *41, 44,
 56, 65, 84*
Steinhauser, Bert, 97
Steinorth, Karl, 127
Stern, Bert, 98, 99, 169, 198; *101, 121*
Stern, Grete, 100, 198; *54*
Stieglitz, Alfred, 20
Strand, Paul, 32
Stroboscopic lighting, 102
Studio Deberny Peignot, 62
Summers, Kevin, 131–32, 198; *131, 153*
Sunkist, Inc., 105

Suntory Ltd., 30, 38
Surgery Through the Ages (Hiller), 66
Swiss National Tourist Office, 75

Tabard, Maurice, 11, 33, 198; *57*
Taber, Isaiah West, 17–18, 198; *19, 26*
Tchibo Frisch-Rost-Kaffee AG, 160
Telingater, Salomon Benediktovitch, 34, 199; *47*
Tennessee Eastman Co., 109
Tennis (Klutsis), 46
Texaco, Inc., 124
Thomas (J. B.) & Associates, 149
Thomas—Le Book (Vormwald), *180*
Thompson (J. Walter) Co., 40, 41, 44, 56, 84, 96, 114
Thrift Syndicate, 31–32; *39*
Tiffany & Co., 174
Torcello, Paul, 199; *158*
Toshiba (Horowitz), 169; *186*
Townend, Peter, 127
Toyo Roshi Kaisha, Ltd., Advantec, Ltd., 189
Traffic Cop (Pennebaker), 67; *89*
Trahey Advertising Inc., 139
Travelers Aid Society, 65, 84
Travel poster, 64, 75
Trivision, 101
Tschichold, Jan, 93
Turbeville, Deborah, 129, 199; *162*
Turner, Pete, 12, 169, 199; *167, 190*
TWA Airlines, 118
Twice a Day (Penn), *183*
Two in a Canoe (Penn), *120*

Umberto Eco (Mulas), 131; *148*
Underwood & Underwood Commercial, 66; *113*
United States Steel Corp., 124
United Technologies Corp., 168, 186
U.S. Treasury Department, 95
U.S. War Department, 17, 24
Untitled (Collins), *182*
Untitled (Piel), 168

Vanity Fair, 30, 32, 36
Vanity Fair Mills, Inc., 93
*View Album and Business Guide, of San Francisco,
 Photographically Illustrated* (Taber), 17–18; *19*
Virgin Atlantic Airlines, 178
VitaVision, 101–2
Vogue, 126, 165
Vol de Nuit (Coster), *61*
Volkswagen of America, 97, 98
Vormwald, Gerhard, 167, 199; *180*

Wall Street Journal (Horowitz), *179*
Warhol, Andy, 13
Wash-Off Relief color process, 70
Water Beads (Kawai), 169; *189*
We Are the Objects of Your Suave Entrapments
 (Kruger), 14; *15*
Western Camera Notes, 19–20
Westley, F. W., 71, 199; *83*
Wheaties (Hutchinson and Hiller), 99; *104*
Wheeler, David, 132
Wicks, Sidney, 12
Wieden & Kennedy, 175
Wilkes, Steve, 166, 199; *175*
Williams, H. I., 64, 71, 199; *86*
Windows in Walls (Schewe), *149*
Winston (Harry), Inc., 128, 141
Winter Morning, Yosemite Valley (Adams), *137*
Winter Vacation—Double Vacation (Matter), 75
Wolf, Henry, 36, 98, 99, 127–28, 131, 199; *132, 139,
 144, 184*
Wolf, Reinhart, 129, 199; *160*
Wolverine Technologies, Inc., 149
Wood & Comer, Ltd., 25
Wundermann, Ricotta & Kline, 178

X-Ray Hand (Muray), *123*

Yednock, Kenneth, 164
Yokosuka, Noriaki, 199; *140, 143*
Young (W. F.), Inc., 54
Young & Rubicam, 96, 107, 158

Zwart, Piet, 199; *53*